IDAHO
IMPRESSIONS

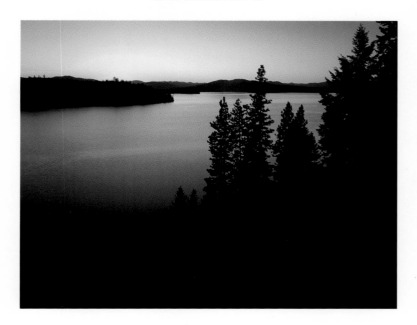

Mark Walker Lots

Christopher

Cecil D. Andrus

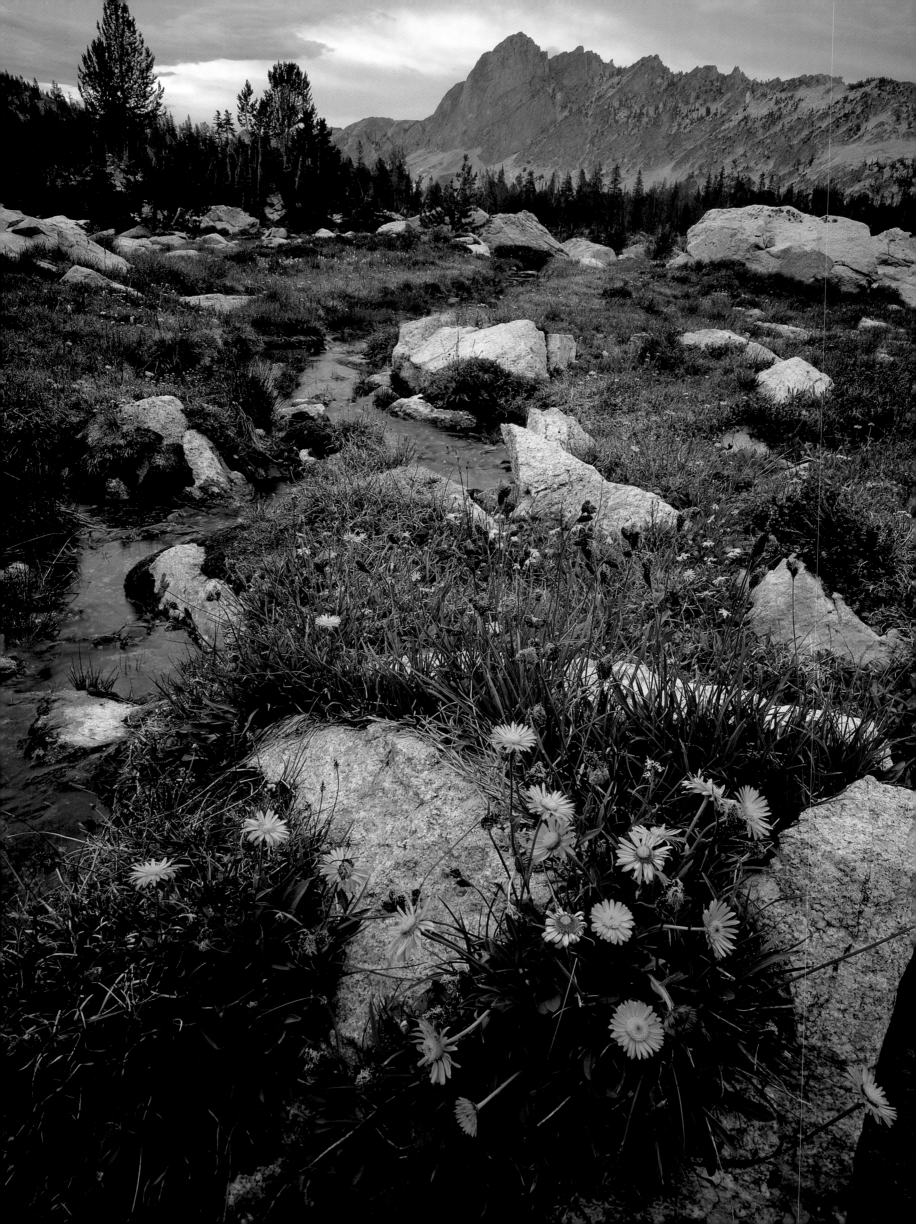

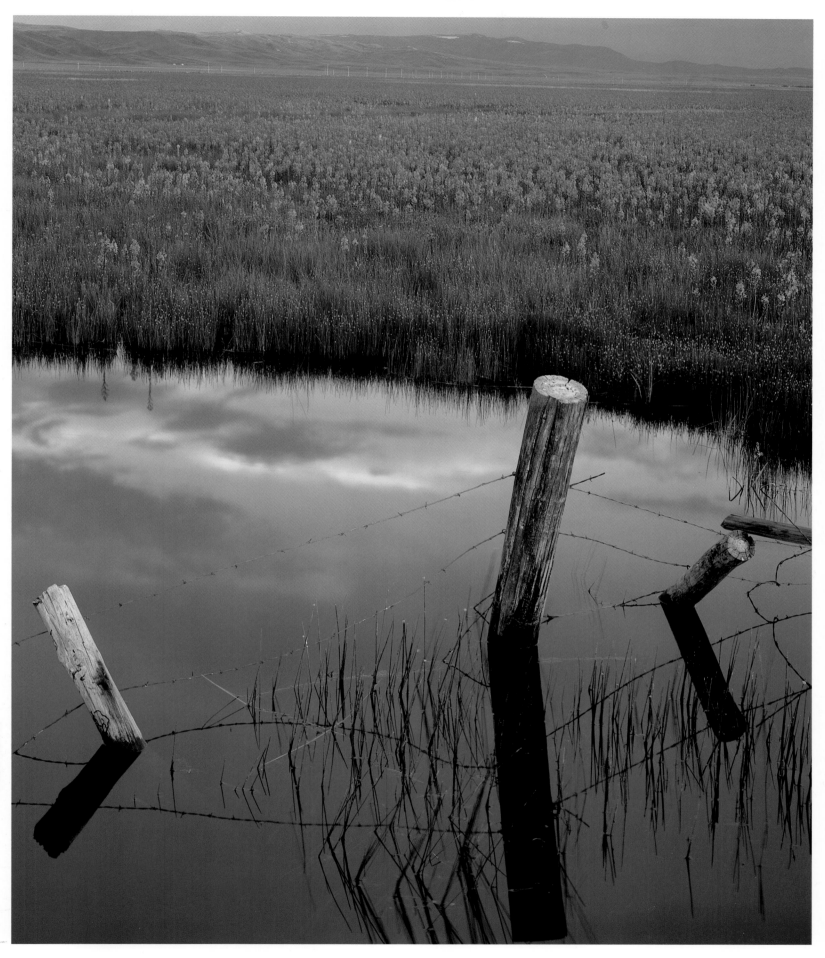

◁ ◁ Priest Lake reflects a quiet evening's solitude. ◁ Alpine asters
light up an alpine meadow in the Sawtooth Wilderness. △ Camas
blankets the Centennial Marsh in southern Idaho's Camas Prairie.
▷ ▷ Perched more than a mile above Hells Canyon, Gem Lake is
one of fifteen high mountain lakes in the Seven Devils Range.

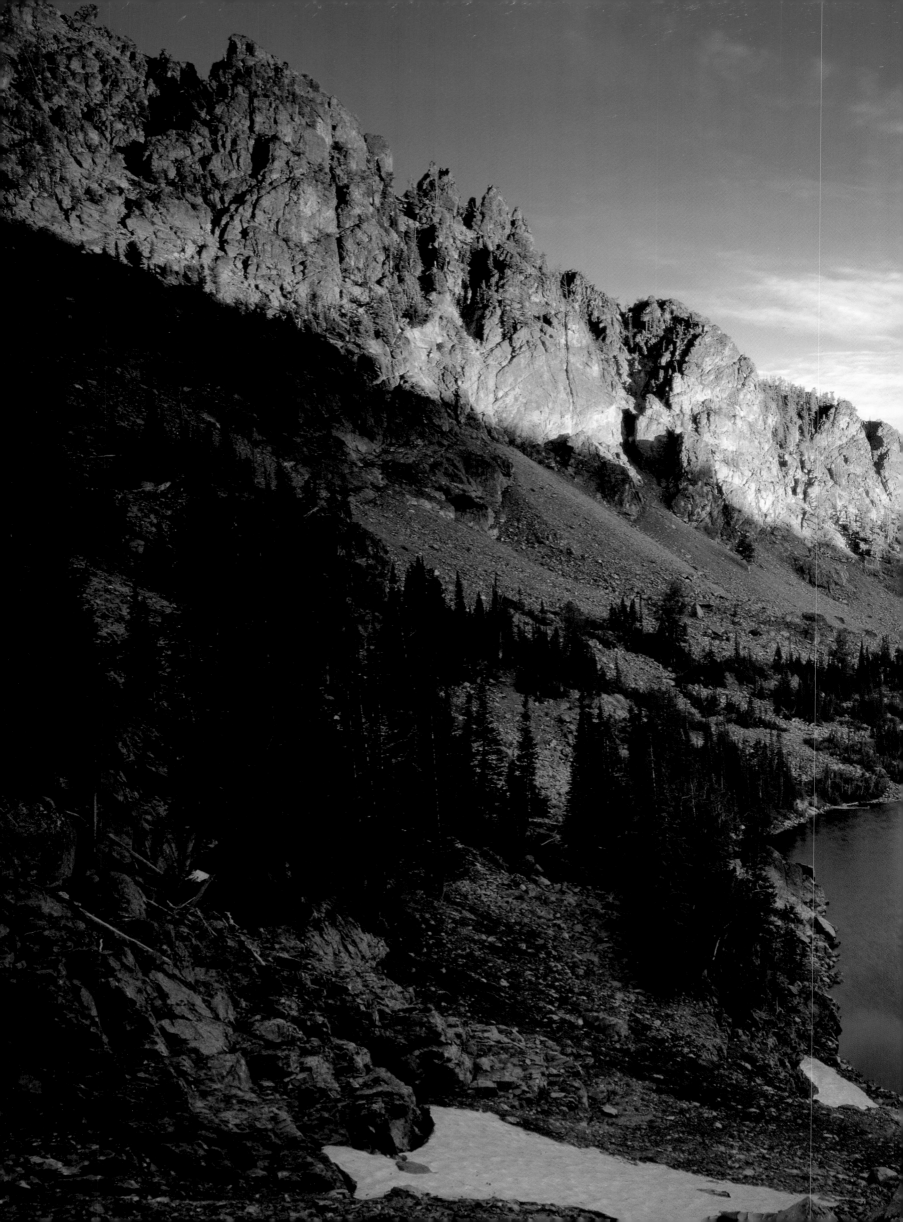

IDAHO
IMPRESSIONS

PHOTOGRAPHY BY MARK W. LISK
ESSAYS BY STEPHEN STUEBNER
FOREWORD BY CECIL D. ANDRUS

GRAPHIC ARTS CENTER PUBLISHING®

▷ Smoky skies make for a muted sunset from the Monarch Mountains overlooking Lake Pend Oreille, the state's largest lake—and one of the country's largest freshwater lakes—with a surface area of 180 square miles. ▷▷ Quaking aspens exhibit their full color in the 1.2-million-acre Caribou National Forest.

International Standard Book Number 1-55868-314-3
Library of Congress Catalog Number 97-70193
Photographs © MCMXCVII by Mark W. Lisk
Essays © MCMXCVII by Stephen Stuebner
Foreword © MCMXCVII by Cecil D. Andrus
Compilation of photographs © MCMXCVII by
Graphic Arts Center Publishing Company
P.O. Box 10306 • Portland, Oregon 97296-0306
503/226-2402
President • Charles M. Hopkins
Editor-in-Chief • Douglas A. Pfeiffer
Managing Editor • Jean Andrews
Photo Editor • Diana S. Eilers
Production Manager • Richard L. Owsiany
Cartographer • Ortelius Design
Book Manufacturing • Lincoln & Allen Company
Printed In the United States of America

IDAHO

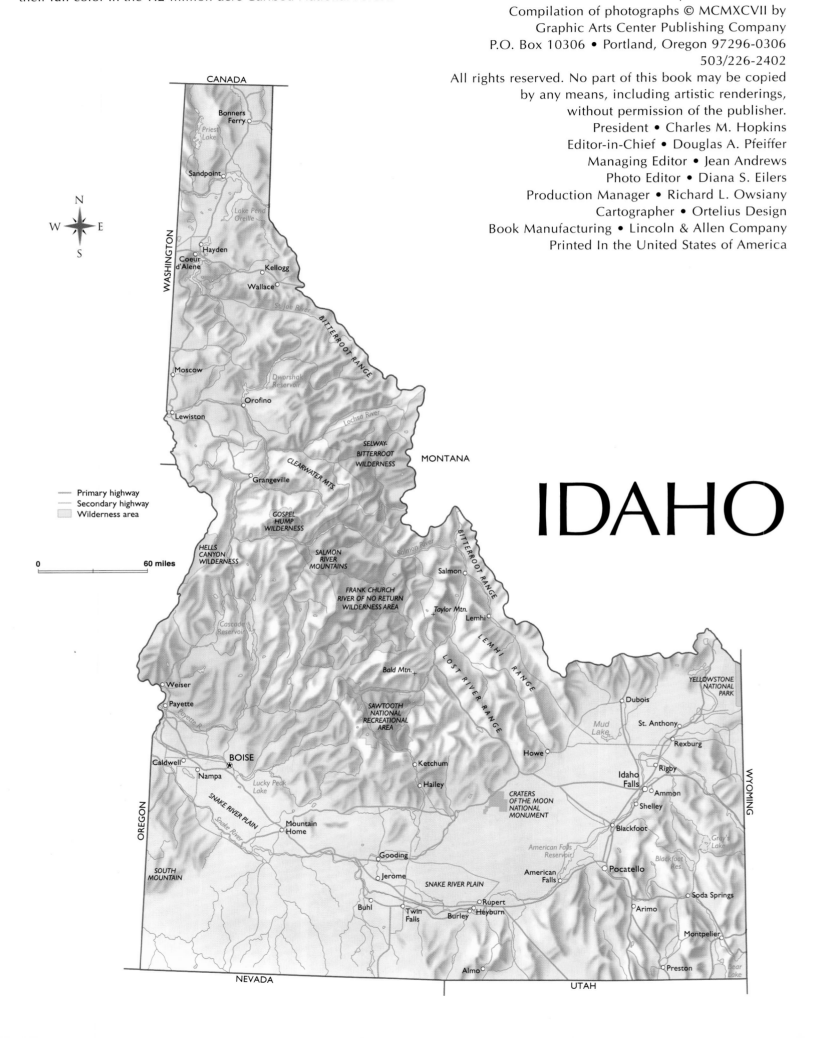

Primary highway
Secondary highway
Wilderness area

0 60 miles

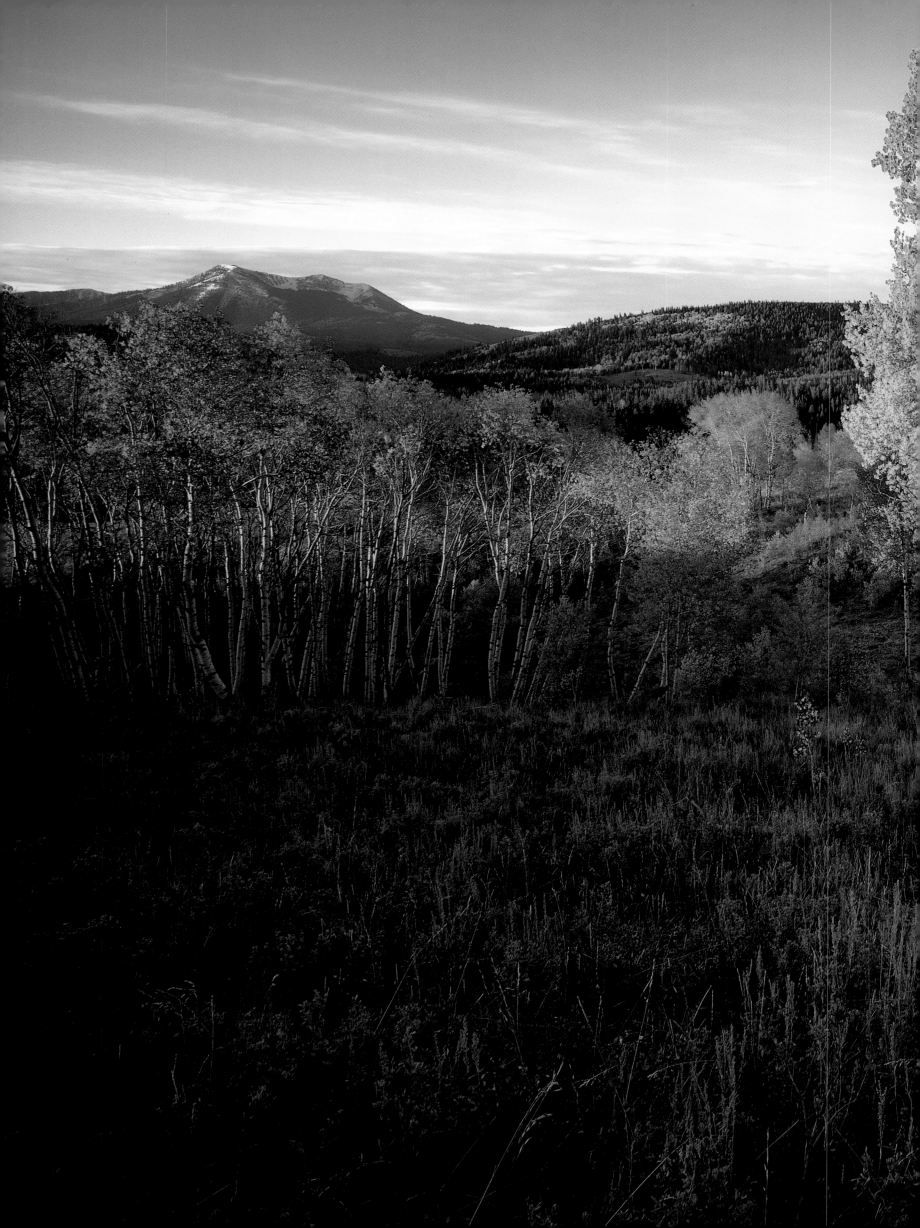

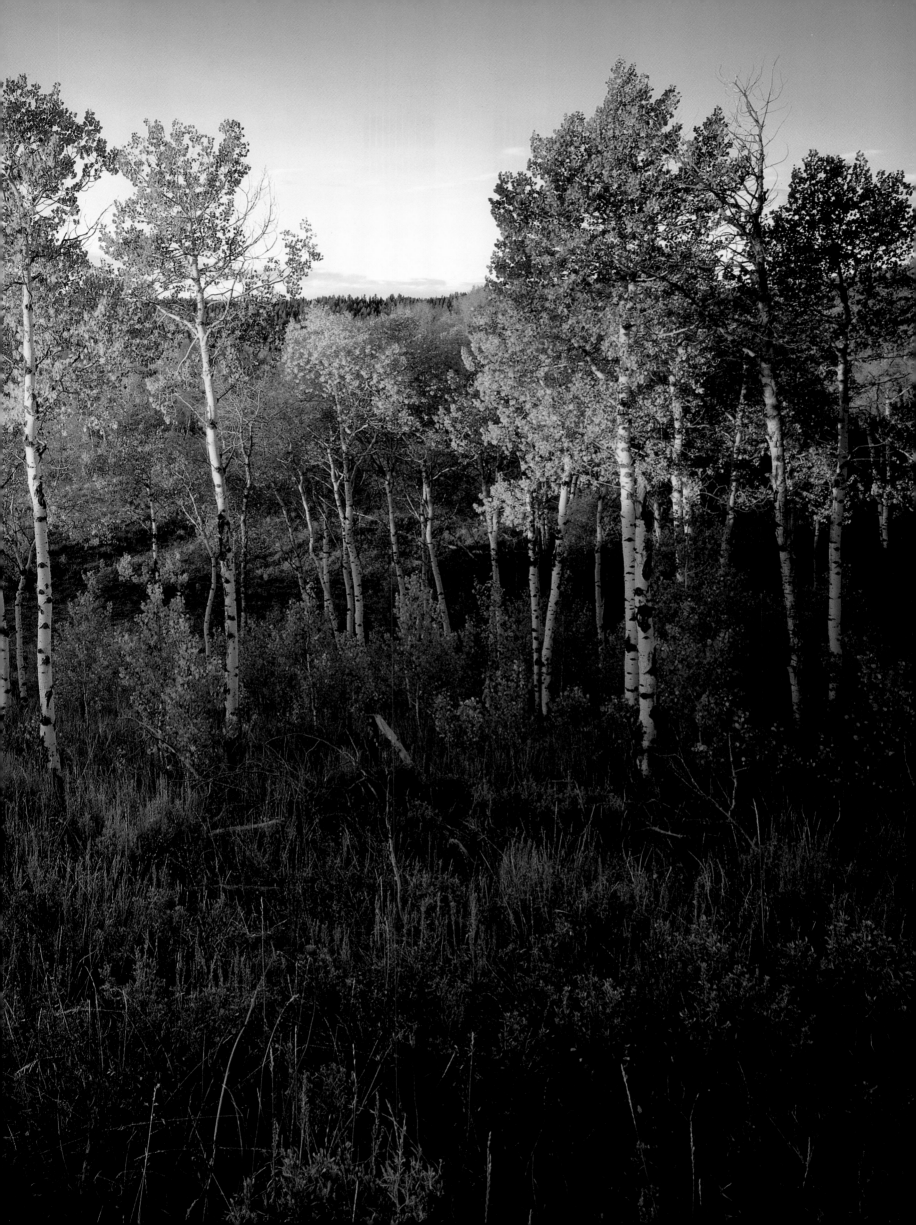

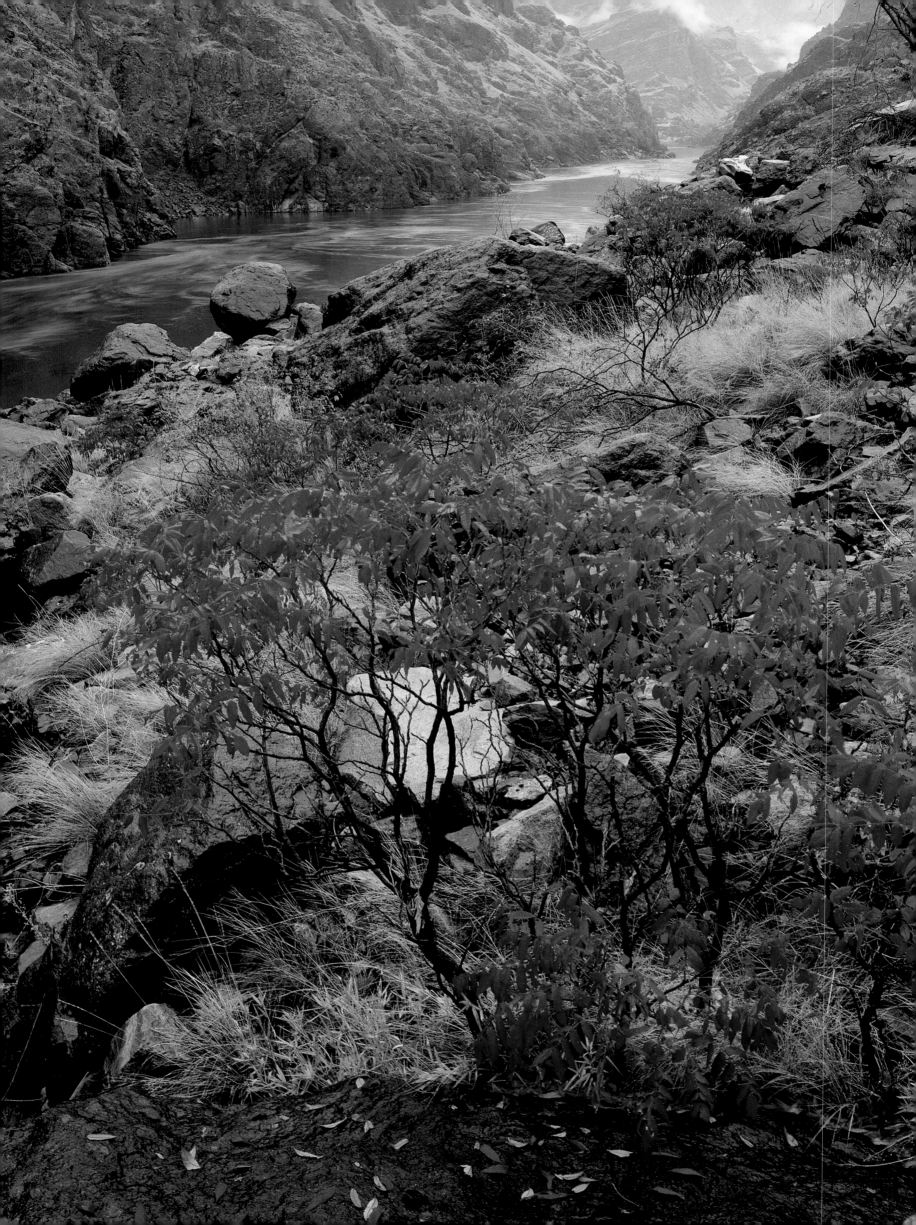

Foreword

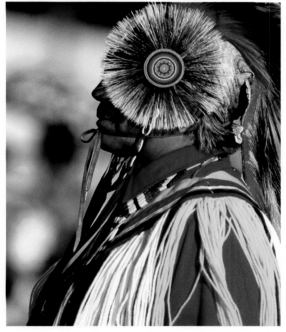

◁ *Flaming red sumac adorns the rocky shoreline of Hells Canyon just below the Salmon River confluence.*
△ △ *A moonrise casts early light over rolling farm fields in northern Idaho.*
△ *A Coeur d'Alene Indian stands proudly in full native attire during a spiritual ceremony and powwow featuring all five Idaho tribes.*

This new book on Idaho is not just a coffee-table book, though it is certainly handsome enough to do service in the most elegant living rooms. *Idaho Impressions* gives us not only exquisite pictures of the disparate areas that make up the state but also an excellent background and a brief, well-researched history of each region. It portrays the spectacular triumphs Nature gave us and some of the changes that have resulted from the impact of humankind.

It is at once a book for now and a warning for the future. We have been blessed with a state of unbelievable beauty, and it is our responsibility to pass that beauty along unspoiled to our children and to their children.

In *The Sound of Mountain Water*, the great western writer Wallace Stegner, writes:

> *Angry as one may be at what heedless men have done and still do to a noble habitat, one cannot be pessimistic about the West. This is the native home of hope. When it fully learns that cooperation, not rugged individualism, is the quality that most characterizes and preserves it, then it will have achieved itself and outlived its origins. Then it has a chance to create a society to match its scenery.*

How might that cooperation be expressed in the modern-day American West? Can balance be achieved among the conflicting demands of growth, jobs, and the environment? It is my unshakable belief that with enlightened leadership, we can successfully meet both the economic and environmental needs of Idaho and of this nation.

Americans have to make a living, but it must be a living that is worthwhile. It cannot be one that permanently scars or destroys or does irreversible damage to our environment and resources. There are ways to log that do no permanent harm. There are ways to mine that allow the surface to be restored. Granted, these procedures are more costly, but it is time we grew up and faced the real value of our mineral resources, which, once they are removed, are gone forever. Western cities, for the most part, have not yet faced their responsibilities to the environment as they continue to eat up the wilderness, desert, and farmland to make room for more population growth.

Throughout history, the success or failure of a society has depended largely on how it responded to major threats to its continued existence, whether it recognized those threats in time, whether it undertook the tough measures necessary to remove the threat, or whether it just continued to do things in the same old way only more so. It is clear such a challenge faces us in the twenty-first century, and we cannot continue to do things in the same old way.

With their flawless photography and commentary, Mark Lisk and Stephen Stuebner have given all of us a great gift by articulating our heritage so beautifully. It is my sincere hope that we are up to the challenge of preserving and enhancing it.

CECIL D. ANDRUS

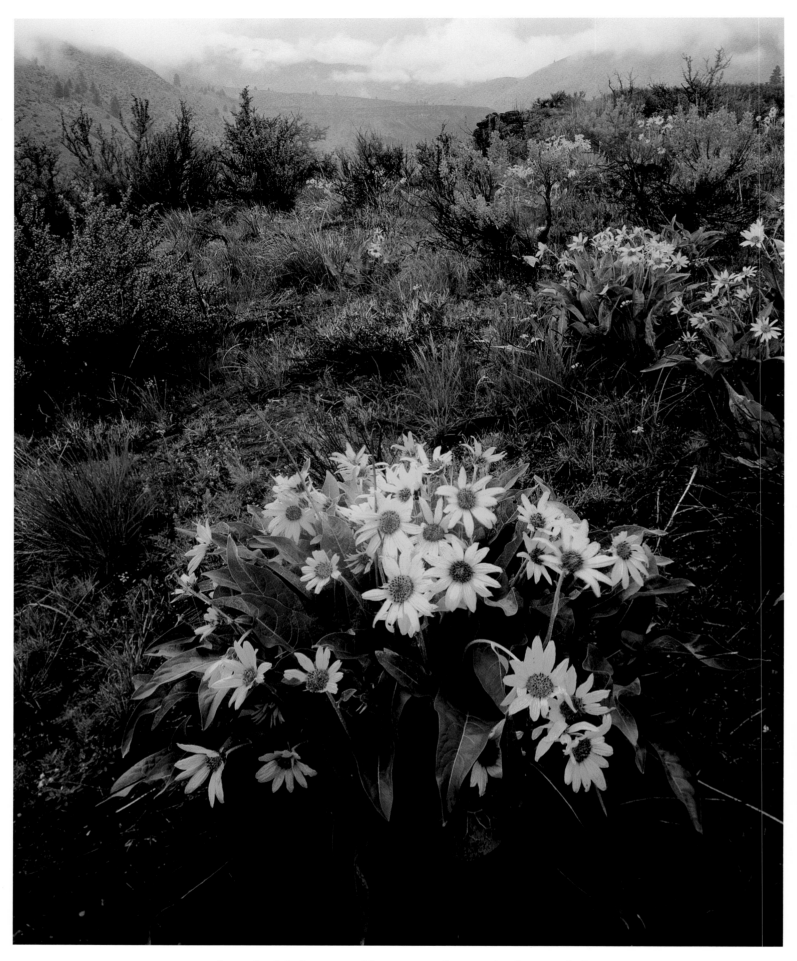

△ Arrowleaf balsamroot blooms on the south slopes of the
sagebrush-dotted foothills overlooking Blacks Creek, east of Boise.
▷ Lichens smother the basalt rock on a cliff overlooking the
Snake River Birds of Prey National Conservation Area on a
Thanksgiving morning in southwest Idaho.

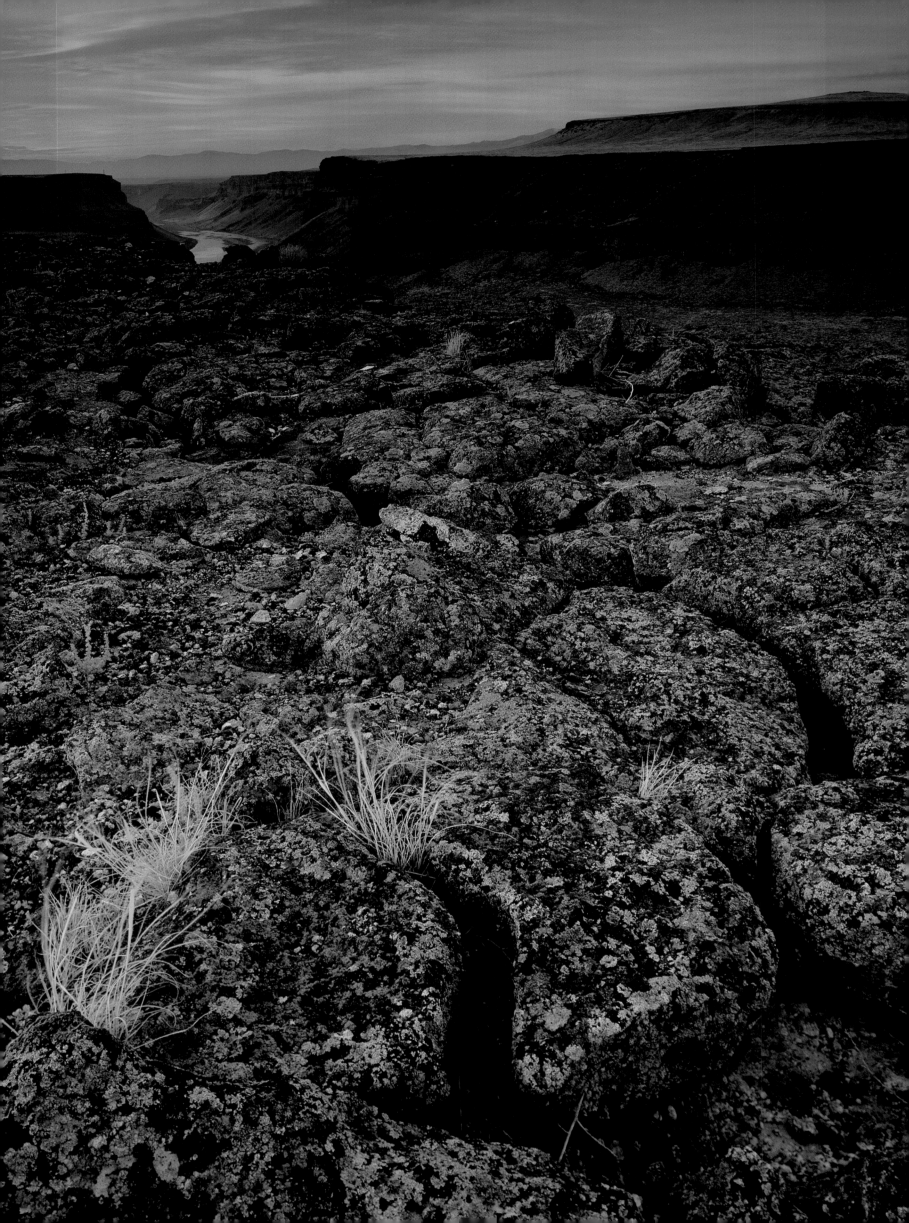

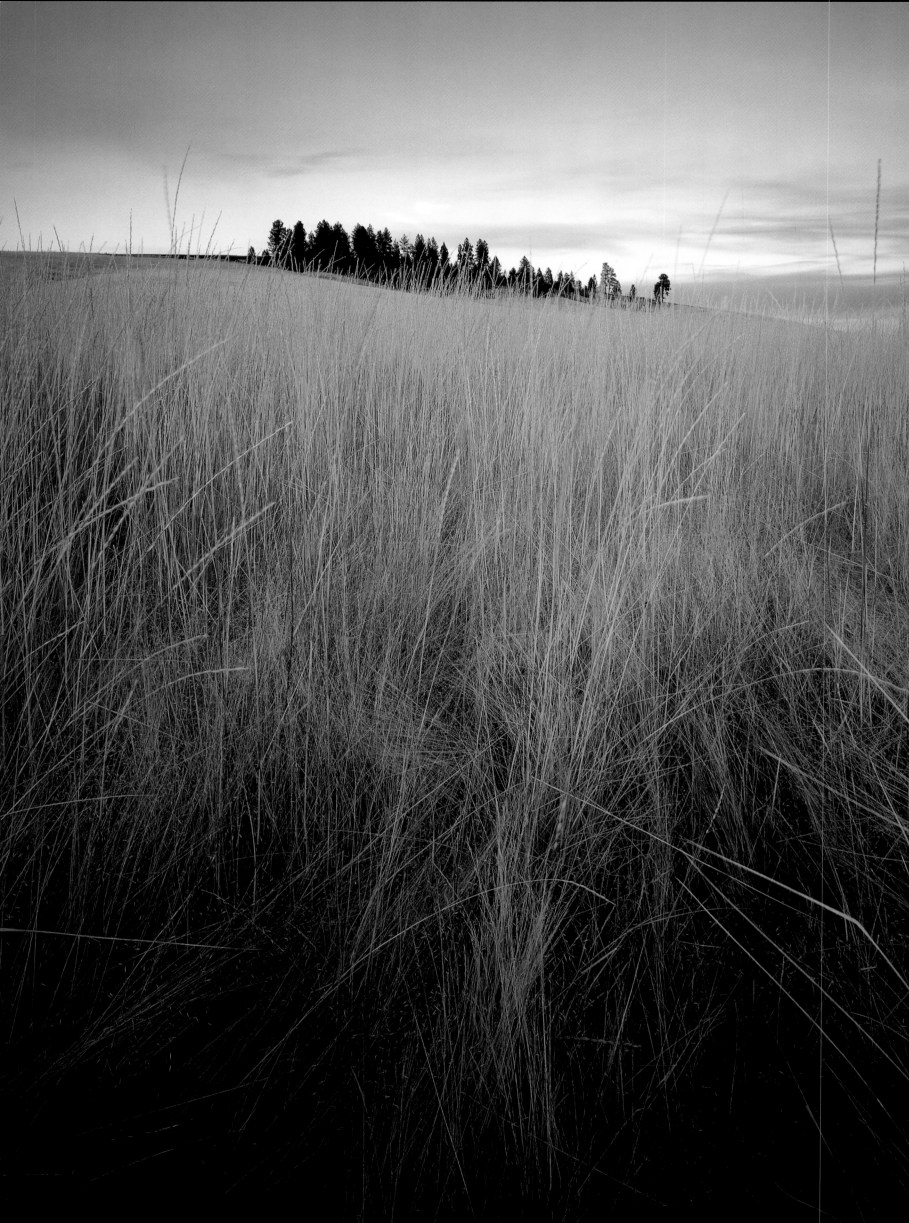

The
Lakes Country

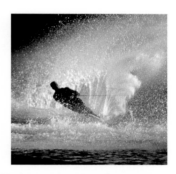

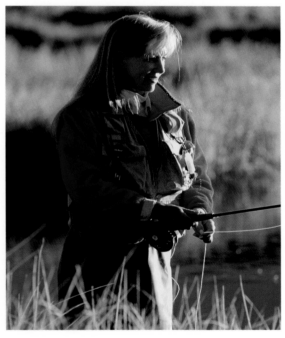

◁ *Wheatgrass as tall as a six-foot man glows in the evening light in a tall-grass prairie south of Lake Coeur d'Alene.*
△ △ *On a mid-summer evening, a slalom waterskier kicks up a wall of water.*
△ *Fly-fishing is becoming ever more popular in the numerous unsung creeks and rivers of Idaho's Panhandle.*

On the eastern side of Coeur d'Alene Lake, scenic U.S. 89 winds along the shoreline, climbing several hundred feet to a perfect vista point overlooking Beauty Bay. A short walk through the pines provides a perfect spot for watching the sun set. On a deceptively clear August evening, a classic summertime light show unfolds in the western sky. Wildfires to the west create a thick backdrop of smoke, enhancing the show. The curtain of gray dissolves into brilliant orange, and the sun turns into a ball of crimson. Then, in every second of every minute, the orange hues fade into a series of reds. The blazing fireball of the sun flashes one more bead of light before it falls behind the mountains, causing a mix of chartreuse and purple hues to dance momentarily on the treetops.

Soft curves on mountain ridges create shadows on still lakes below—a signature Panhandle scene symbolic of the north Idaho landscape. In a way, the soft curves mirror the laid-back lifestyle of the tourists who flock to the Panhandle region to vacation each summer, and the mellow lifestyle of Indian tribes who enjoyed the region's mild weather and teeming bounty of fish, game, and furs. At the same time, the rough, spiny ridge of the Selkirk Mountains, a massive granitic intrusion, embodies the tough character of the early loggers, miners, and farm pioneers who brought civilization to the region.

Today, the Panhandle features a mixture of the relaxed, easy life—tourism, artistic gatherings, chic shops, and restaurants in Sandpoint and Coeur d'Alene—and the hard life of people working the woods, mines, and farms. It's an interesting cultural mix, a tension of sorts that creates a synergistic energy, just like the opposing forces of the land.

The defining element of the Panhandle region is water—copious amounts of it. Northern Idaho receives the most snow and rainfall in Idaho with an average of thirty-plus inches a year, and more than seventy inches in the mountains. Even though Idaho's borders were drawn largely by accident—we got the "leftovers" after Washington and Montana staked their own state lines—it's quite remarkable that we ended up with such an impressive set of natural assets in the Panhandle, a swath of land only fifty miles wide. All the magnificent lakes, rivers, rain forests, and moss-covered waterfalls in this region add yet another distinct dimension to the state's landscape.

Long periods of glaciation, dating from 130,000 years ago to as recently as 15,000 years ago, left an indelible mark on the forests and valleys of the Panhandle region. Massive ice sheets boring into Idaho from Canada via the Purcell Trench created the region's trademark lakes—Priest, Pend Oreille, and Coeur d'Alene—and more than fifty others. The Purcell Trench is a classic U-shaped valley carved by glacial activity. U.S. Route 95 follows its swath from Sandpoint to Bonner's Ferry. Glacial action gave the surrounding countryside a feeling of gentle, rounded curves, a look that is markedly absent from the rough-hewn mountains and canyons in central and southern Idaho. There were violent geologic events, too: An ice dam near present-day Sandpoint impounded glacial Lake Missoula, a massive body of water that extended two hundred miles west into Montana. At times, the shifty ice dam flooded the Clark Fork Valley about two thousand feet deep between Lake Pend Oreille and Missoula. When the ice dam collapsed (geologists say it did so more than a dozen times), it sent a torrent of water rushing toward Coeur d'Alene and veering westward across Rathdrum Prairie, to Post Falls and Spokane. As the water poured across the open prairie, it laid down large quantities of sand and gravel. A natural transportation corridor formed in its wake, creating commercial ties with eastern Washington.

Another key geologic event in the Panhandle was the rise of the Kaniksu Batholith, a mass of granite that formed the Selkirk Mountains nearly seventy million years ago. It was an upthrust that took place over thousands of years, much like the rise of the Idaho Batholith in central Idaho. Following the contours of the granite rock, the Selkirk crest rises and falls like a uniform set of ocean swells from Schweitzer Basin Ski Area to Canada.

The wet climate, with heavy snowfall in the Selkirk, Cabinet, Coeur d'Alene, and Purcell Mountains, gives birth to a number of wide, meandering rivers in the Panhandle. The Coeur d'Alene watershed dominates much of the region, draining the Silver Valley and the St. Joe and St. Maries country. From the Bitterroot Divide on the Montana border, the Coeur d'Alene River courses nearly one hundred miles before it empties into Coeur d'Alene Lake. Many of the region's people settled in the Coeur d'Alene Basin—in timber towns like Harrison and St. Maries, and in the Silver Valley—with 25,000 in Coeur d'Alene itself, the region's largest city. Still, most of the Panhandle's population, which exceeds 110,000, live in rural locales— either in the forest or adjacent to one of the many lakes.

Three Indian tribes—the Coeur d'Alene, Kutenai, and Kalispel—were the earliest known occupants of the Panhandle. The tribes peacefully coexisted in the region, according to Indian experts. They fished the lakes and rivers for salmon, whitefish, trout, and sturgeon, and they hunted for bighorn sheep, mountain goats, grizzly and black bear, moose, elk, deer, and woodland caribou. The tribes gathered the roots of camas, bitterroot, and wild onion, and picked the abundant huckleberries, chokecherries, serviceberries, and blackberries. The relatively mild climate of the Panhandle—featuring less frosty winters than in the higher elevations to the south—and the wealth of food resources made for relatively easy living.

Early white settlers to the region had a much more difficult time. David Thompson was the first fur trapper and explorer to trap and map the Panhandle region, and he built "Kullyspell House" on Lake Pend Oreille in 1809. When other settlers moved into the area, however, they found great difficulty in traveling through the thick forests surrounding Priest, Pend Oreille, and Coeur d'Alene Lakes. In the 1860s, miners with gold fever followed a swampy trail around Lake Pend Oreille in hopes of reaching Montana. An anonymous account from the *Helena Daily Herald* in 1866 indicates that the trip was hellish: "I have described that portion of the trail over which we passed yesterday as 'horrible,' but today, I am satisfied that no words in the English language can convey an idea of its condition. . . . Saddle horses with saddles become submerged in mud and can not extricate themselves. Weak and poor horses are constantly being hauled out of one hole, only to flounder in another. . . . In short, the road is impossible to anything without wings or life-preservers." Later on, a steamboat ferried miners and loggers across the lake at a point near the Pack River confluence called *Sinayaka-teen* (Indian for *crossing*). Other boats carried settlers to the head of the lake, near Bayview, to travel over the Fourth of July Pass east of Coeur d'Alene, to Mullan and Montana.

In the early 1860s, Lieutenant John Mullan led a contingent to build the first road through the Silver Valley. A 620-mile route from Fort Benton, Montana, to Walla Walla, Washington, the "Mullan Road" opened the region to pioneers. Gold miners were the first to poke around for mineral reserves in the Silver Valley, along the south fork of the Coeur d'Alene River, but none of the gold discoveries compared to the area's potential for silver, lead, and zinc. Noah Kellogg credits his stubborn mule's "asinine behavior" for leading him to the discovery of a rich silver vein on Bunker Mountain, just behind present-day Kellogg. The mule escaped from its hitching post, the story goes, ran up the mountain and stood over the top of the vein. As Kellogg approached the mule, it seemed mesmerized by "a great outcropping of mineralized vein matter ... a marvelous ore-shoot across the canyon, which then, as you see it, was reflecting the sun's rays like a mirror. Never have I seen a galena vein to compare with that!" Kellogg said.

Within the first decade, steely-tough mining pioneers drilled holes into the hard rock, filled them with black powder and dynamited tunnels that bored straight into the silver vein. By the mid-1890s, the two-mile-long Kellogg tunnel was finished, and thirteen mills went into production. A ten-thousand-foot tramway was built to shuttle ore from a number of mine portals to the smelters. The minerals were carried to eastern markets by the Northern Pacific and Union Pacific Railroads, which tied the Silver Valley to Montana and Spokane in 1890. Over time, more than ninety mines were developed, producing 40 percent of the nation's silver and large quantities of lead, zinc, copper, gold, antimony, and cadmium. Before the Bunker Hill smelter closed in 1982, ending the mining era in the Silver Valley, an estimated $4.2 billion worth of silver and other metals had been mined and processed in the valley.

Violence between workers and mining corporations often broke out in the early days, leading to the organization of the state's first unions. Fearsome natural events also shook the region. The great forest fires of 1910 burned three million acres in Idaho, Montana, and Washington, and killed seventy-two miners trapped underground in Silver Valley mines. Much later, in 1972, deadly carbon monoxide fumes from a mine shaft fire claimed ninety-one lives. It was dirty, tough, and dangerous work, but working the mines was the best-paying job around.

The first loggers in the Panhandle also faced many struggles as they toiled to tame the woods in the early 1900s. Vast stands of white pine, western red cedar, hemlock, Douglas fir, and white fir excited the first timber scouts, but access to the trees was difficult at best. Loggers drove teams of oxen into the thick forest, rarely gaining more than three miles a day. They cut mammoth trees by hand with crosscut saws. Wooden flumes were fashioned for skidding logs to the riverbanks. When the spring floods came, loggers sluiced the logs to the lakes and mills below. After World War II, improved technology vastly increased timber production and profits. Logging is still an important industry in the area. Sawmills dot the landscape in towns like Bonner's Ferry, St. Maries, Harrison, and others.

Local boy and media magnate Duane Hagadone put Lake Coeur d'Alene on the world map as a tourist destination when he built the nineteen-story Coeur d'Alene Resort in 1986, along with its nifty golf course and island green. In the 1930s, pioneering filmmaker Nell Shipman brought attention to Priest Lake with her silent films. Sandpoint, with its gourmet eateries and nearby Lake Pend Oreille and Schweitzer Mountain Ski Resort, continues to draw summertime travelers. Silver Valley residents are working to build a tourist economy, with historic mining tours and the world's longest gondola leading to Silver Mountain, a summer and winter ski resort. The Hollywood movie, *Dante's Inferno*, was filmed in Wallace in 1996.

Shimmering lakes will continue to distinguish the region as a preeminent vacation land. Logging and farming will always play an important role, and the mining legacy will remain as a fixture in the annals of history. Two forces—the tranquil feel of the lakes on a perfect hot summer day and raw hard work— together define this lovely region of Idaho.

▷ *Thimbleberry leaves and ferns mix with moss-covered alder trees in northern Idaho's forests.*

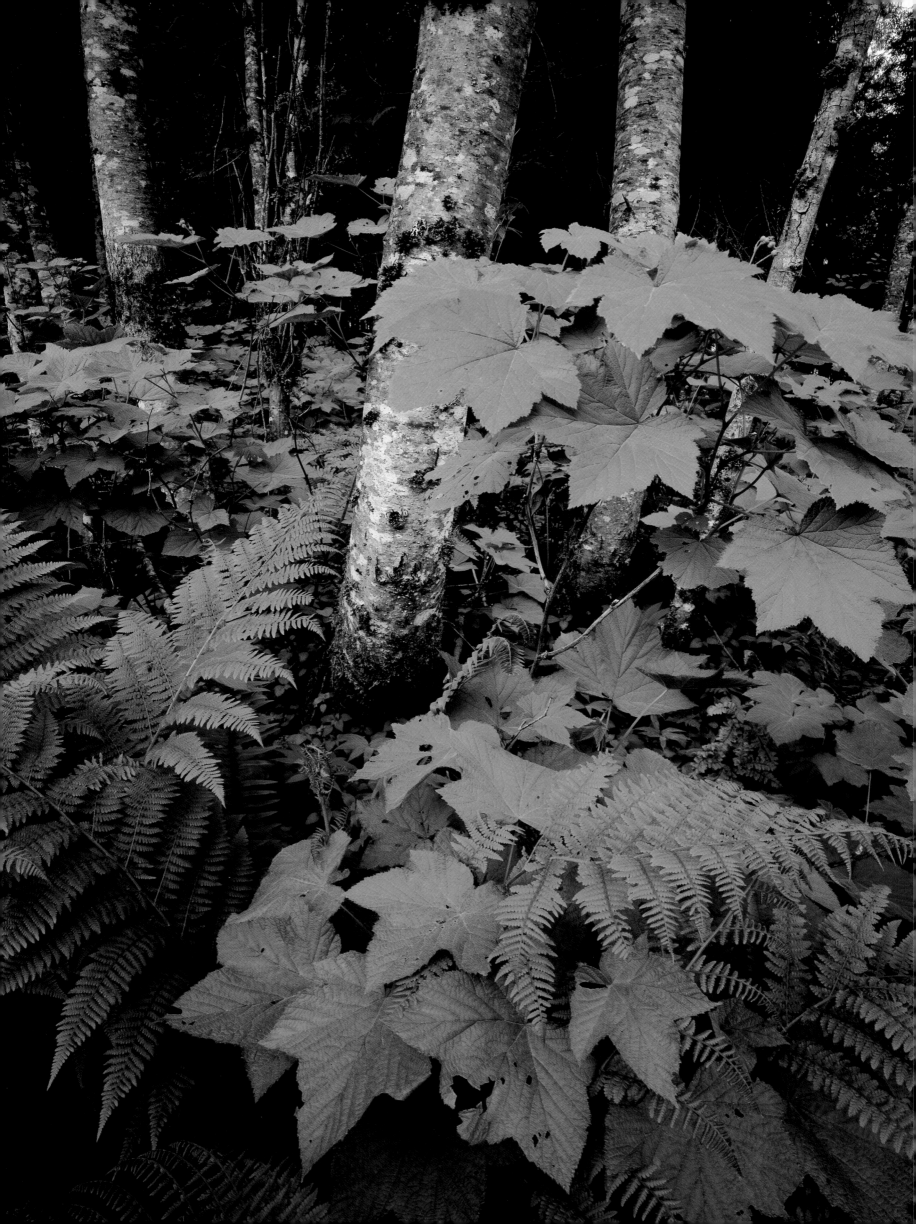

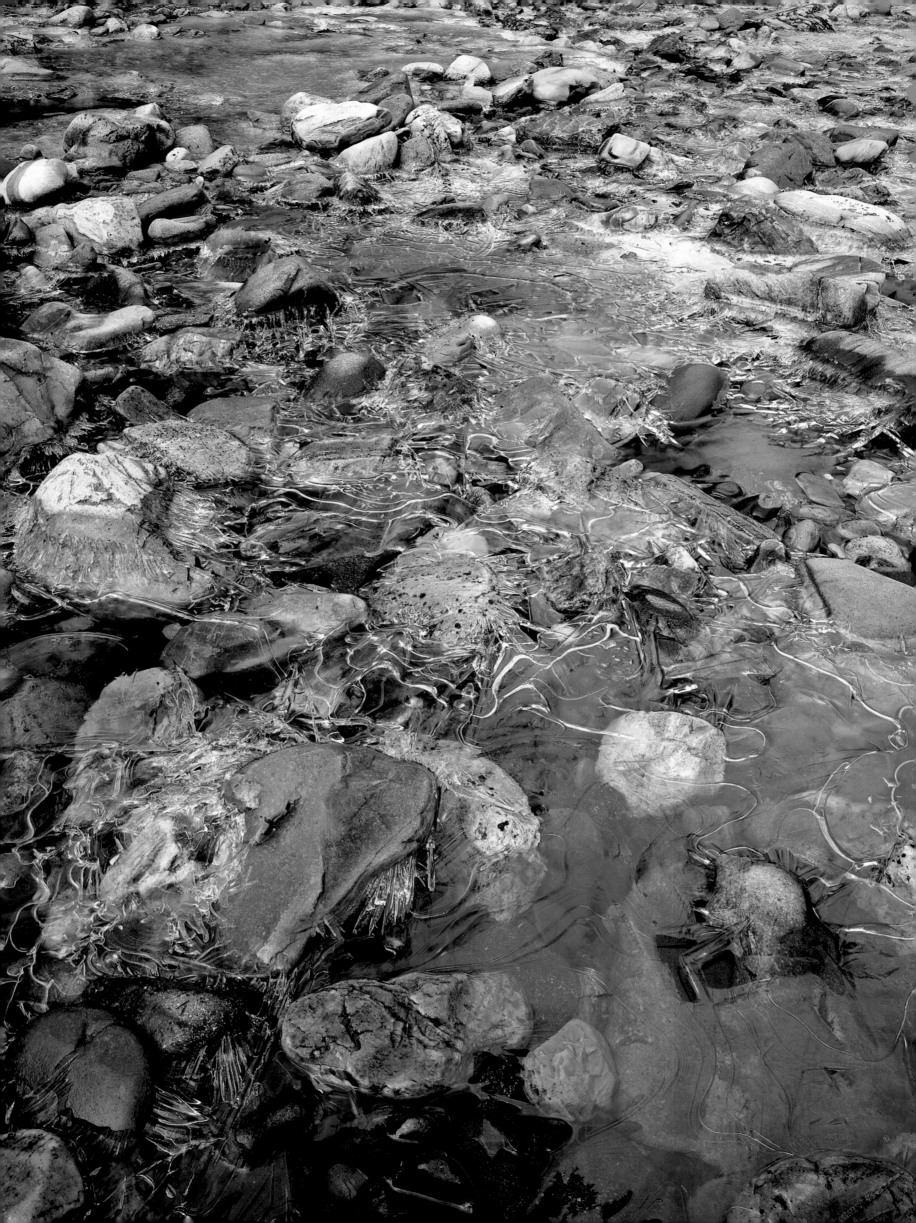

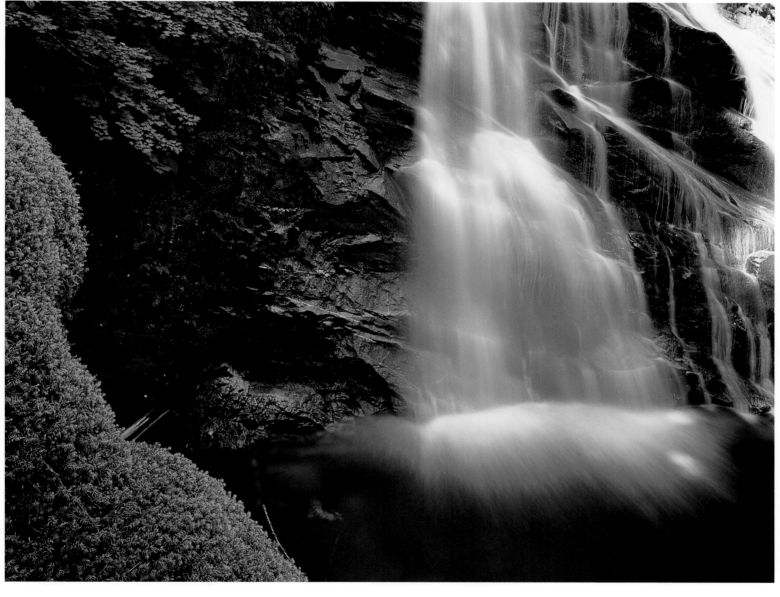

◁ The first freeze lays down a thin glaze of ice on the upper Saint Joe River. △ Snow Creek Falls plunges more than fifty feet into a mint-colored pool surrounded by thick layers of spongy moss. ▷ ▷ Oxeye daisies blanket the foothills near Saint Maries.

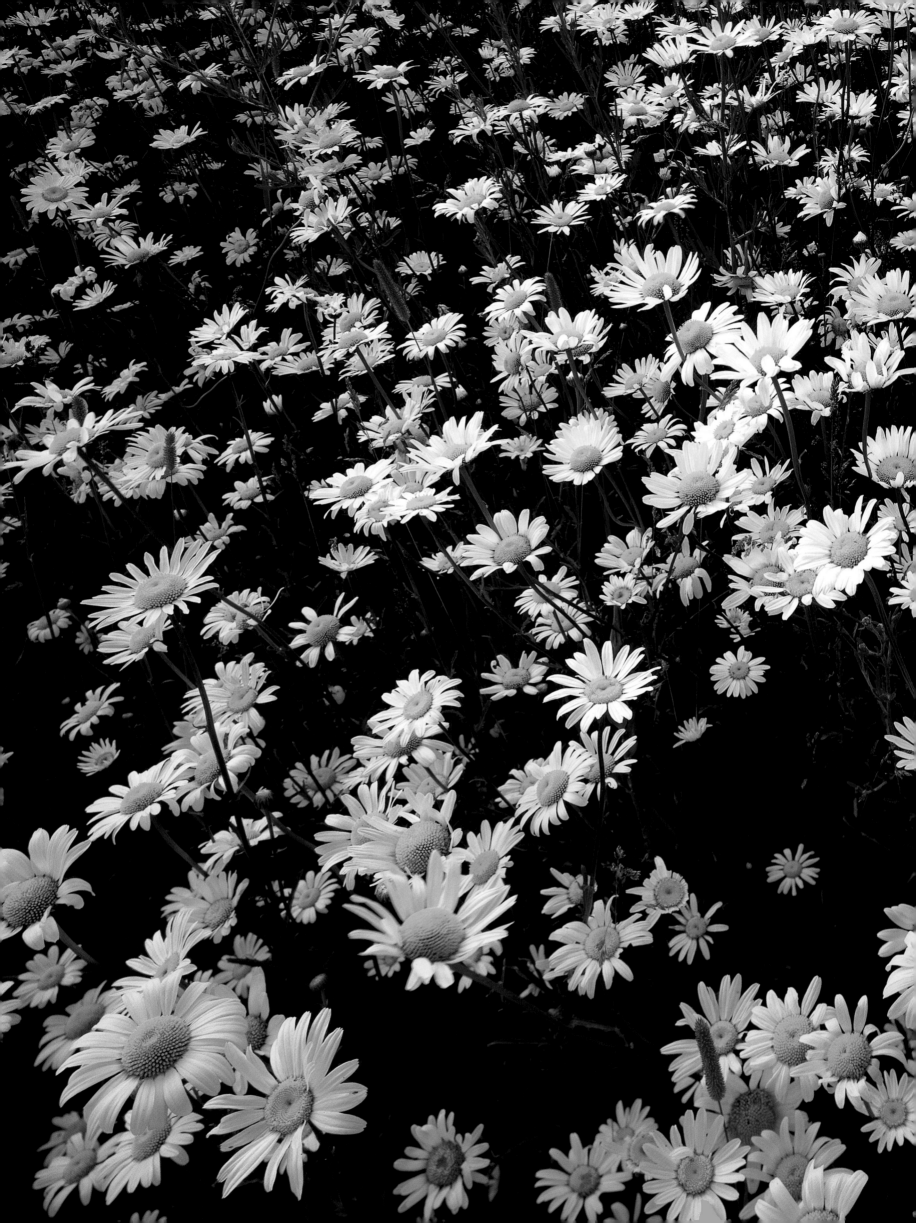

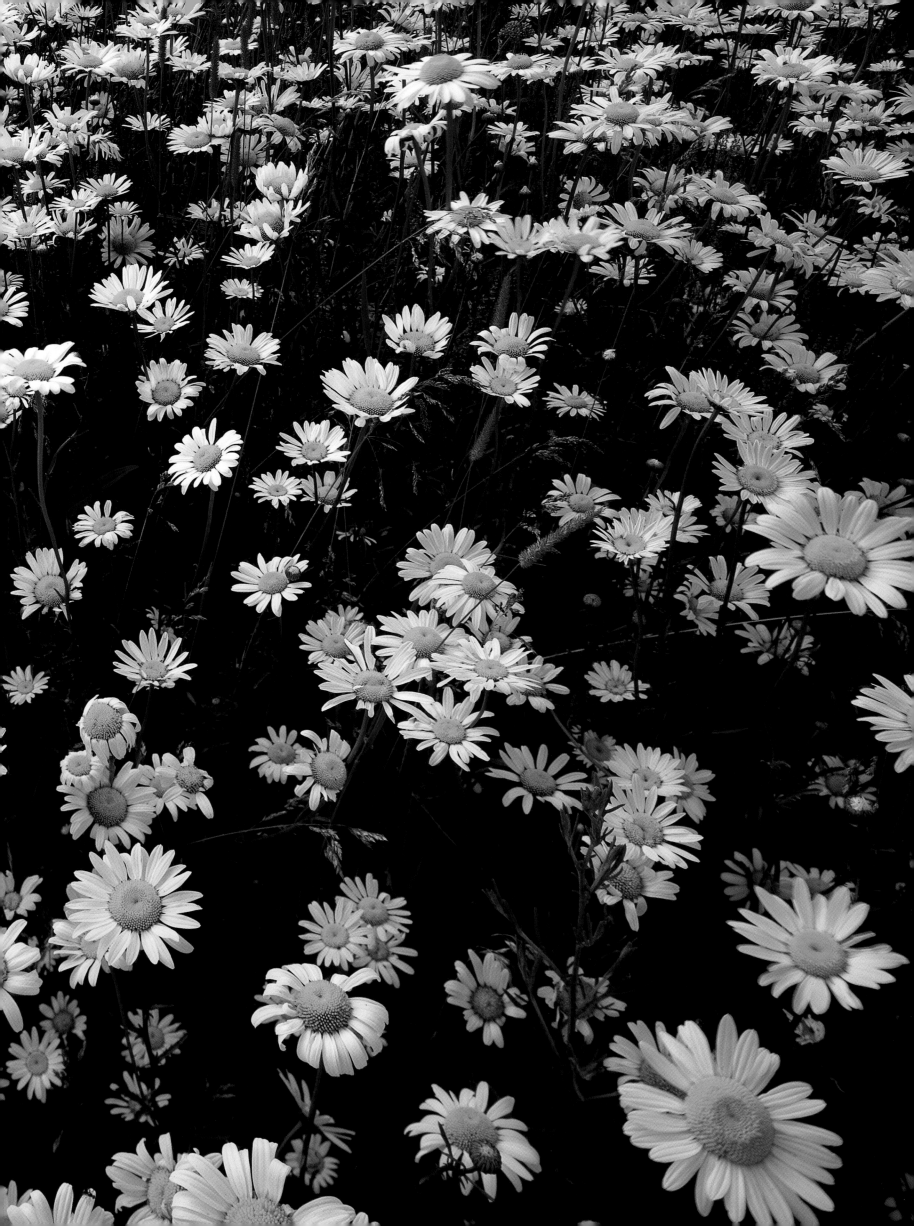

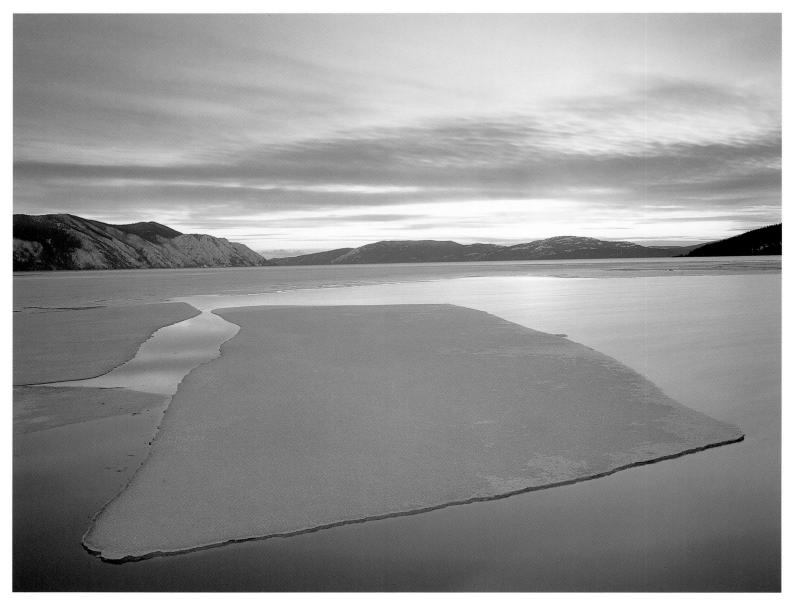

△ Sheets of ice form patterns near Denton Slough on the northeast shore of Lake Pend Oreille, which is 1,225 feet at its deepest point. ▷ Chimney Rock (elevation 7,124 feet) juts out of the Selkirk Crest like a sentinel amidst the craggy granite and snags. ▷▷ Afternoon sunlight punctuates fall foliage along the shore of Medicine Lake.

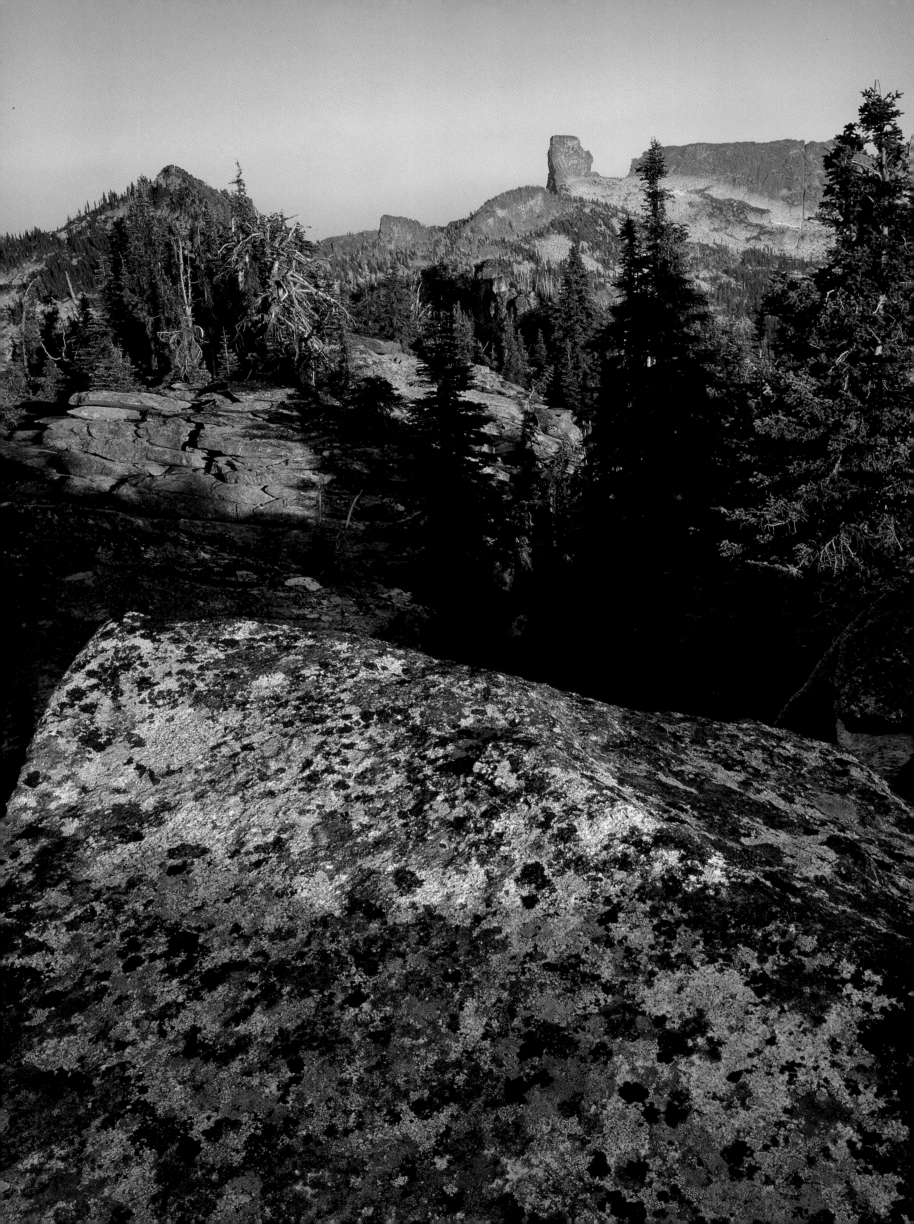

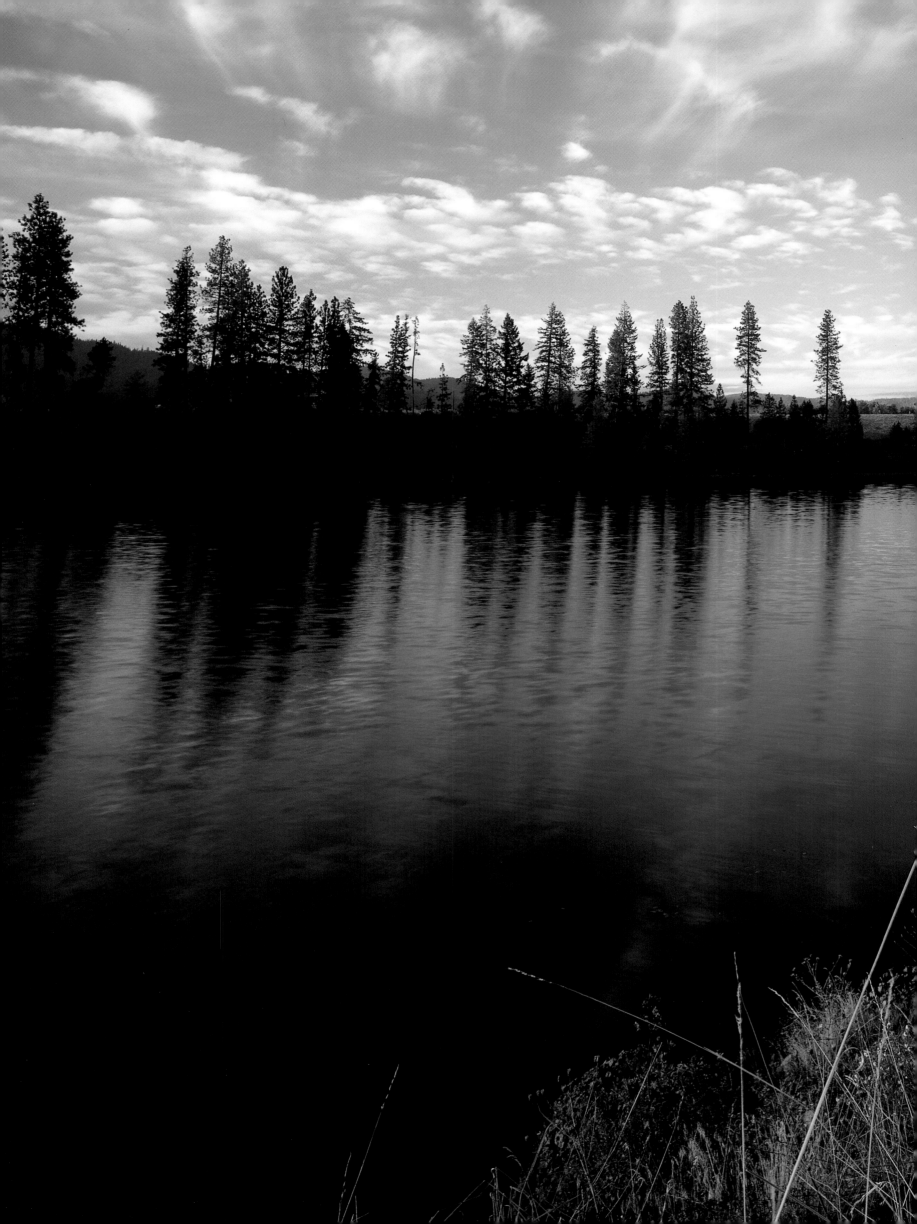

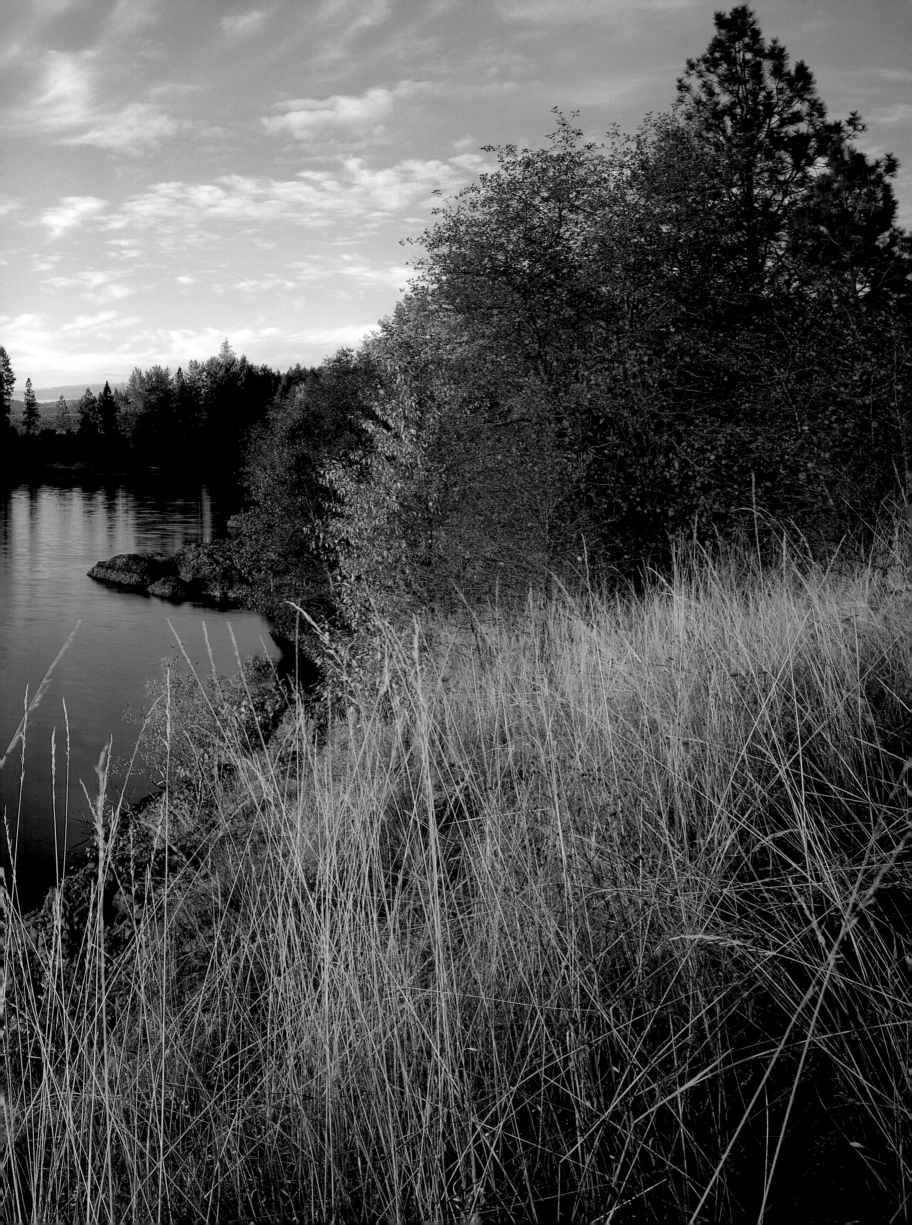

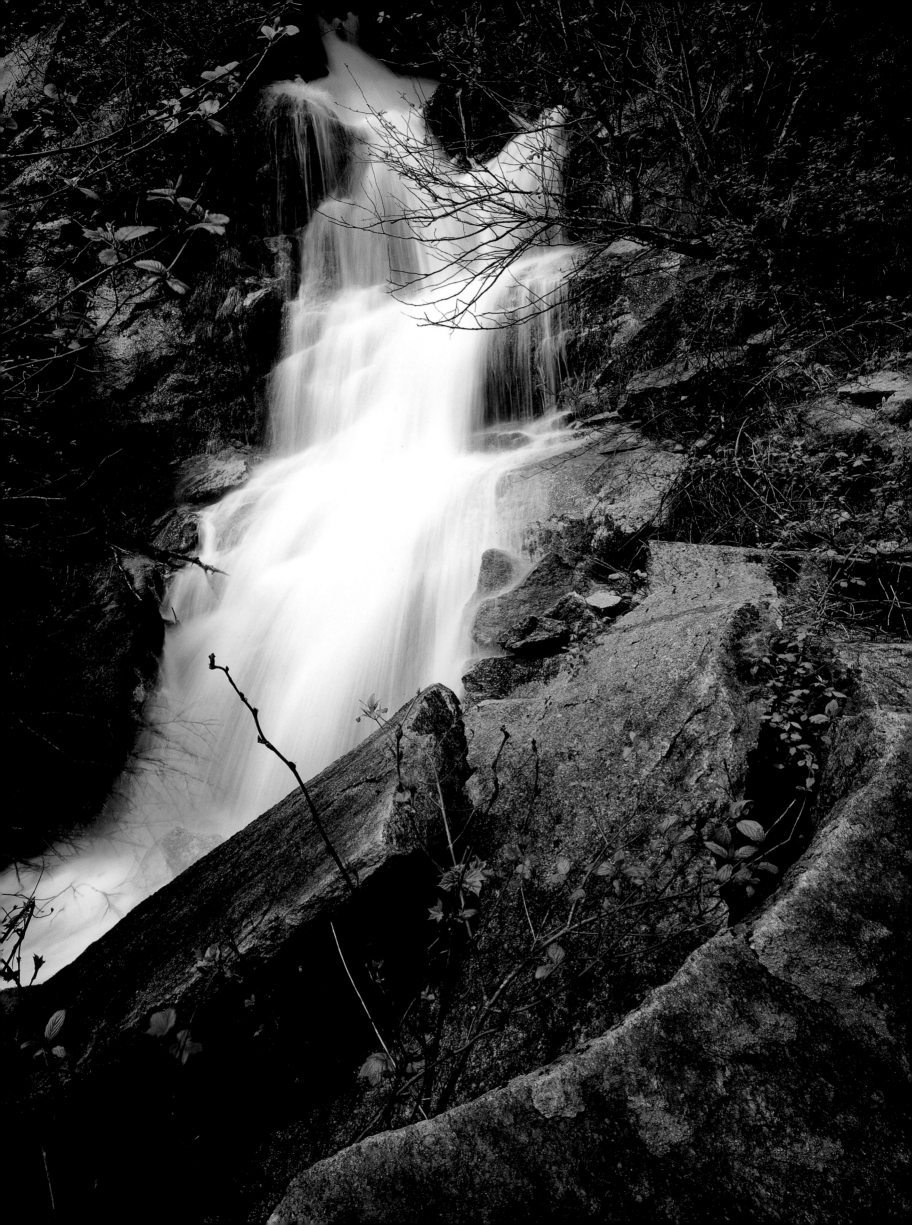

The Clearwater-Palouse

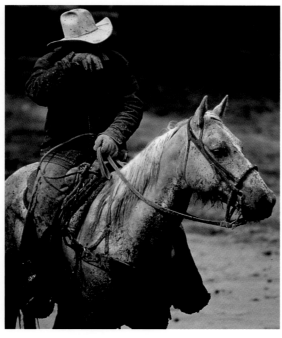

◁ *Deadman Creek plunges like a staircase toward the Lochsa River in the 1.9-million-acre Clearwater National Forest.*
△ △ *Dawn light illuminates tall grass near Moscow, one of the most productive areas in the nation for growing cereal crops.*
△ *During a genuine roundup, a cowboy wipes mountain mud from his eyes.*

Nearly a vertical mile above the Lochsa River, on the north side of the canyon, 6,658-foot Sherman Peak offers a 360-degree panoramic view of the Clearwater National Forest. Sharp-rising rock fins, etched with snow, loom above distant layers of mountains to the south—a tell-tale view of the Selway Crags. To the east, waves of coniferous trees roll up and over a series of ridges, finally reaching a V-slot at Lolo Pass on the Idaho-Montana line. Way off to the west, a patch of gold shines in the afternoon sun on the Camas Prairie. It was this view—the first glimpse of a significant opening out of the seemingly endless forest—that lifted the spirits of Lewis and Clark's expedition in late September of 1805. They named this high perch near Sherman Peak "Spirit of Revival Ridge," evoking images of the tattered men leaping for joy and tossing their hats with glee.

The view from Sherman Peak reveals a grand wilderness, a working forest for lumber and paper production, and an ocean of wheat—three elements that define the Clearwater River watershed and the Palouse. To Lewis and Clark, the seemingly impenetrable forest, the paucity of wild game and the early snow made for a miserable crossing of the Lolo Trail. Some of their men nearly starved or froze to death, and they were forced to kill one of their horses for meat. Eventually, with the aid of Nez Perce scouts, the explorers reached the banks of the Clearwater River, called the *Koos Koos Ke* by the Nez Perce. With the toughest part of their six-thousand-mile journey behind them, the white explorers traveled in dugout canoes down the Clearwater to the Snake River confluence at Lewiston, and onward to the Columbia River and the sea.

Lewis and Clark's struggle in the north Idaho woods nearly two hundred years ago forced them to realize that there was no inland passage to the ocean. They also learned that the wilderness presented great obstacles to development—a lesson Idaho pioneers in the Clearwater and Palouse country were to relive as they tried to tame the wilderness, only to be foiled by the relentless power of nature. Even today, only one paved road traverses the Clearwater Basin: U.S. 12, a road with hundreds of curves and no services for seventy-five miles. It's no wonder the vast majority of people in this region settled in small towns in the lower Clearwater Valley; in Lewiston, the center of commerce in the area; and in Grangeville and Moscow, in the vanguard of the farm country.

The Clearwater-Palouse region features a distinct mix of human activities and landscapes in a relatively compact space, at least in Idaho terms. In only 150 miles, the Clearwater River plunges more than seven thousand feet from its highest tributaries, through pockets of fern- and moss-covered rain forest, to the Port of Lewiston, the lowest point in Idaho at nine hundred feet. As the stream tumbles toward Orofino, its wooded border is replaced by a tight basalt canyon. On top of the mantle of basalt, on the north and south sides of the lower basin, farmers raise winter wheat, lentils, peas, and rapeseed in the world's most productive area for cereal crops. This part of the basin is known as the Palouse—a derivative of the French word *pelouse*, meaning "green lawn."

A golden eagle takes off from the top of a granite spire on 5,235-foot Lolo Pass and heads west over the jagged peaks and emerald lakes of the 1.2-million-acre Selway-Bitterroot Wilderness. Near Pierce, he passes dozens of logging projects and old mining sites. He circles over hundreds of wheat farms in the Palouse, rides the thermals north to Moscow Mountain and the University of Idaho, then coasts back toward the city of Lewiston. From wilderness to wheat, it's a steep transition

that—from an eagle's perspective—happens nearly as fast as a molecule of water sluices over forty-foot Selway Falls.

As in many parts of Idaho, the people of the Clearwater-Palouse region mirror the countryside that surrounds them. It's an eclectic mix of plain-talking, blue-collar workers who labor in lumber and paper mills; thousands of independent farmers who work the Palouse; Nez Perce who farm, teach school, or work in nearby mills; bankers and other urban white-collar types in Lewiston; and a bundle of Ph.D.'s in the university and farm town of Moscow. In all, about ninety-three thousand people reside in the five counties (Latah, Nez Perce, Lewis, Idaho, and Clearwater) that circle the Clearwater Basin.

Geologic events dating back millions of years laid the foundation for human settlement and the modern economy of the Clearwater-Palouse country. Underlying the rugged forest on both sides of the Lochsa River is the northern segment of the Idaho Batholith, a homogenous granite formation that dominates Idaho's midsection. Near present-day Kooskia and Orofino, dark streaks in the granite reveal a major shear zone, marking what once was the western edge of the North American continent. To the west, Columbia River basalt lava-flows some twelve million years ago overlaid the ancient rock and filled in the lower Clearwater Valley with an impressive mantle of basalt. Layers are clearly visible in the walls of the Clearwater River canyon between Orofino and Lewiston. In the Palouse country, in the uplands above, repeated lava flows trapped many small lakes and allowed sediments to build up and form the highly productive Palouse soils. Silt also blew into the region and settled on top of the sediments. More than a foot deep, the loamy soils are capable of storing rain and snowmelt for long periods of time.

Prior to the arrival of white settlers, the Nez Perce nation enjoyed a relatively peaceful life in the Clearwater Basin. They lived off three very dependable sources of food—camas roots in the uplands, salmon and steelhead from the Clearwater and Salmon Rivers, and big game. When horses migrated from Mexico to western North America in the 1700s, the Nez Perce became more mobile. They quickly became accomplished horse handlers and developed their own special breed, the Appaloosa. Occasionally, the Nez Perce traveled into Montana to hunt bison on one of several routes: one was the Nee-Me-Poo trail that Lewis and Clark followed; another, the approximate route of the Magruder Corridor road, a primitive goat trail that runs east-west for nearly one hundred miles on the northern edge of the Salmon River canyon to Montana.

After they had been so helpful to Lewis and Clark and the early missionaries, it's a sad tale how the Nez Perce were driven from their prized ancestral lands during the multiple battles of the Nez Perce War in 1877. It all started in June with a battle at the bottom of Whitebird Hill, a fight decisively won by the Nez Perce. The warring continued for three and a half months, culminating in Chief Joseph's surrender fifteen hundred miles away in the Bear Paw Mountains of Montana, only forty miles from the Canadian border. Chief White Bird escaped during the night with 230 of his people, and reached safe refuge in Canada, where they remained for many years. Joseph's band was exiled to reservations in Missouri and Oklahoma—where many of them died of smallpox—before they were shipped west in the mid-1880s.

Gold strikes in Pierce, Florence, and Orogrande brought the first waves of white settlers to the Clearwater region in the early 1860s. Gold strikes were substantial in the beginning, producing $9.6 million in Florence and $8 million in Pierce,

but it wasn't long before miners moved on to places like Thunder Mountain. Farmers began working the Palouse in the 1860s and 1870s. Before long, every tillable acre was put into production. The deep, loamy soil had an uncommon capacity to store precipitation. Winter wheat was an ideal crop for the area's soils and weather. No artificial irrigation was necessary.

The University of Idaho, the state's land-grant college, opened in 1892 with about thirty students on a twenty-acre site in Moscow. Today, the campus has more than eight thousand students on 450 acres. The university is the state's preeminent institution of higher learning, particularly for graduate studies.

Loggers wouldn't get a toehold in the giant groves of white pine on the Clearwater's north fork until the turn of the century. The largest tree identified early on was 227 feet tall, 425 years old, and ten feet in diameter. It was cut down in 1911 and milled in Potlatch. Logging in those days was rough work with little or no access to the thick woods. Trees were cut by hand, and logs were driven down the Clearwater's north fork, Little North Fork, and the Clearwater itself to mills in Orofino and Lewiston. The Potlatch Lumber Company, the largest employer in northern Idaho, was born out of the initial race for timber wealth. After many years of struggle, Potlatch became the lumber king in the basin, eventually acquiring 670,000 acres of private timberland in the Clearwater, St. Joe, and St. Maries areas. Potlatch added to its timber operations by building a pulp and paper mill in Lewiston in 1950. At the massive Lewiston complex, it manufactures paper, paperboard products and tissue products. Sawmills run by other business interests in Orofino, Kooskia, and Elk City have prospered for many years and remain productive in the 1990s.

In the mid-1970s, the U.S. Army Corps of Engineers closed the gates on Lower Granite Dam and finished the creation of a 350-mile shipping lane on the lower Snake and Columbia Rivers—from the Pacific Ocean to Lewiston—the closest they would come to President Jefferson's dream of an inland water-way to the Pacific. The Lewiston port is a key shipping point for millions of tons of grain raised in Idaho and Montana to be barged downriver to the Port of Portland, along with shipments of lumber and paper from Potlatch and other mills.

Tourism is slowly growing in prominence in the Clearwater Basin. Steelhead fishing is a multi-million-dollar industry in the fall. Elk hunters from throughout the world search for the nation's largest trophy bulls in the Selway-Bitterroot Wilderness. Backpackers and equestrians regularly visit the fern-lined cedar forests in the summer, and enjoy fishing in more than fifty high-mountain lakes. In the springtime, expert whitewater boaters flock to the Lochsa River (Lochsa means *rough water* in the Nez Perce tongue), and a few lucky boaters draw permits to run the Selway River, for an intimate five-day wilderness whitewater trip, where only one party is allowed to launch per day. Outfitters offer both mountain bike and horse-back trips along the Lewis and Clark Trail, now a one-lane dirt road known to locals simply as "the 500 road." High up in the north fork drainage, Kelly Creek is known as one of the state's finest blue-ribbon trout streams. Dworshak Reservoir, on the lower reaches of the Clearwater's north fork, draws fishermen, campers, and power boaters throughout the summer months.

And so, as we soar like an eagle over the wilderness and the camas and the wheat, let us ponder this diverse segment of Idaho with a refrain from musician Karla Bonoff's tune called "Home": "And, home, sings me of sweet things; my life there has its own wings, to fly over the mountain, though I'm standing still."

▷ *Near Mission Creek on the Nez Perce Indian Reservation, a sumac thicket turns crimson in the fall.*

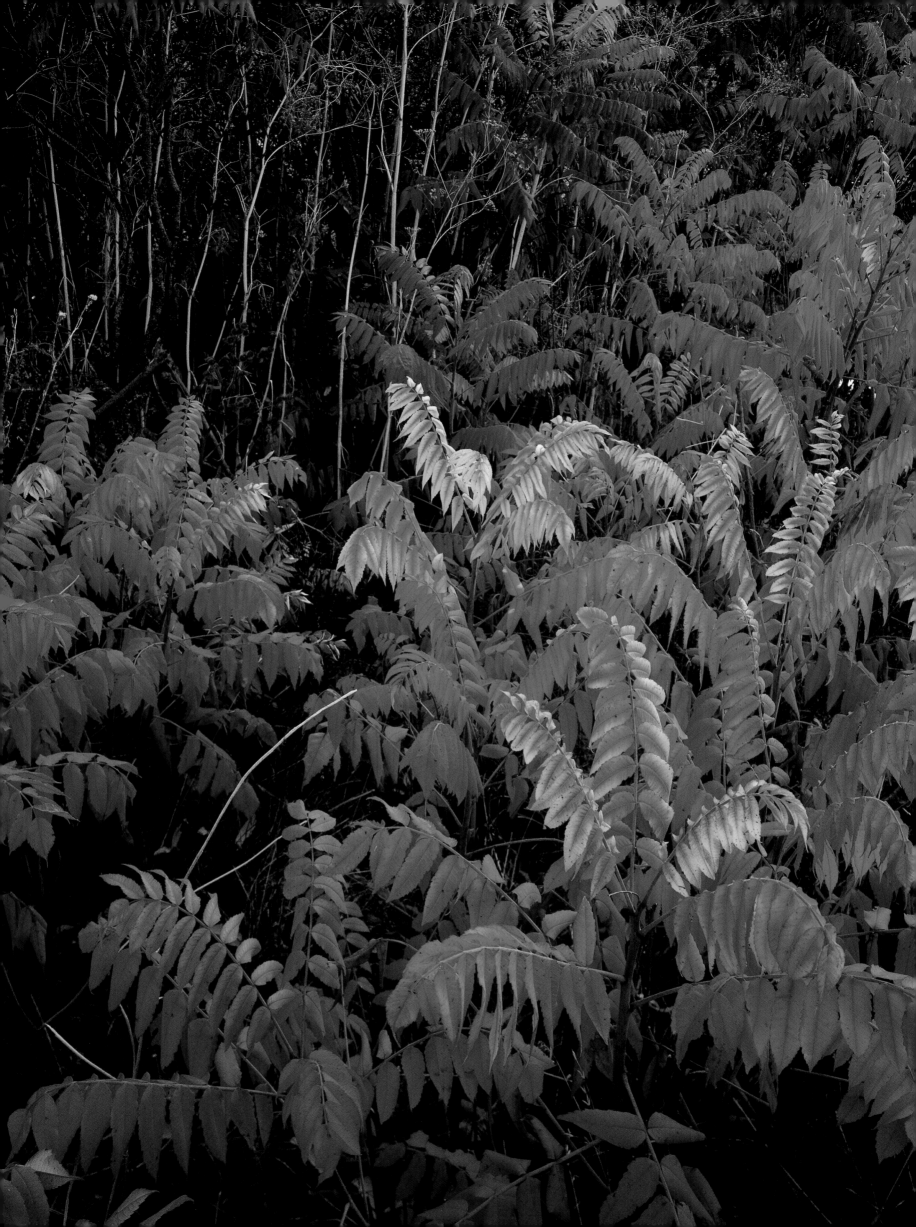

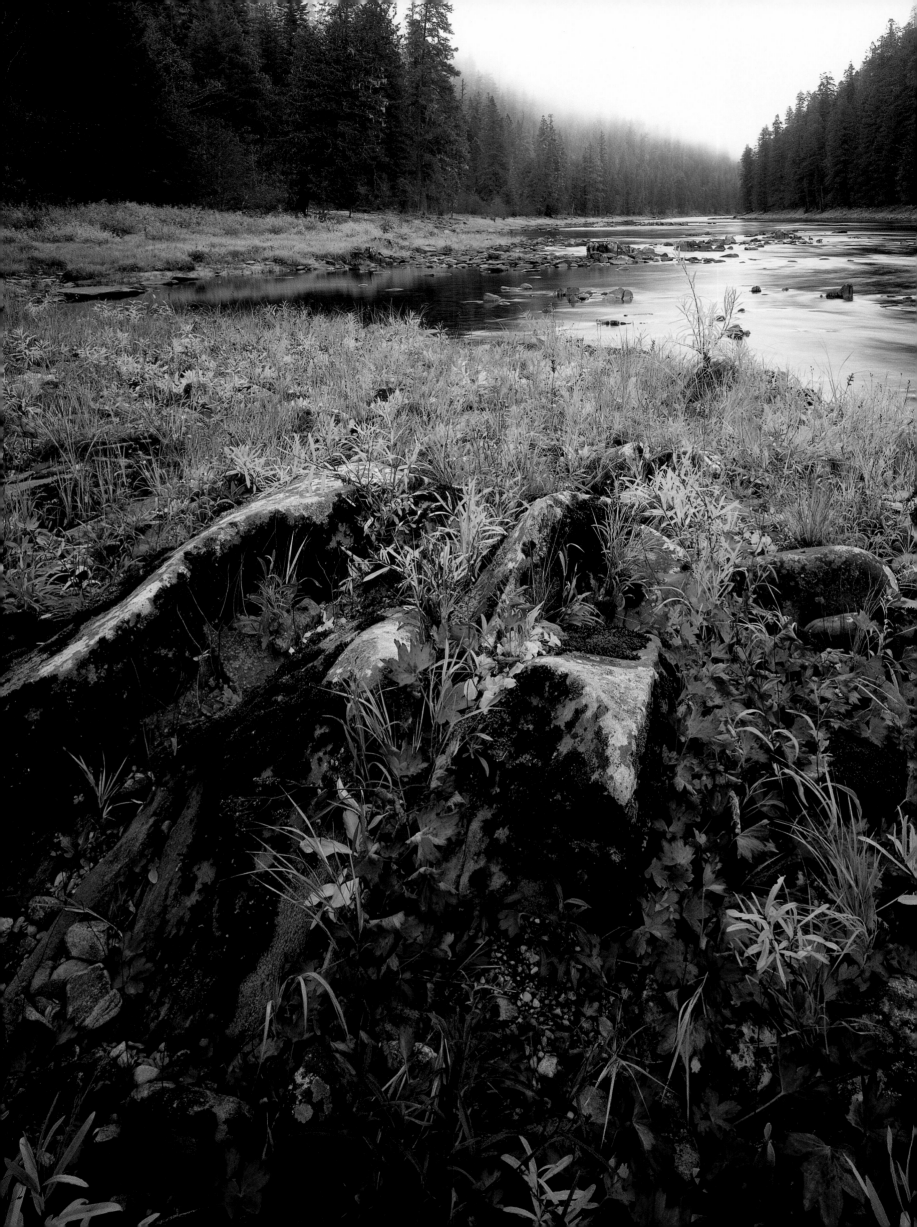

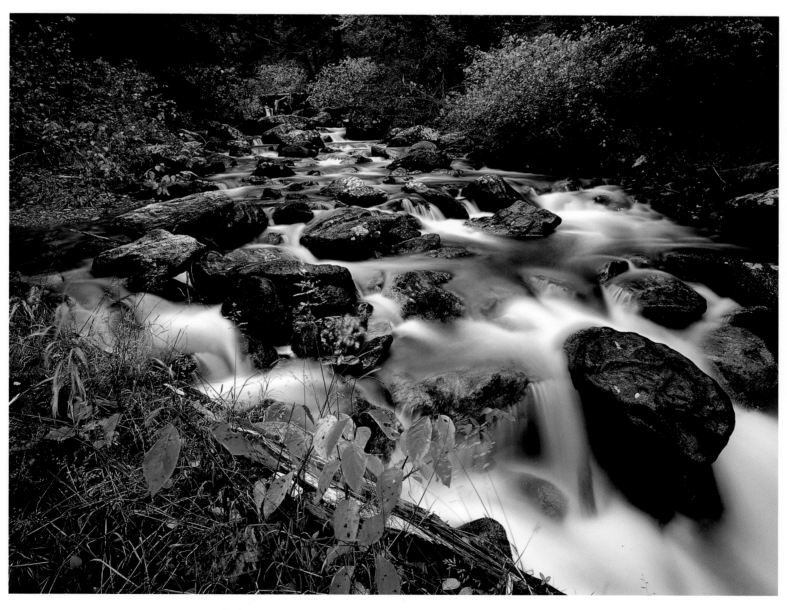

◁ A kaleidoscope of fall colors borders the lower Selway River near Lowell. △ Meadow Creek tumbles through dense vegetation and poison ivy in fall transition in the Clearwater National Forest.

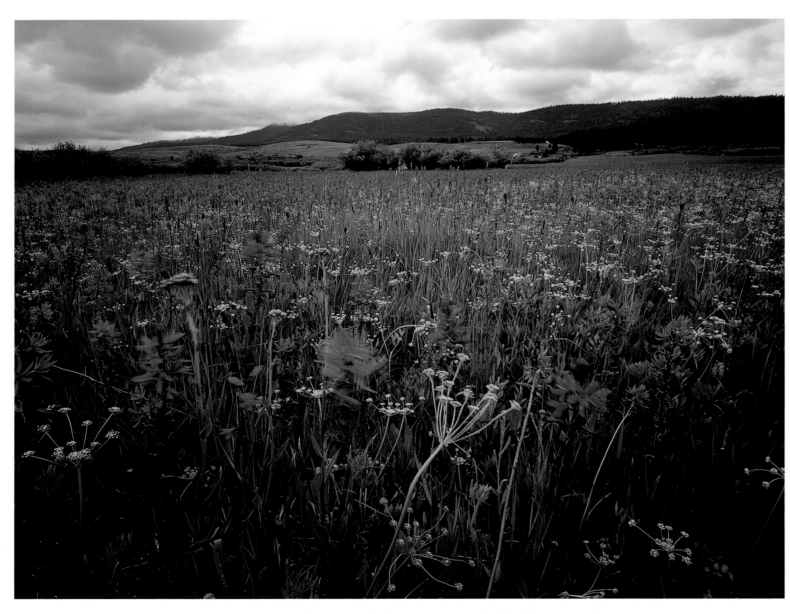

△ Near Grangeville, a gentle breeze sways a field of camas and sweet fennel. ▷ The muted colors of late evening filter through a grain field ripe for harvest near Potlatch. Productive farms in north central Idaho help make agriculture the state's single largest industry, worth $3.1 billion to the state's economy.

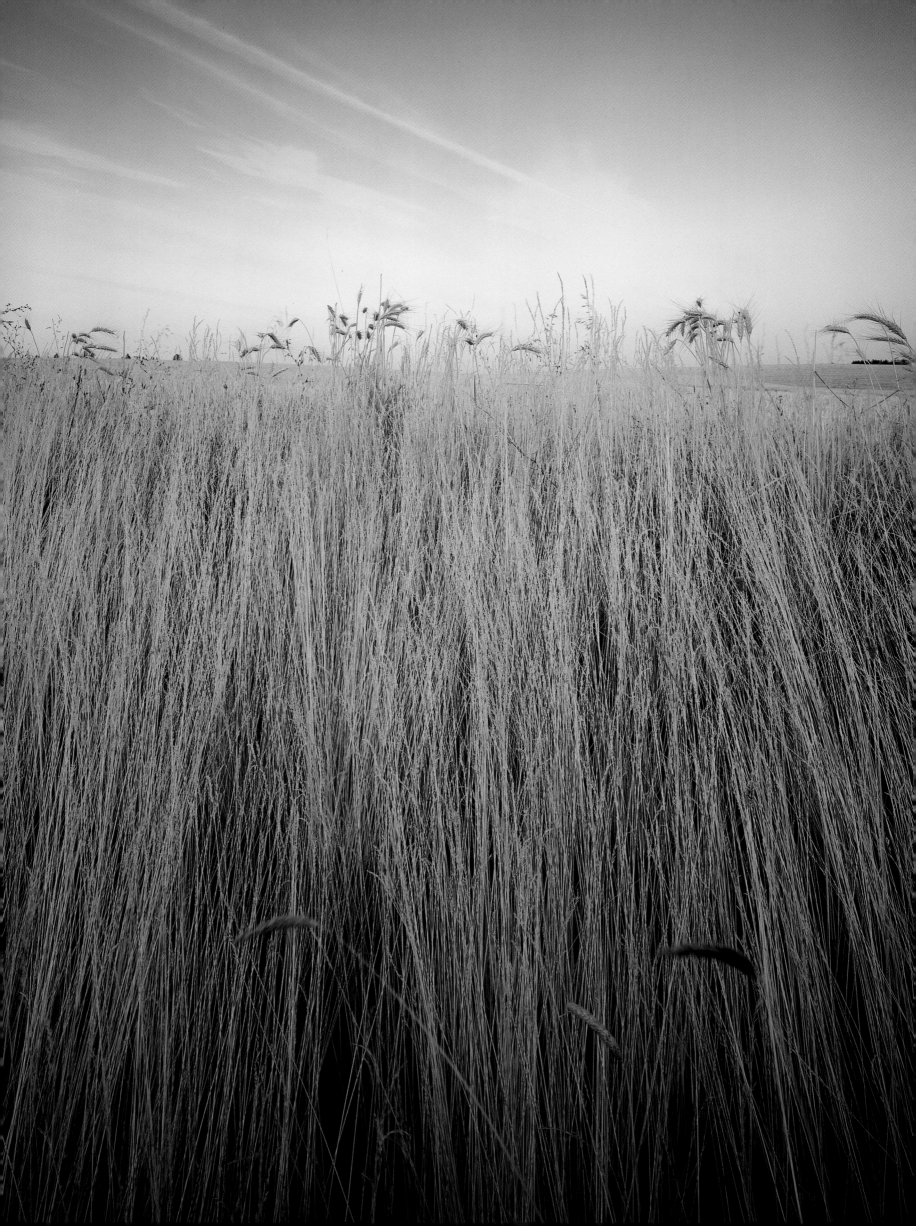

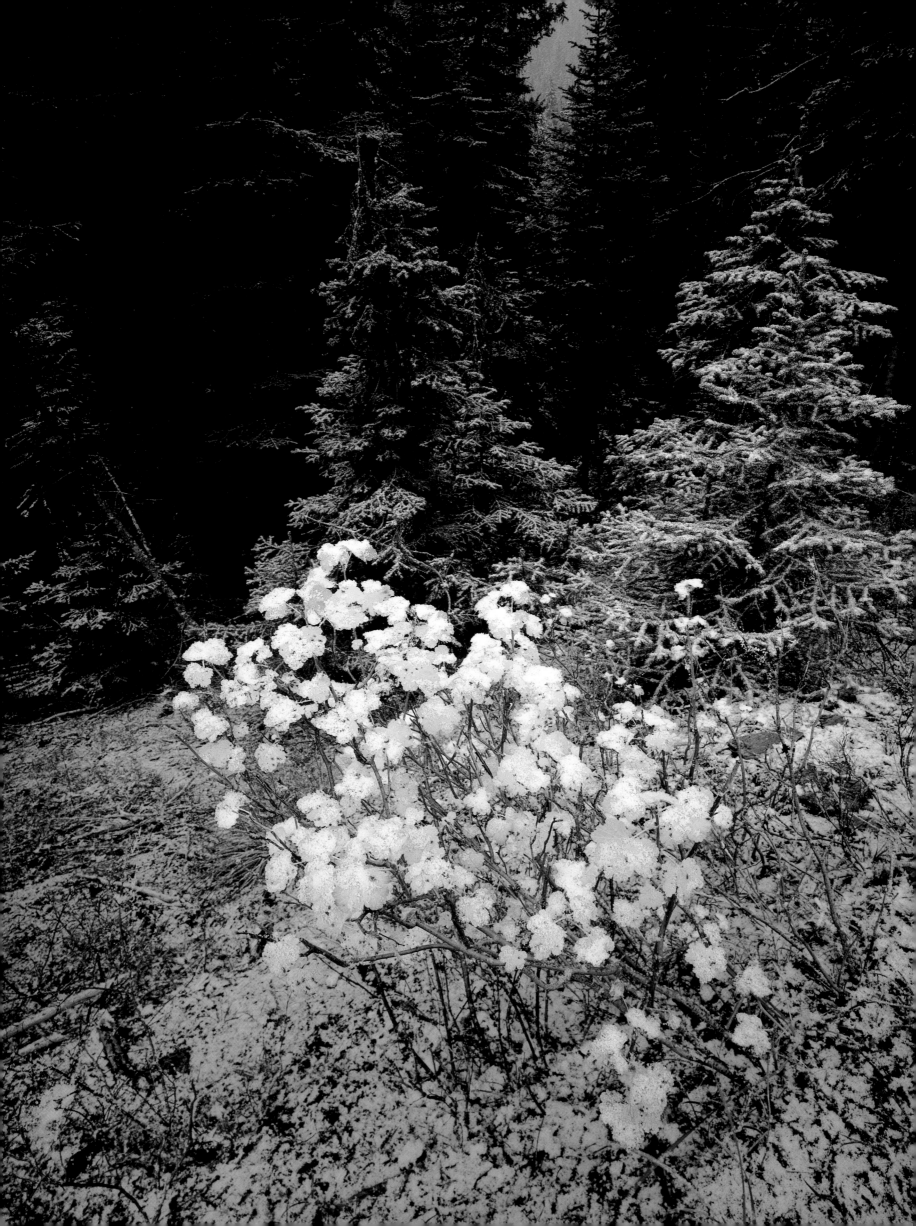

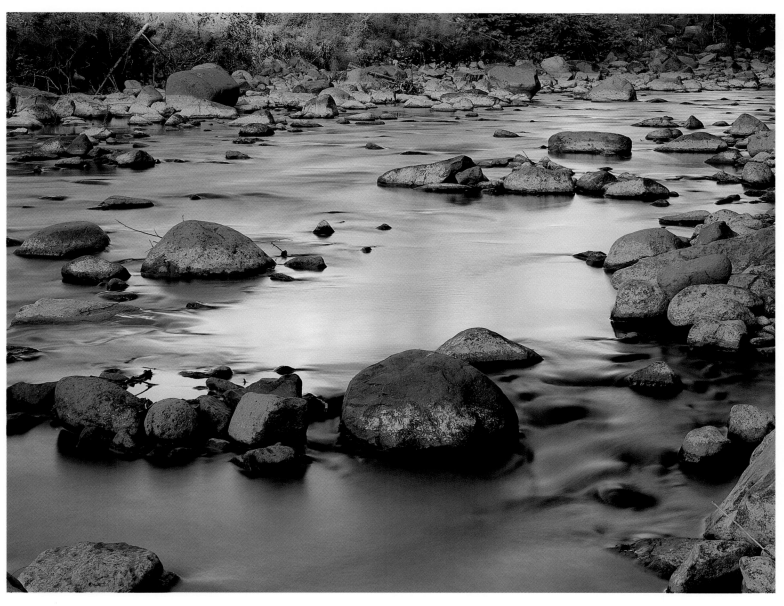

◁ The first dusting of snow covers a swatch of spruce trees in the Red River area of the Nez Perce National Forest. △ During a calm moment, Lapwai Creek reflects a neighboring hillside in evening light. Lapwai Creek is a lower tributary of the Clearwater River. ▷ ▷ Sunlight breaks through a foggy scene in the Clearwater Forest.

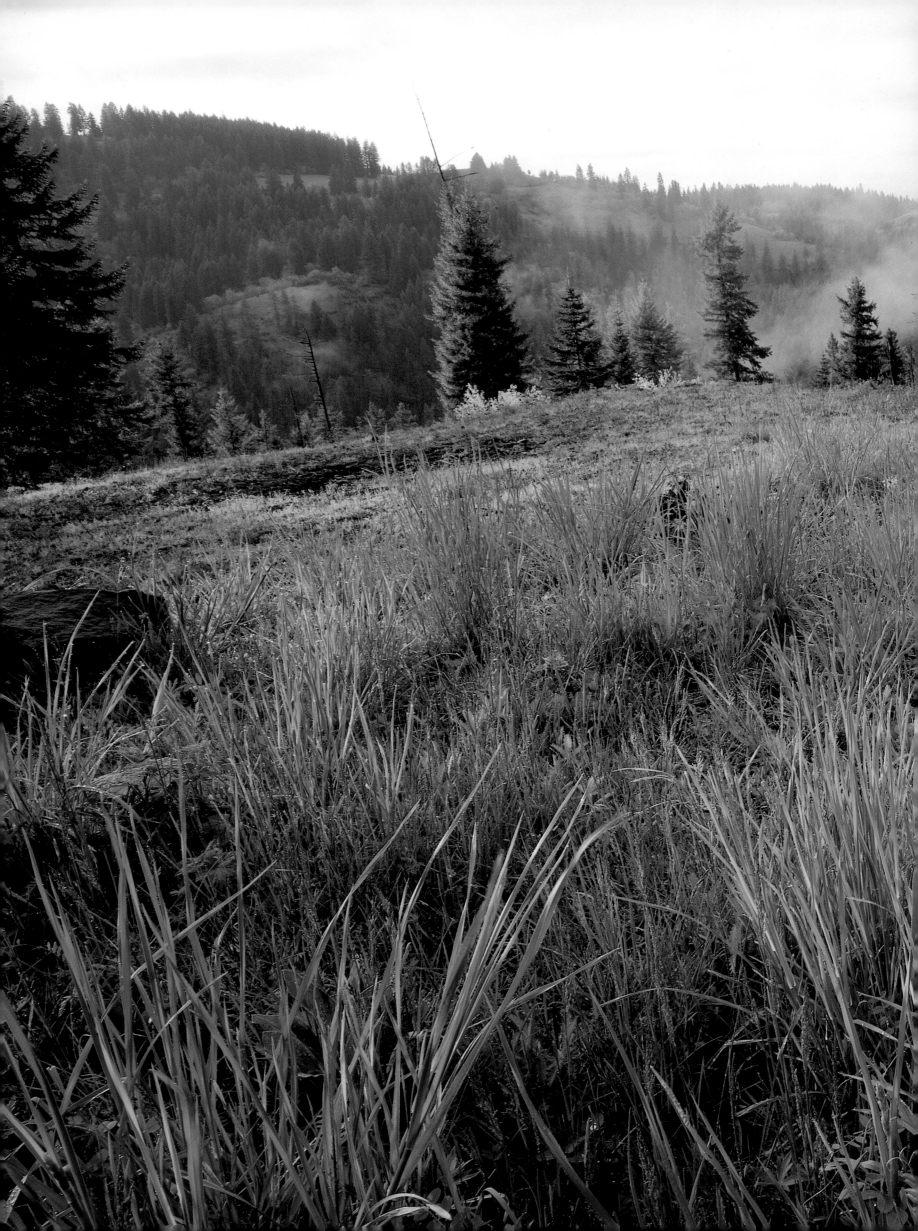

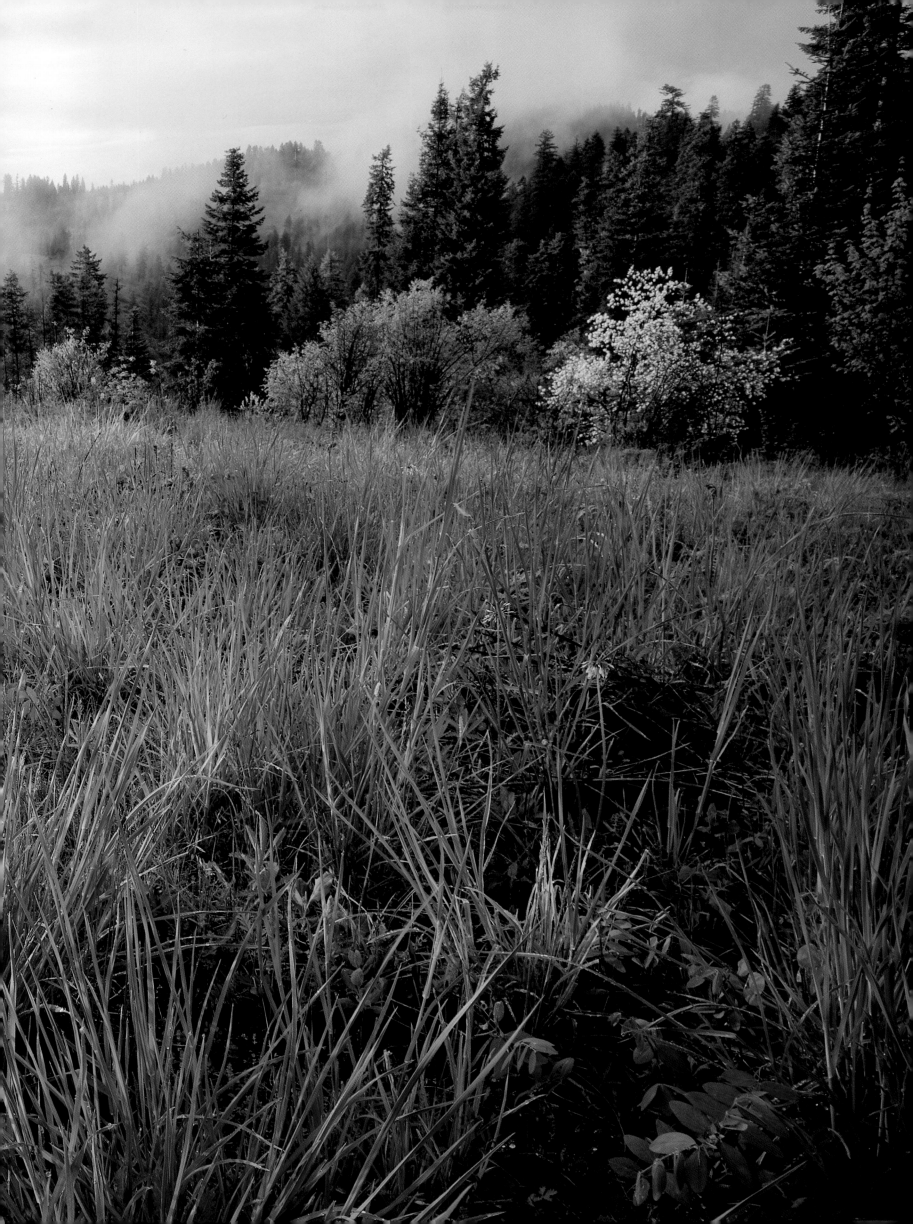

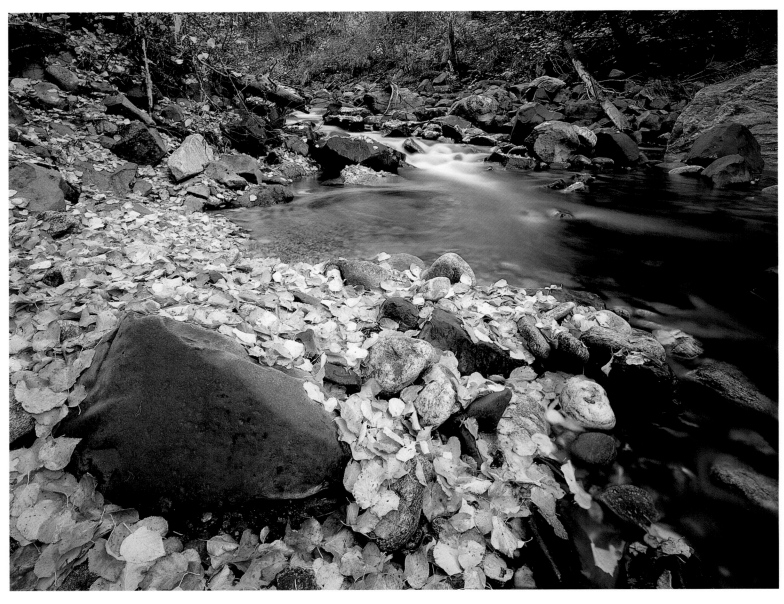

△ Yellow cottonwood leaves accentuate a curvaceous border of Meadow Creek, a dark green pristine stream that rivals the Selway for purity and beauty. Meadow Creek joins the Selway just above Selway Falls in the Nez Perce National Forest.

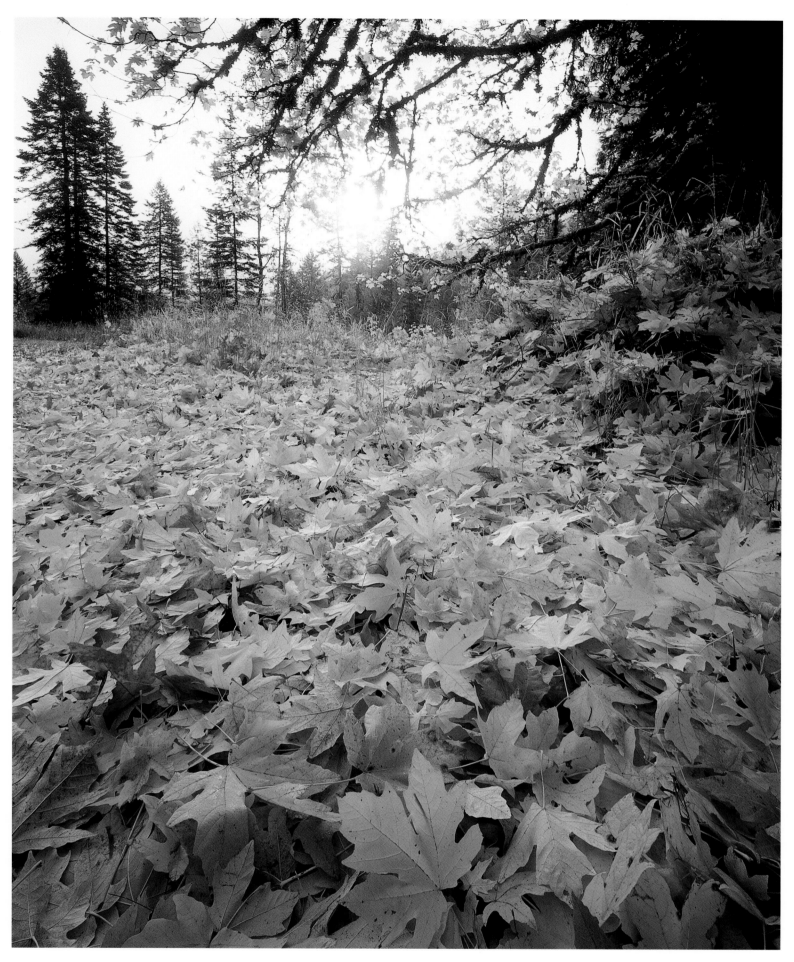

△ Multiple layers of maple leaves indicate the sting of winter is on its way to the Selway River country. Hardwood trees are a rarity in the Clearwater River basin, which is dominated by evergreens such as western red cedar, hemlock, and white fir.

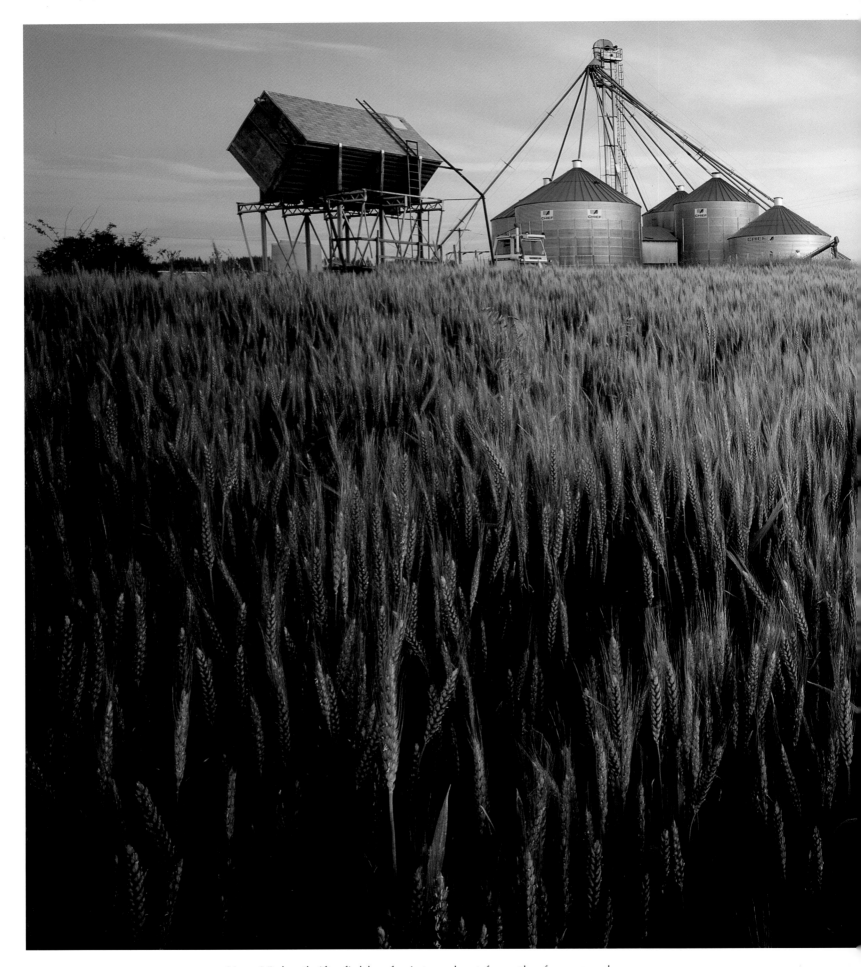

△ Near Viola, thrifty fields of winter wheat form the foreground for a magenta sky. The Palouse region features some of the best growing conditions for cereal crops in the world.

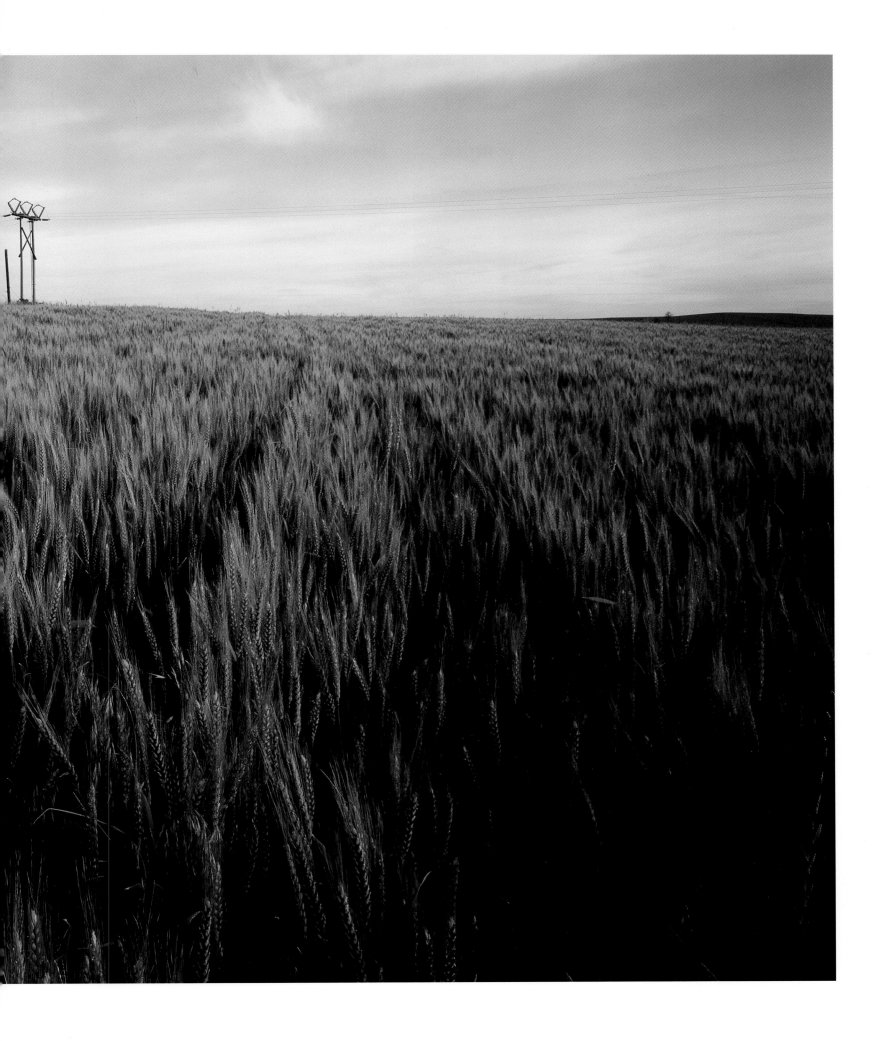

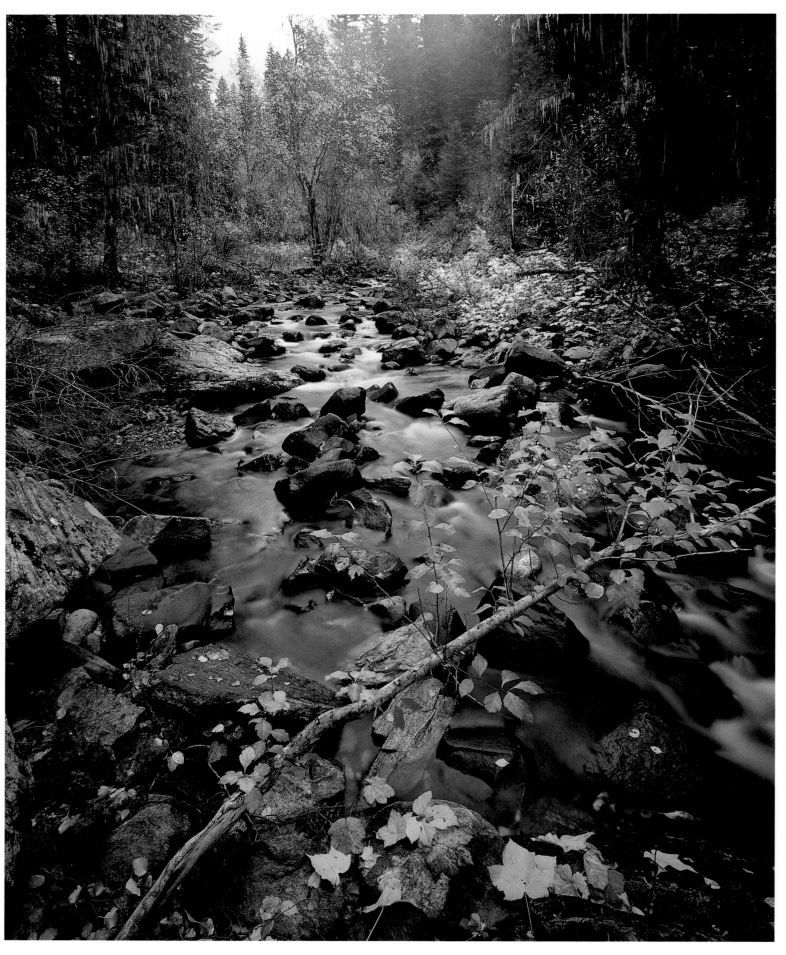

△ Reds and yellows frame a foggy moment in the Clearwater Forest, a rainforest zone whose climate is more akin to western Washington's Olympic Peninsula than southern Idaho's dry forests.

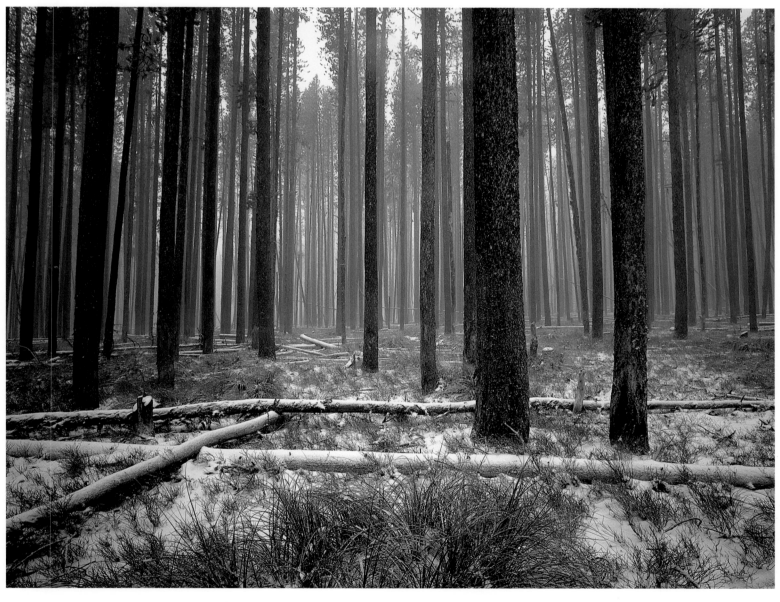

△ Early snowflakes fall through columns of lodgepole pine in the Gospel-Hump Wilderness. ▷ ▷ The aptly named Cascade Creek pours over moss-covered granite on its way to the Selway River.

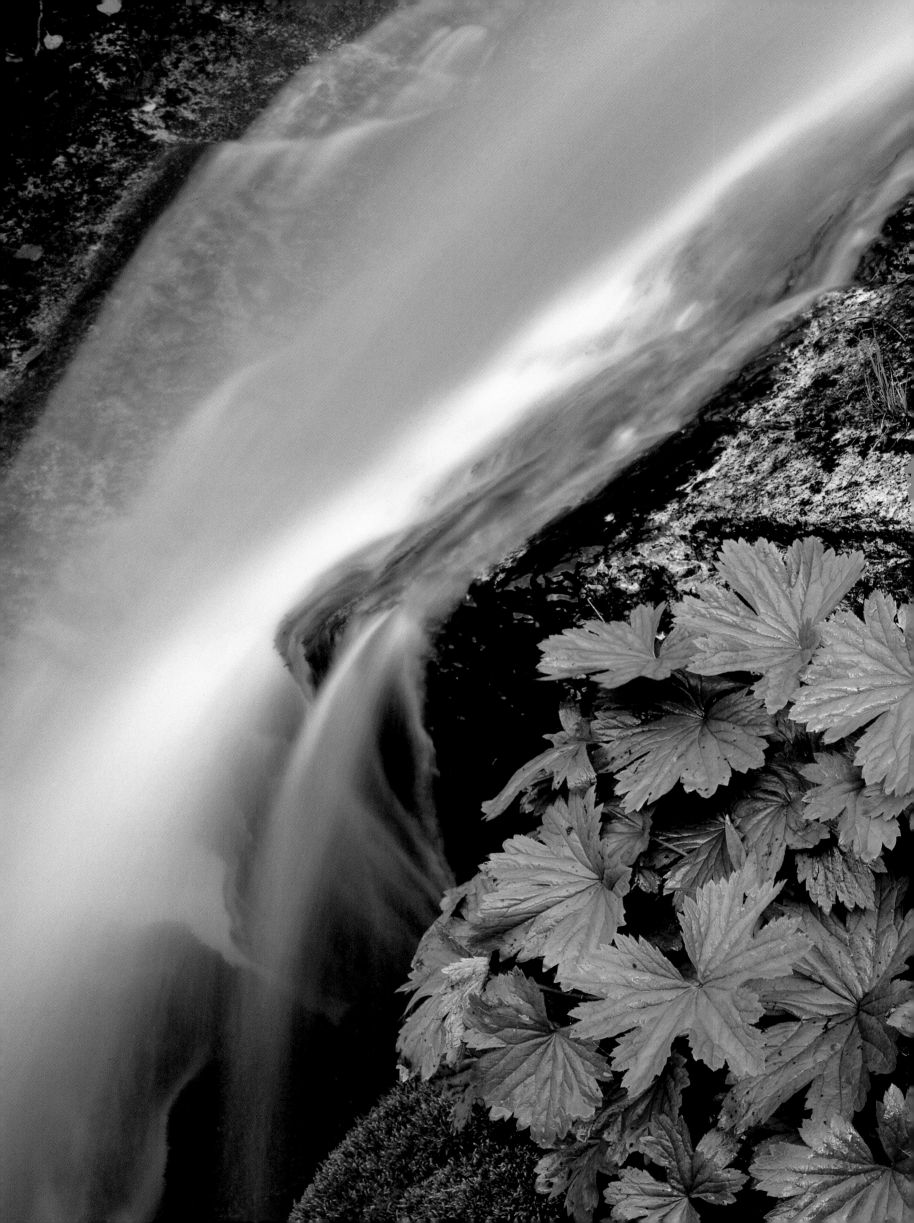

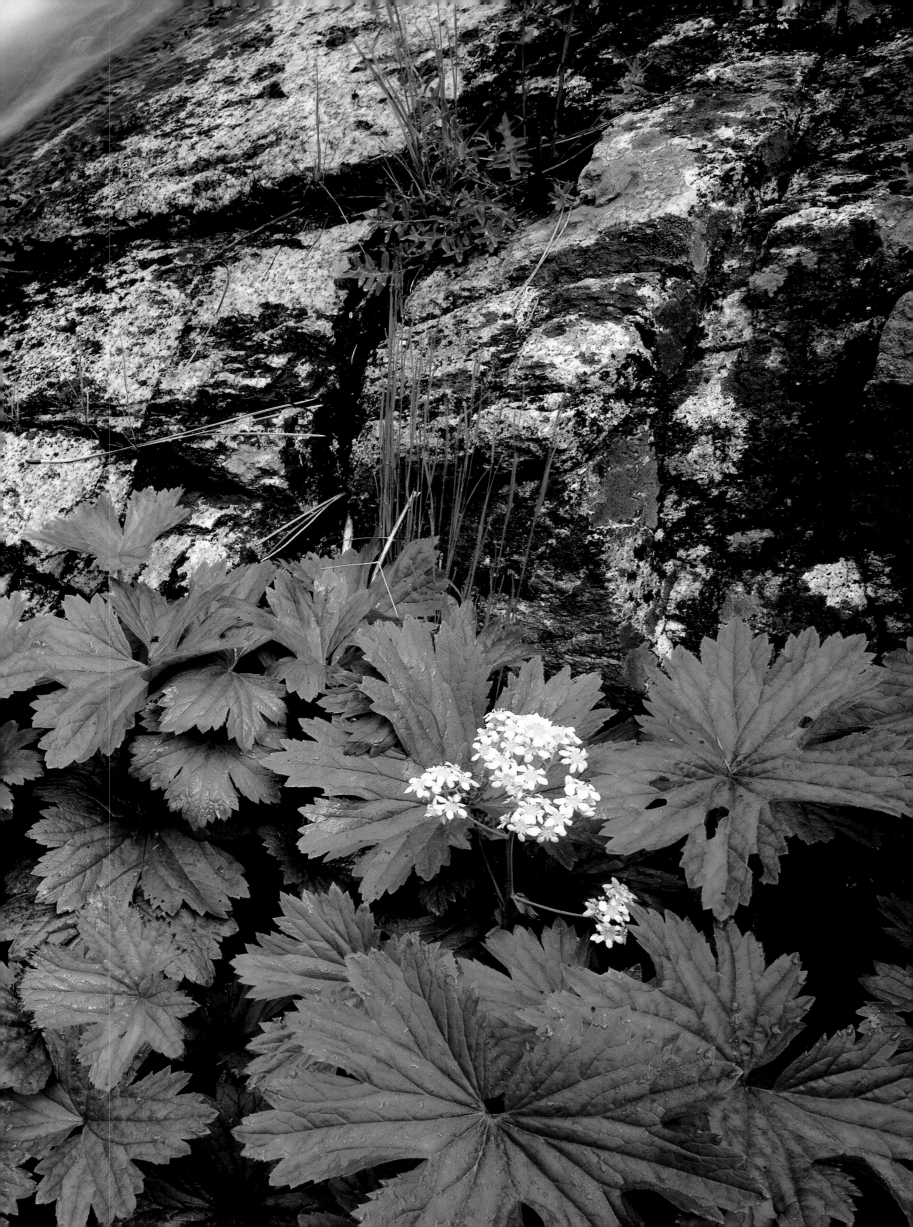

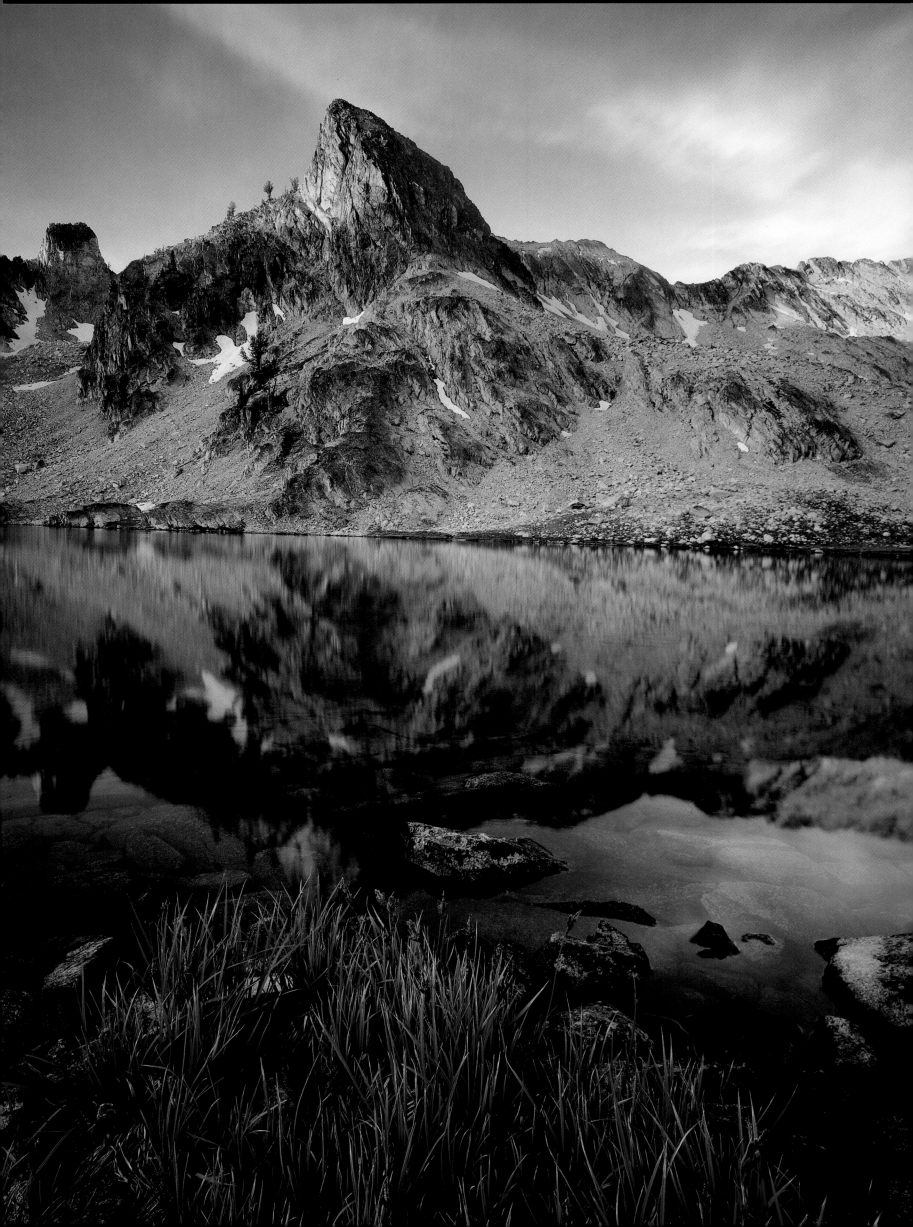

The Heart of Idaho

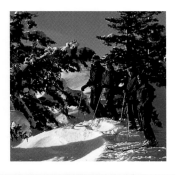

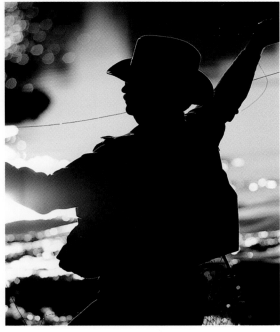

◁ Early morning light nips
the tip of a granite knob
looming over Twin Lakes
in the Sawtooth Wilderness.
△ △ Alpine skiers soak up
the sun's warmth before
taking the plunge.
△ Fly-fishing for native
cutthroat trout is a
popular activity in the
Salmon River country.

Meet the General, a pointy 10,325 foot peak. The General keeps watch over a seemingly infinite sea of white granite mountains in the middle of the Salmon River country. It's a breezy blue day. Soft, muffin-shaped clouds hover over countless peaks and ridges, casting long shadows. On his north flank, the General looks down on the birthwaters of Loon Creek, a pale blue tributary of the middle fork of the Salmon River. Behind his back, he looms over the Yankee Fork, a major feeder stream of the main Salmon River and a historic mining district. In little alpine basins surrounding the base of the General—separated by serrated rocky ridges—four emerald lakes shimmer under the noonish sun, surrounded by green meadows and patches of wildflowers: Mystery Lake. China Lake. Lightning Lakes Number One and Number Two.

From his post, the General can see at least one hundred miles in every direction, but it's impossible to see any break in this ocean of wilderness. No power lines; no roads; no tourist resorts; no trappings of civilization or wilderness parks. Just you, the General, the wind, and the wilderness.

The core of the Salmon River country is protected for perpetuity inside the 2.3-million-acre Frank Church-River of No Return Wilderness. As conservation writer Ted Trueblood puts it, to see the sea of wilderness in the "Frank" is to see the wild landscape "just the way God made it." Indeed, one can watch a herd of elk silently grazing in a lush high-mountain meadow, hear coyotes or wolves howling in the background, and think, hey, this scene hasn't changed in thousands of years. It's not hard to imagine a band of Sheepeater Indians holding a special salmon ceremony in the meadow, singing and chanting to a spirited drum-beat in preparation for the season's first feast of chinook salmon, the river's namesake.

The General knows the wilderness has a nasty streak, too. Clouds can gather quickly to shower lightning bolts onto the peaks—and on rare occasions onto unwary mountaineers. Summer-like weather in September can be erased by a cold front and a foot of snow in a matter of hours. Pure moments of quietude can be disrupted by a microburst of tornado-force winds without warning. Spring floodwaters on the Salmon can turn the popular whitewater stream into a frightening freight train of hydraulic chaos. It's appropriate to remember that the Lemhi band of the Shoshone called it "River of No Return."

Traced from its headwaters, the Salmon River forms a giant question mark as it carves through 475 miles of wilderness, riverside ranches, gold mines, and rocky timber-lined canyons in central Idaho. The Finger of Fate, a tall granite column in the Sawtooths, wags its pointy tip at anyone who tries to tame the Salmon—to carve out a living along its banks or test their boating skills against its challenging rapids. The Finger of Fate knows that the river always rules. No matter how one makes a living in the Salmon River country—whether as a logger, a miner, a rancher, an outfitter, or a back country pilot—every outdoorsy character shares a deep sense of respect for nature's awe-inspiring beauty. An old-timer who lived at the Jim Moore homestead across from Campbell's Ferry told me, "I spent the happiest days of my life" on the Salmon River. "It's a beautiful place to live, but it's a damn hard place to make a living."

The people who actually live in the Heart of Idaho—the survivors—must be as tough as the gnarled whitebark pine trees that grow on the wind-whipped ridgetops and lake basins in the Salmon River Mountains; as fluid as the river that ebbs and flows with the forces of nature; and flexible enough to change with the economic realities. These folks face new challenges every day: some as daunting as Rubber Rapids, the

middle fork's mightiest drop; others as smooth as Dolly Lake, a deep, dark, fish-laden pool that lies between two rapids.

As the single largest wilderness area in the Lower Forty-eight states, the "Frank" is bigger than Yellowstone National Park and three times the size of Yosemite. Although it encompasses about thirty-six hundred square miles of high-mountain frontier, the "Frank" only begins to define the length and breadth of the Salmon River system. Like a human heart, the Salmon has five major arteries—streams that trend south-to-north for up to one hundred miles from the Snake River divide. In total, the Heart of Idaho occupies Idaho's midsection, border to border, from Hells Canyon—the nation's deepest gorge—on the Oregon side, to Lookout Pass on the Montana side. The Salmon winds through six national forests and portions of five counties. Nevertheless, only thirteen thousand people live in the basin—about one-third of a person per square mile.

The river is born in the snow atop 8,701-foot Galena Summit, thirty miles north of Sun Valley. It plunges quickly into a pastoral valley framed by two of the state's most spectacular mountain ranges, the spire-showered Sawtooths and the tall, angular White Clouds. It rolls on through green pastures to Stanley, and then it begins a great bend to the east, picking up the Yankee Fork, the East Fork, the Pahsimeroi, and the Lemhi, all major tributaries. Near the town of Salmon, the river butts up against the Continental Divide and the Beaverhead Range, then turns abruptly west at North Fork and cuts a V-shaped, mile-deep gash across Idaho's midsection— a natural division between north and south. Along the way, dozens of tributaries pour in from tight canyons on the north and south sides of the river gorge. High above the river, Chamberlain Basin, the Big Horn Crags, the Gospel-Hump Wilderness, and many natural features punctuate the view.

Below the little hamlet of Riggins, the Salmon River winds past old Chinese mining terraces, strikingly vertical bald-faced mountain flanks, and the velvety finger ridges of Whitebird Hill before heading into a final roadless canyon—a fifty-mile gorge with four distinct sub-canyons. The Salmon finally joins the Snake in Hells Canyon, 475 miles from Galena Summit and some seventy-five hundred vertical feet below its source.

The Salmon is the longest free-flowing (undammed) river in the contiguous United States and the longest river system wrapped inside a single state. The Salmon owes its freedom largely to its rugged character: rough-hewn terrain that not only defied Lewis and Clark, but later also blocked the Northern Pacific Railroad and foiled dam-builders in a very pro-development state. Eventually, led by Ted Trueblood and others, conservationists lobbied then-governor Cecil Andrus and longtime Idaho Senator Frank Church to create the 275,000-acre Sawtooth Wilderness in 1972, and the Frank Church-River of No Return Wilderness in 1980. The White Clouds still await official protection.

Most of the Salmon River country, as well as the Sawtooths and the White Clouds, represent a magnificent vertical display of the Idaho Batholith, a homogenous granitic formation that rose from molten rock some eighty million years ago. Much more recently, during the Ice Age, glaciers carved hundreds of alpine basins below the peaks and left in their wake more than 875 high-mountain lakes. Two diagonal mountain ranges, the Lost River Range and the Lemhi Range, trace their origins to a geologic syndrome known as "basin and range." In thousands of earthquakes over millions of years, Idaho's highest peaks in the Lost River Range rose like an elevator from the earth's crust, climbing to heights over twelve thousand feet while the

adjacent valleys sank. Geologists have matched rocks on the floor of the Lost River Valley with those on top of Borah Peak, the state's highest summit at 12,650 feet.

The Salmon River country owes its foundation to these basic geologic events, but the region is far more complex from the standpoint of mineralization. The basin is loaded with a diversity of metals, a fact that was not lost on early miners. One of the state's earliest gold strikes occurred in 1862, in Florence, on the north side of the Salmon River canyon. Soon afterward, on the south side of the Salmon, prospectors moved into Warren. By 1902, William Campbell had started a ferry service on the Salmon River to provide a way for miners from Florence, Dixie, Orogrande, and Humptown to cross the river and reach Thunder Mountain, above Yellow Pine. Around the seams of the Salmon River country, many other mines were developed to extract gold, tungsten, silver, cobalt, and copper. Today, several modern open-pit mines ring the Salmon River country to extricate gold and molybdenum, and they provide good-paying jobs for the locals.

For nearly a century, cattle and sheep ranchers have grazed livestock and raised hay in the fertile riverbank meadows near Stanley, Clayton, Challis, Salmon, and Mackay. Most of the ranching operations today focus on cattle rather than sheep. Logging has played a long and important role in Riggins and Salmon, but after its sawmill burned in the early 1980s, Riggins became one of many rural communities in the West to reluctantly convert to tourism. For business and jobs, Riggins now relies on the Salmon River's challenging and fun white-water rapids and its position on U.S. 95, the state's only north-south highway. It's not unusual to run into a river guide in Riggins who used to be a logger or a miner, or both.

Commercial whitewater trips on the famed middle fork of the Salmon and main Salmon Rivers have been popular for years. Early boatmen like Harry Guleke and Johnny Mackay charged miners up to $1,000 per person for a ride down the Salmon on big wooden sweep boats. By the mid-1970s, whitewater rafting on the middle fork and "the Main" was big business. In the 1990s, outfitters specialize in eco-travel trips—fly-fishing on the Salmon's middle fork with luxury dutch oven cooking. Quotas keep river traffic to a manageable level, about twenty thousand people a year, and strict catch-and-release regulations on the middle fork preserve thrifty populations of wild cutthroat trout.

Unfortunately, the same can not be said of the mighty chinook. Even as recently as the late 1960s, the Salmon River produced up to half the salmon and steelhead (ocean-going rainbow trout) in the entire Columbia River Basin. But when the lower Snake River was turned into a flat waterway with four dams, the fish populations began to die off in rapid fashion. Now the chinook is an endangered species.

Back country horseback and llama trips, fly-in "camping with wolves," and hunting for elk, bear, cougar, deer, wild sheep and mountain goats are big business, too. Back country pilots do a flourishing business in the Salmon River region, serving hunters, backpackers, and floaters in high season. Throughout the year, they fly in the mail.

From the vantage point of a little Cessna fixed-wing aircraft, flying over the sea of mountains in the Salmon River country can be a humbling experience, but it's the closest you'll get to seeing the Heart of Idaho from the perspective of the General. The mountains seem to go on forever. To see it up close is like floating on top of those muffin-like clouds, and looking down on the General's pointy head, a throne of eternal wisdom.

▷ *A lone subalpine fir shoots out of a rock crevice next to Alpine Lake in the Sawtooth Wilderness.*

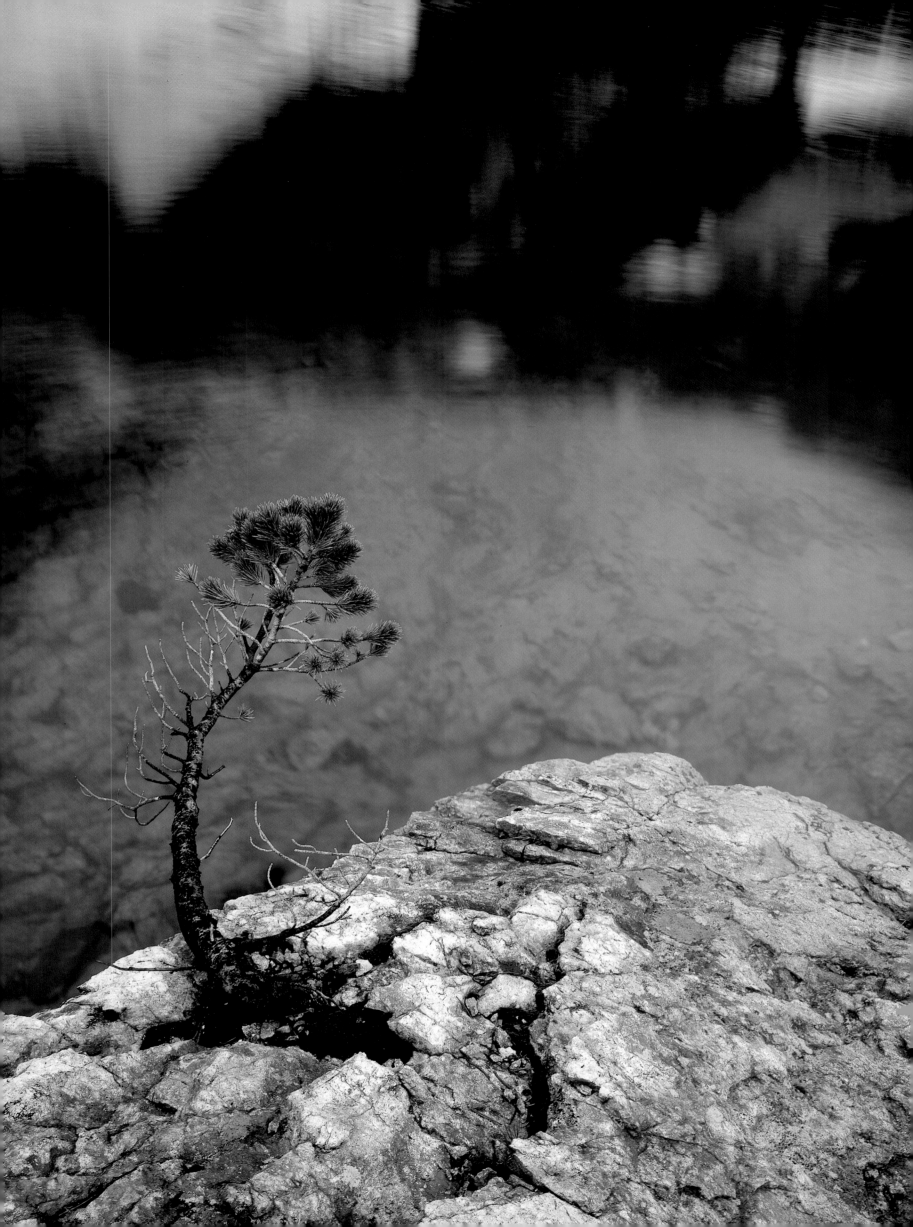

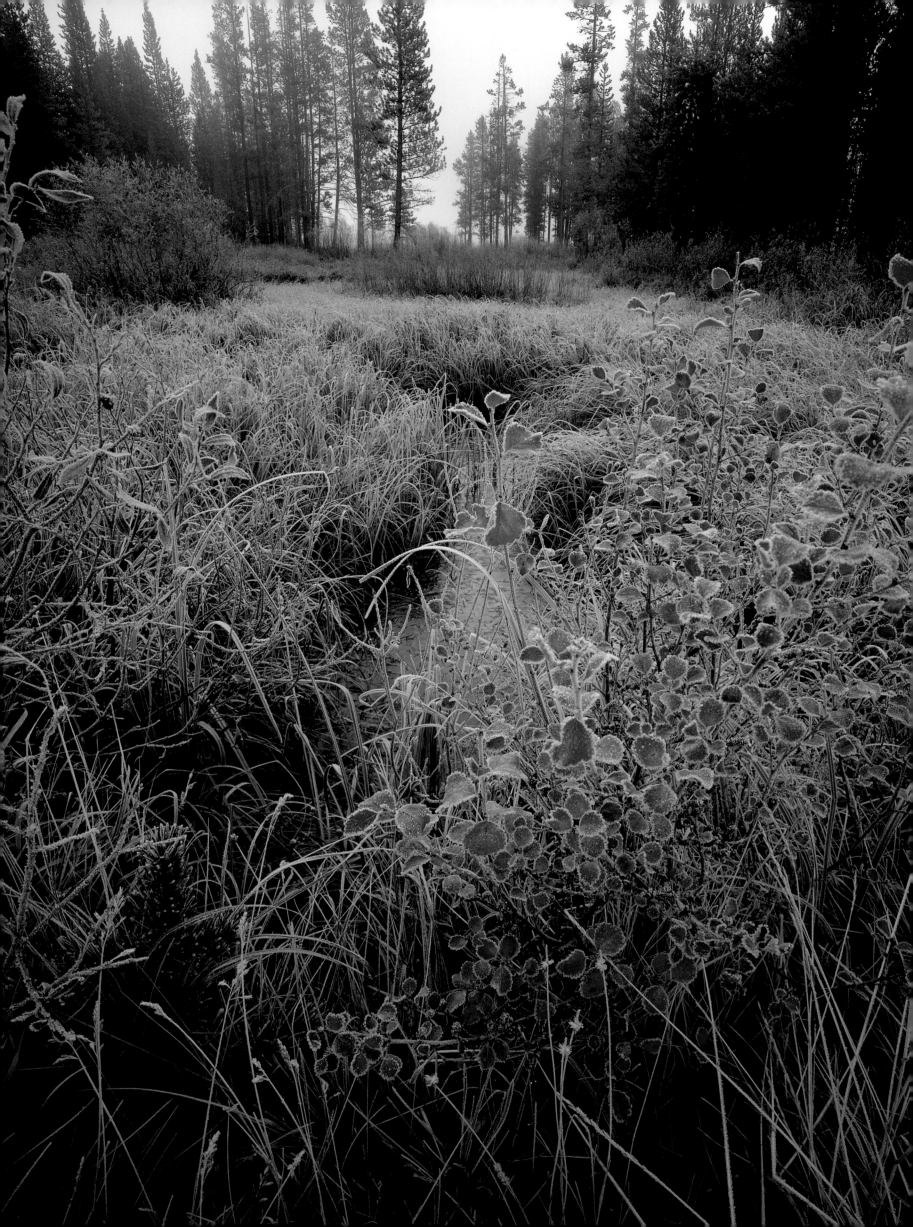

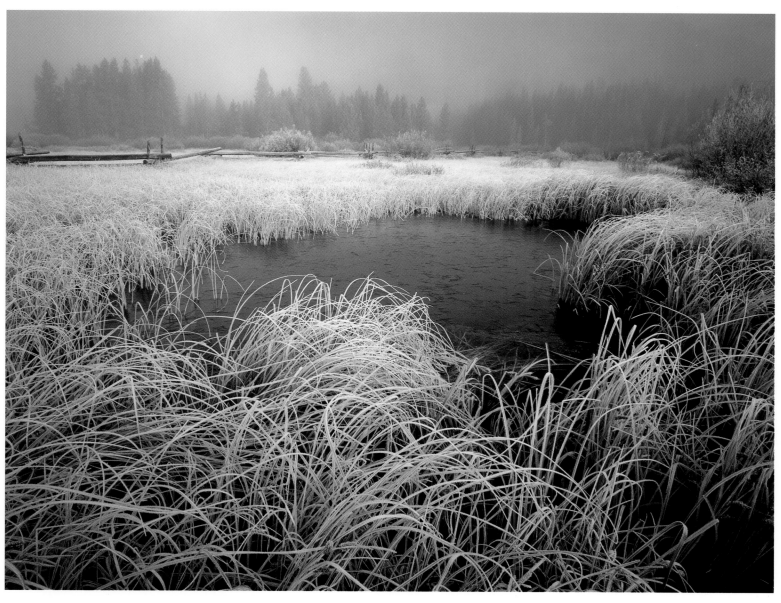

◁ In October, dawn breaks slowly in a wetland near Stanley Lake.
△ On a frosty morning in the Stanley Basin, fog hides a plethora of wildlife and grazing cattle. The basin is home to a large herd of Rocky Mountain elk, and in summer and fall, cattle graze in the basin near the headwaters of Valley Creek, a Salmon River tributary.

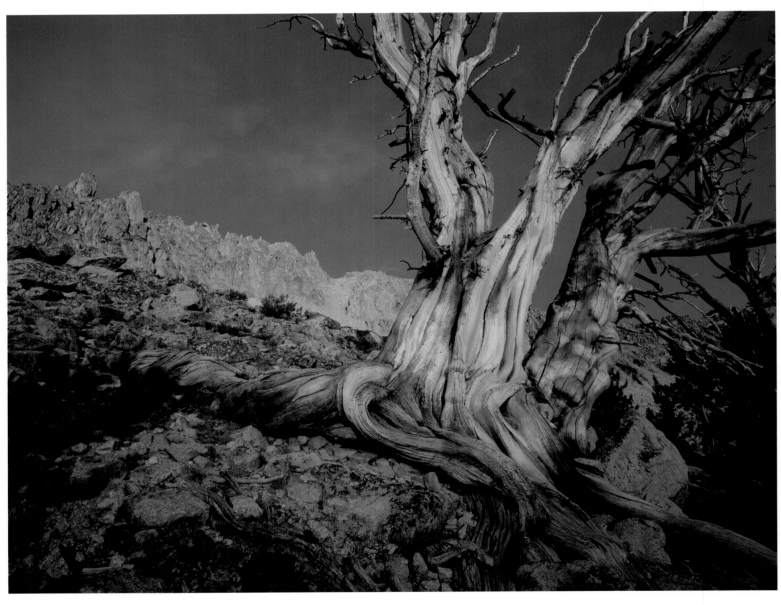

△ A gnarled whitebark pine in the White Cloud Mountains is symbolic of the hardy lifestyle of people who live in the Salmon River country. ▷ The Finger of Fate, hovering nearly ten thousand feet over a set of mountain lakes in the Sawtooth Wilderness, is a popular hangout for technical rock climbers.

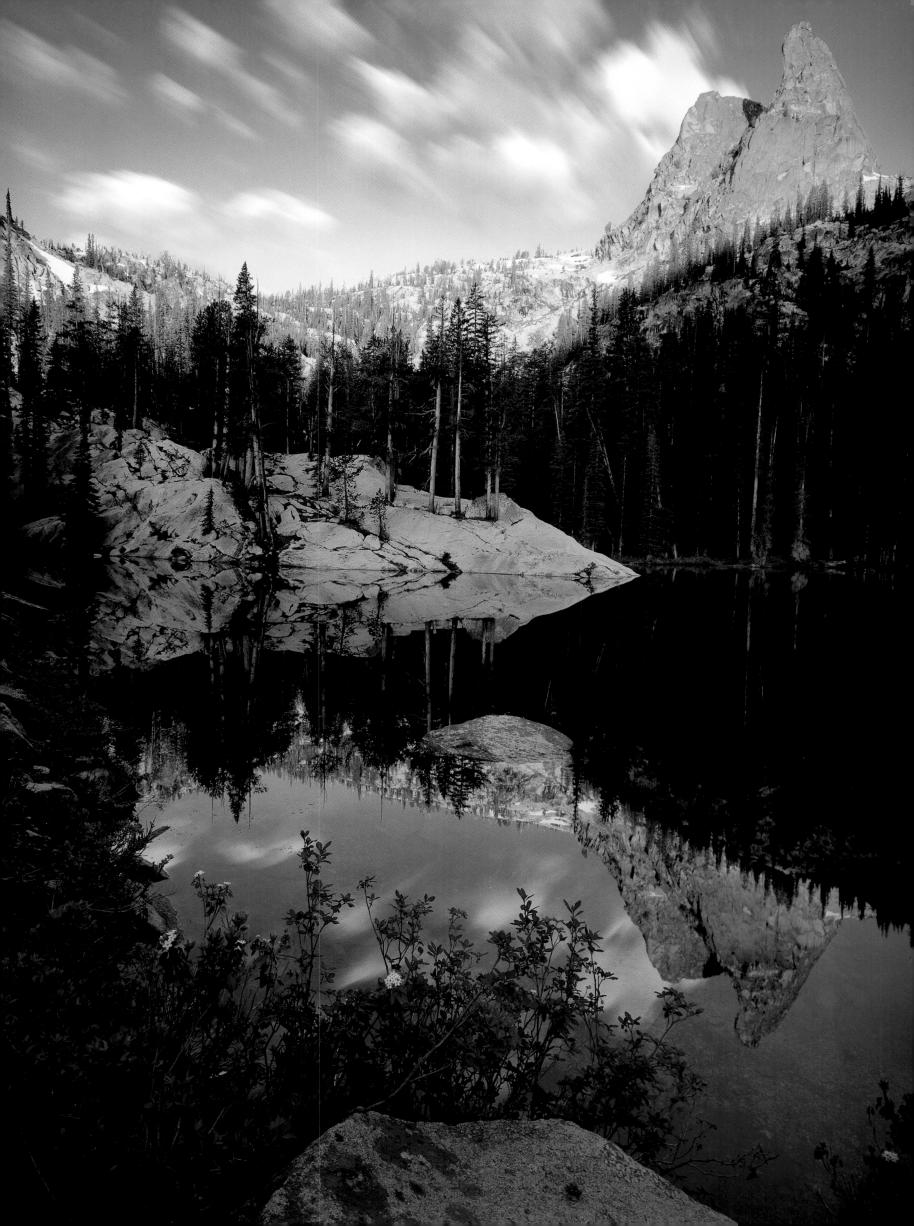

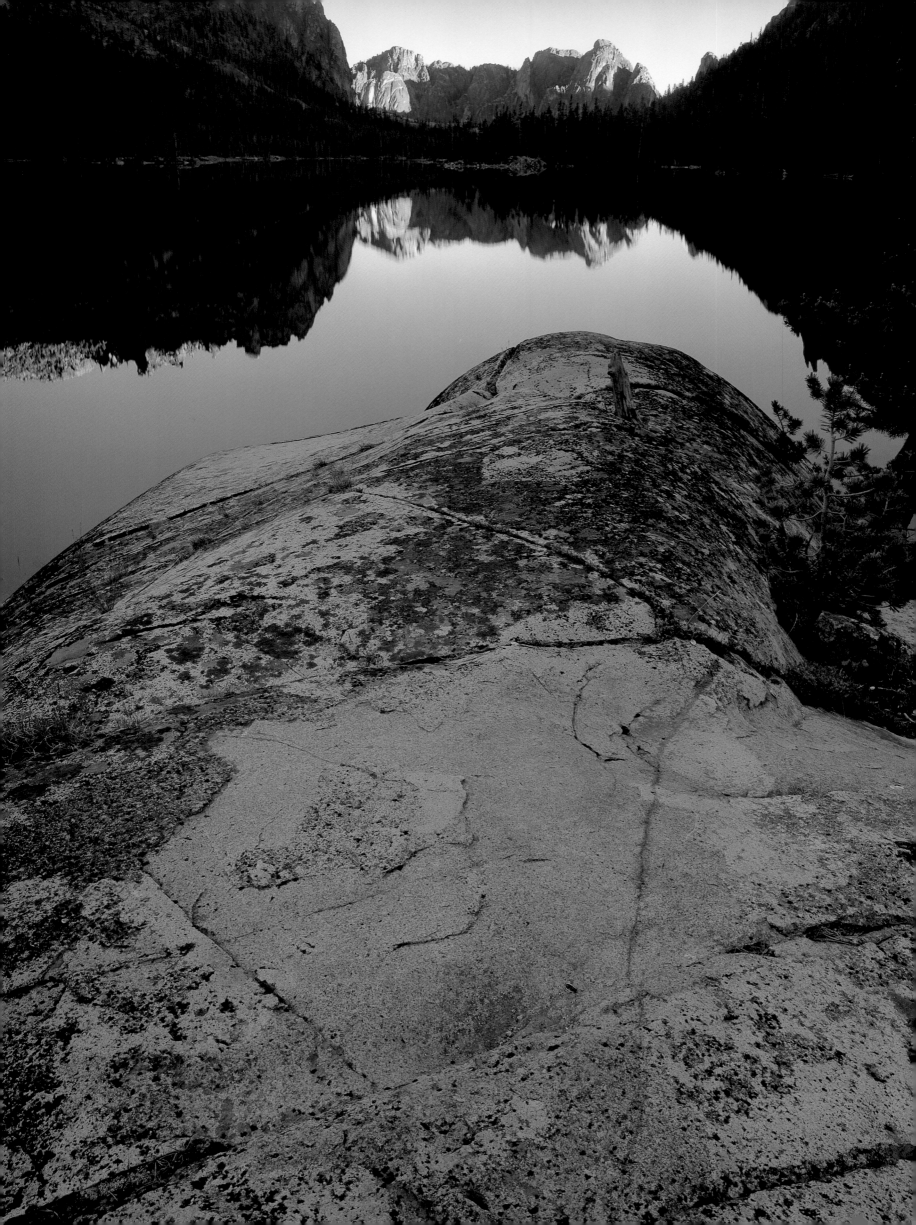

◁ Ship Island Lake, the largest in the Big Horn Crags, is bounded by a guardian of rugged peaks at its outlet, the beginning of Ship Island Creek. From there, the creek dives four thousand feet in just four miles to the middle fork of the Salmon River. △ Subtle fall colors blanket a lodgepole pine thicket near Redfish Lake Creek.

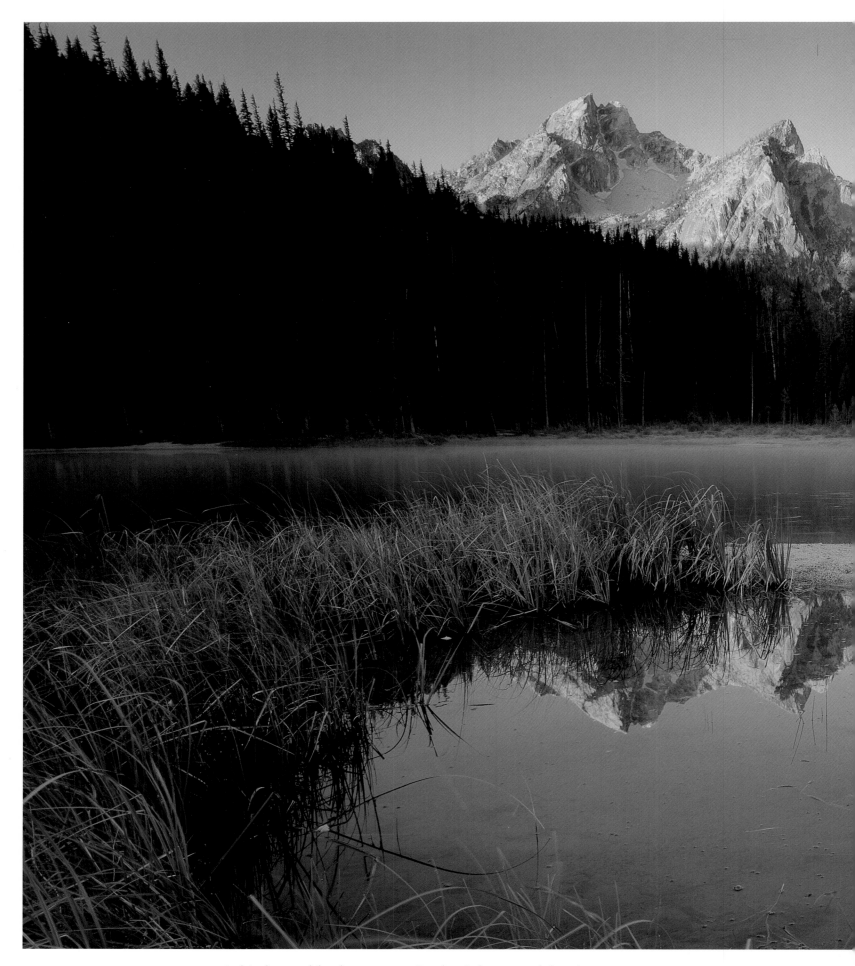

△ A thin layer of fog hovers over Stanley Lake, one of the signature gems in the Sawtooth Mountains. On the left, McGowan Peak (elevation 10,000 feet) is named for George I. McGowan, one of the first white settlers in the Stanley Basin.

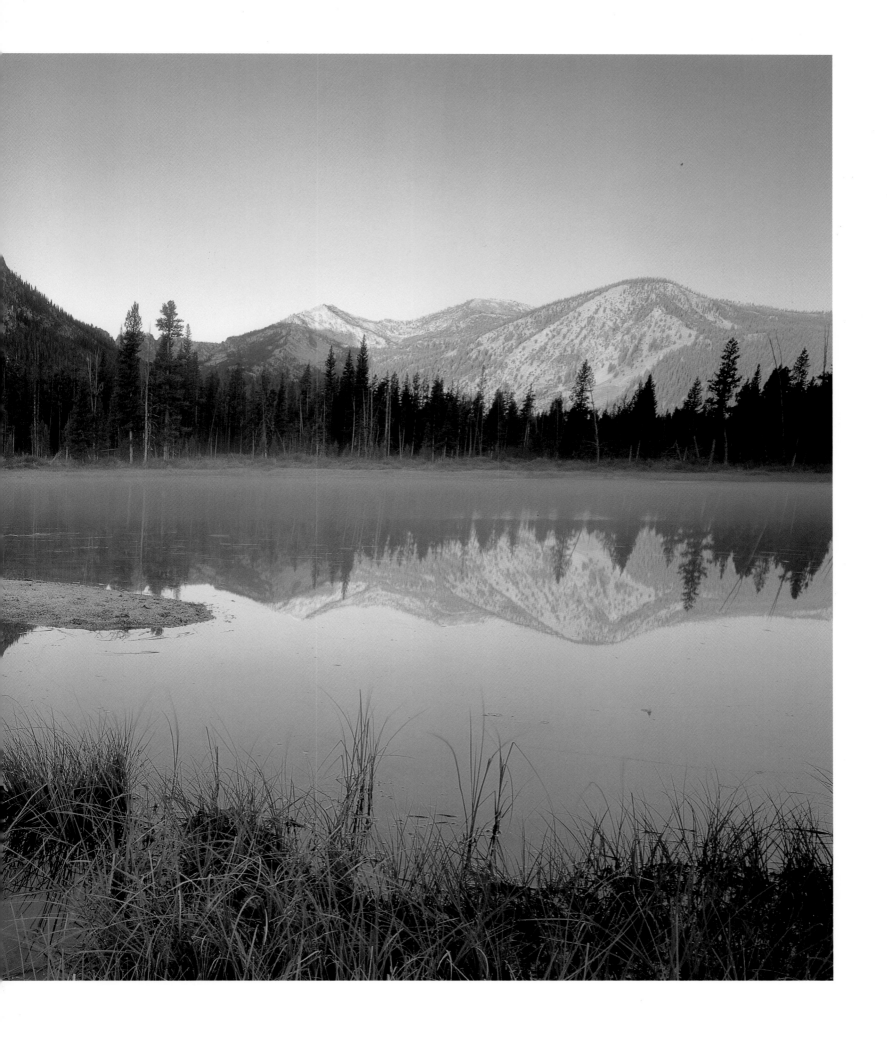

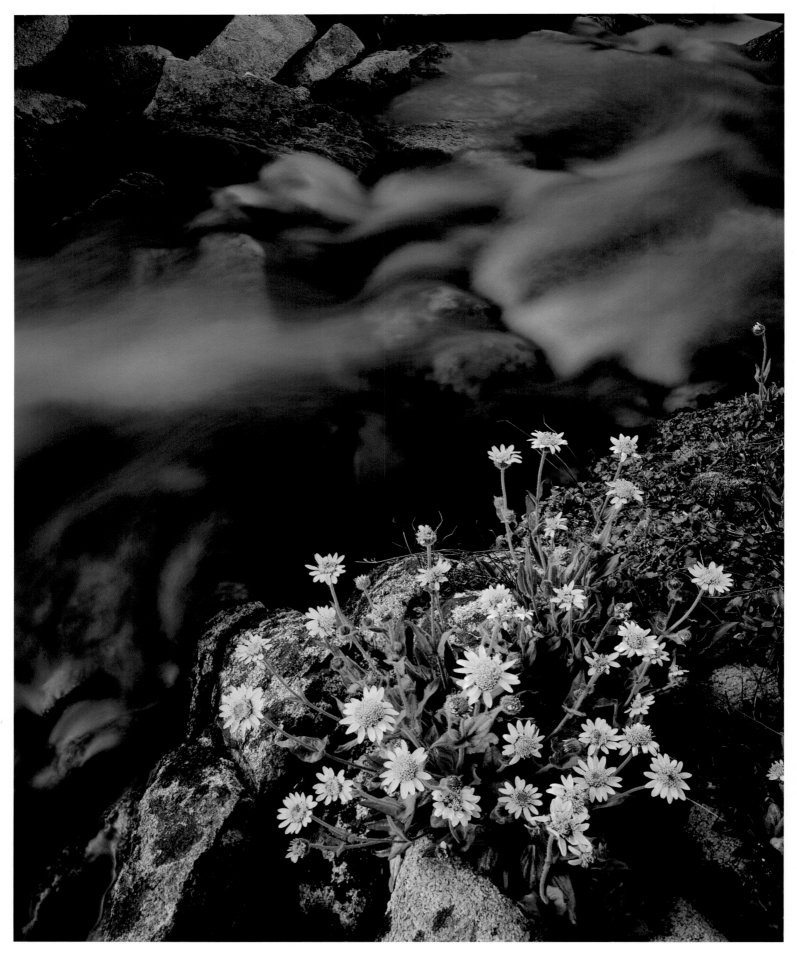

△ Yellow daisies illuminate the border of a little creek pouring out of Sapphire Lake in the White Cloud Mountains. ▷ Castle Peak (elevation 11,815 feet) towers over rocky talus terrain, high above timberline, in the heart of the White Clouds. Shaggy mountain goats and pikas like the serenity afforded by the high basin.

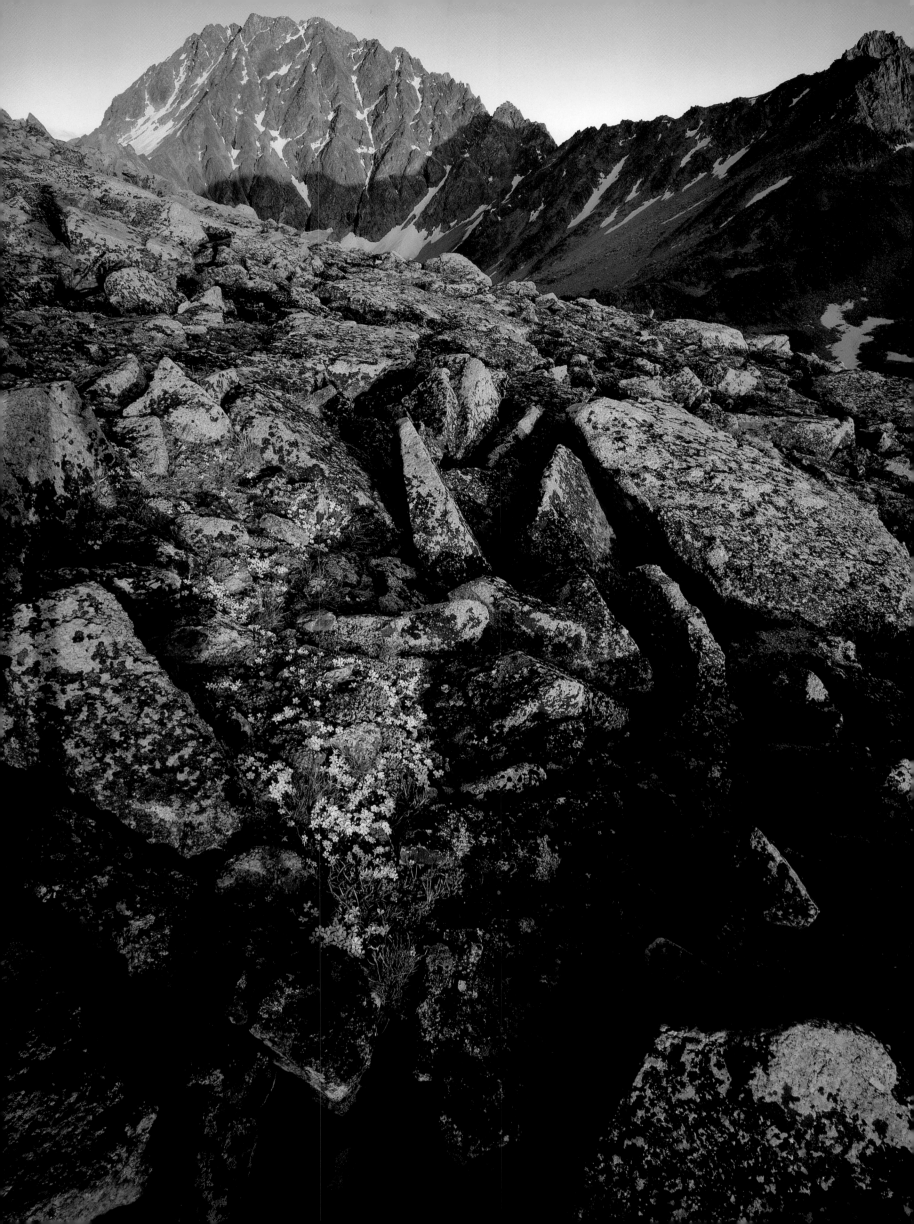

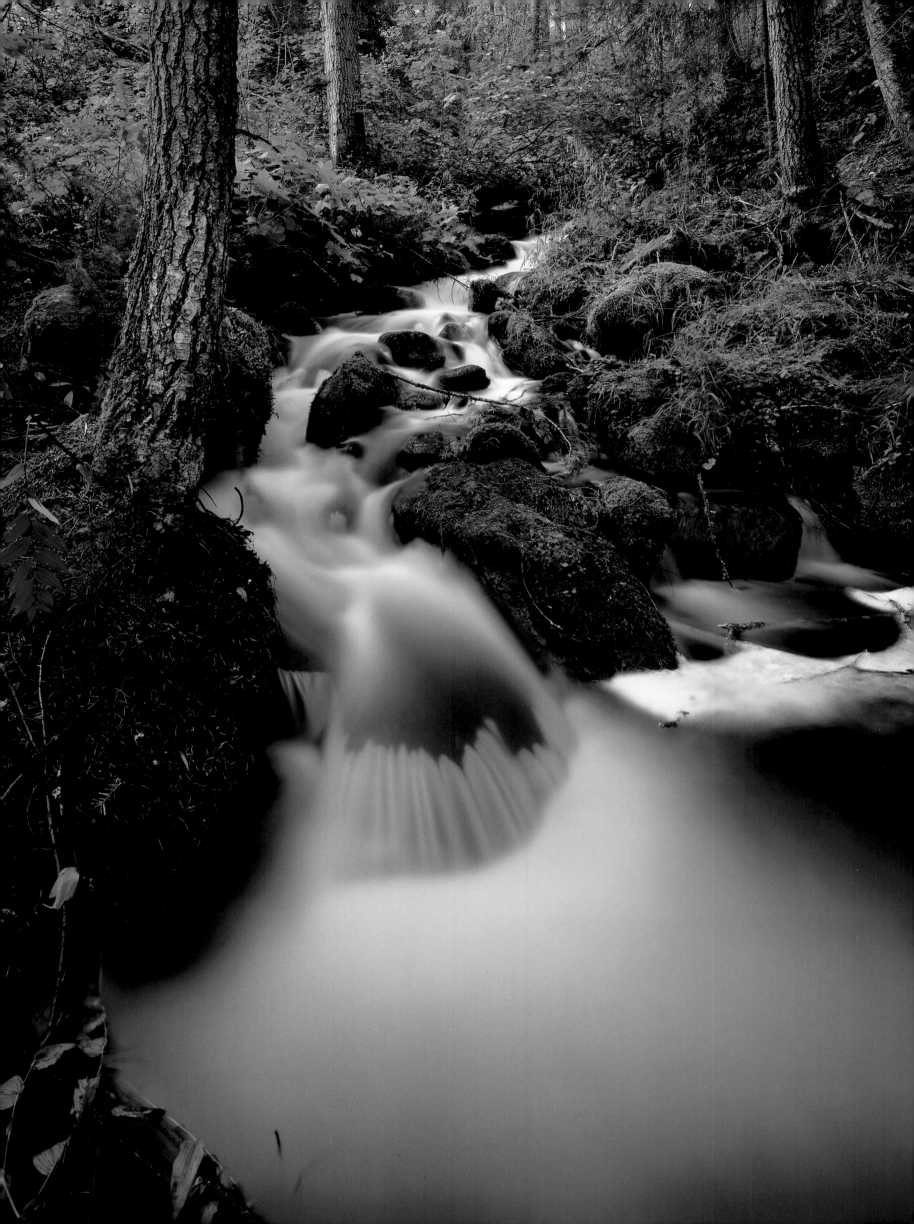

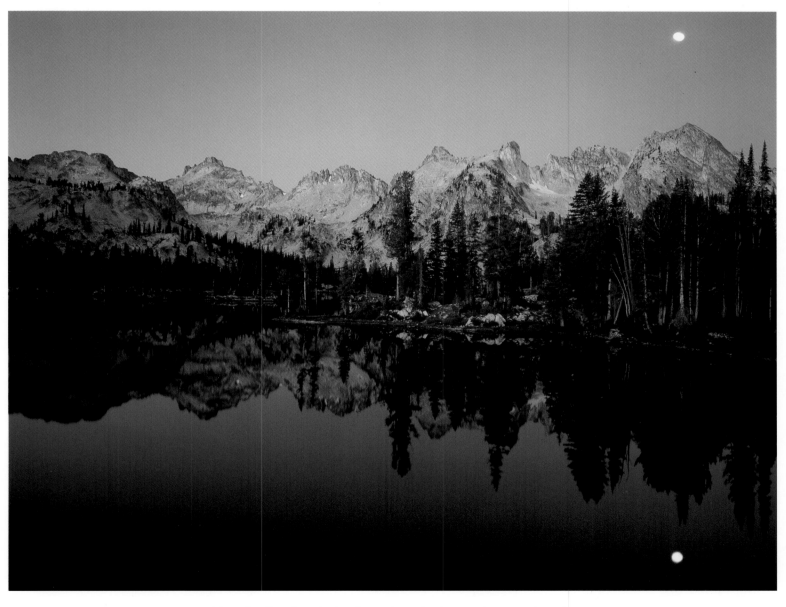

◁ Magpie Creek winds through a lush ponderosa pine forest near the Salmon River in the 2.3-million-acre Frank Church-River of No Return Wilderness. △ A full moon hovers over an amphitheater of peaks that ring Alice Lake in the Sawtooth Wilderness. The highest peak is 9,901-foot El Capitan.

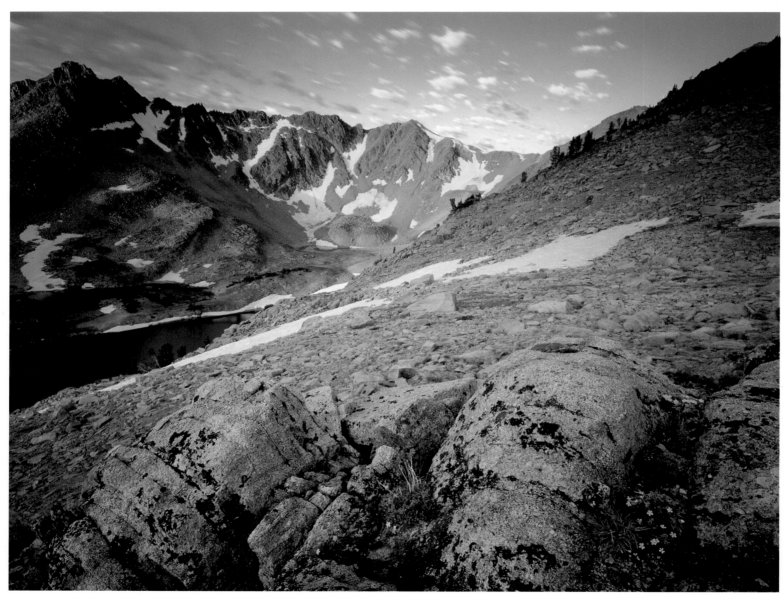

△ Nothing but granite, snow, and ice surround Four Lakes Basin in a secret perch above the more popular Quiet Lake and Noisy Lake in the White Cloud Mountains. ▷ A small creek cuts a swath through a white sandy beach along the Salmon River, exposing the granite bedrock that underpins the basin.

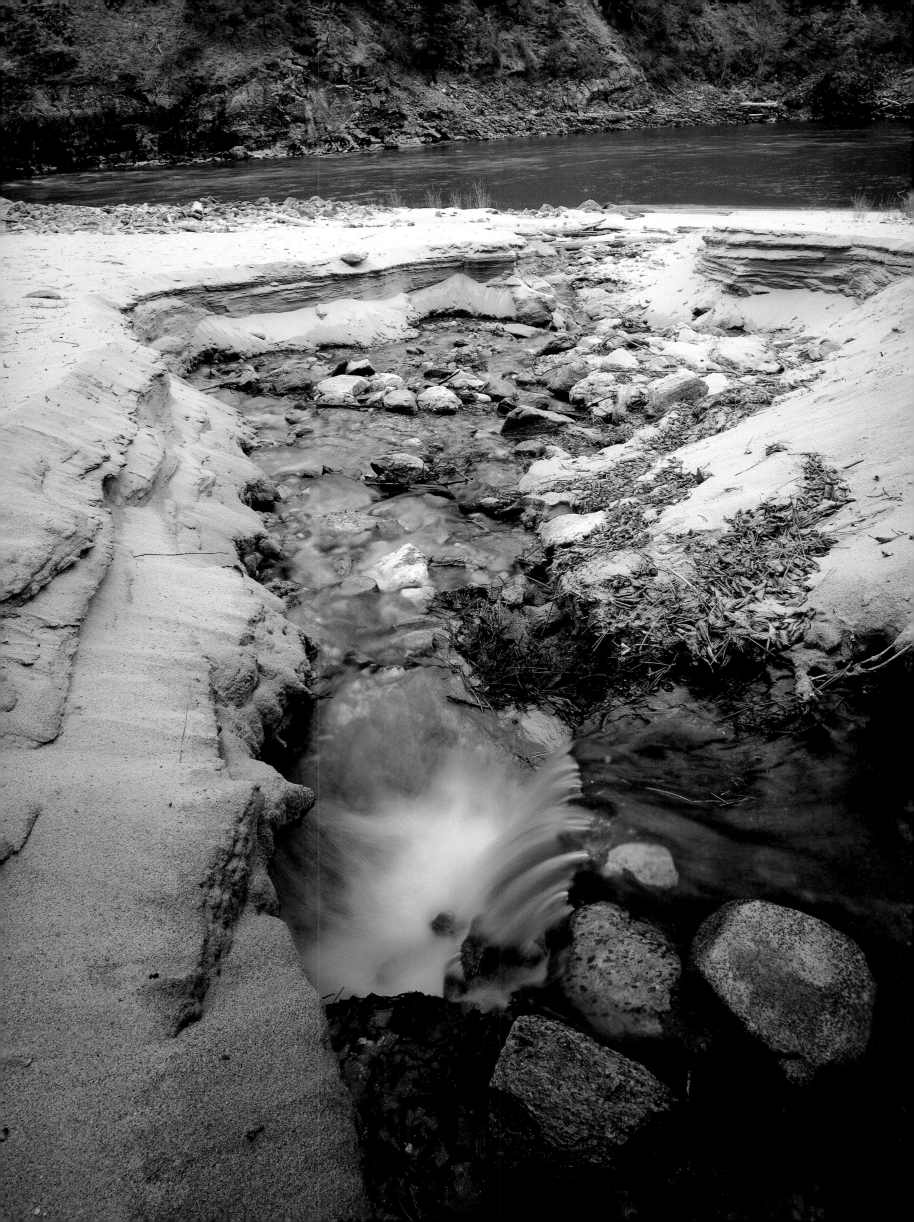

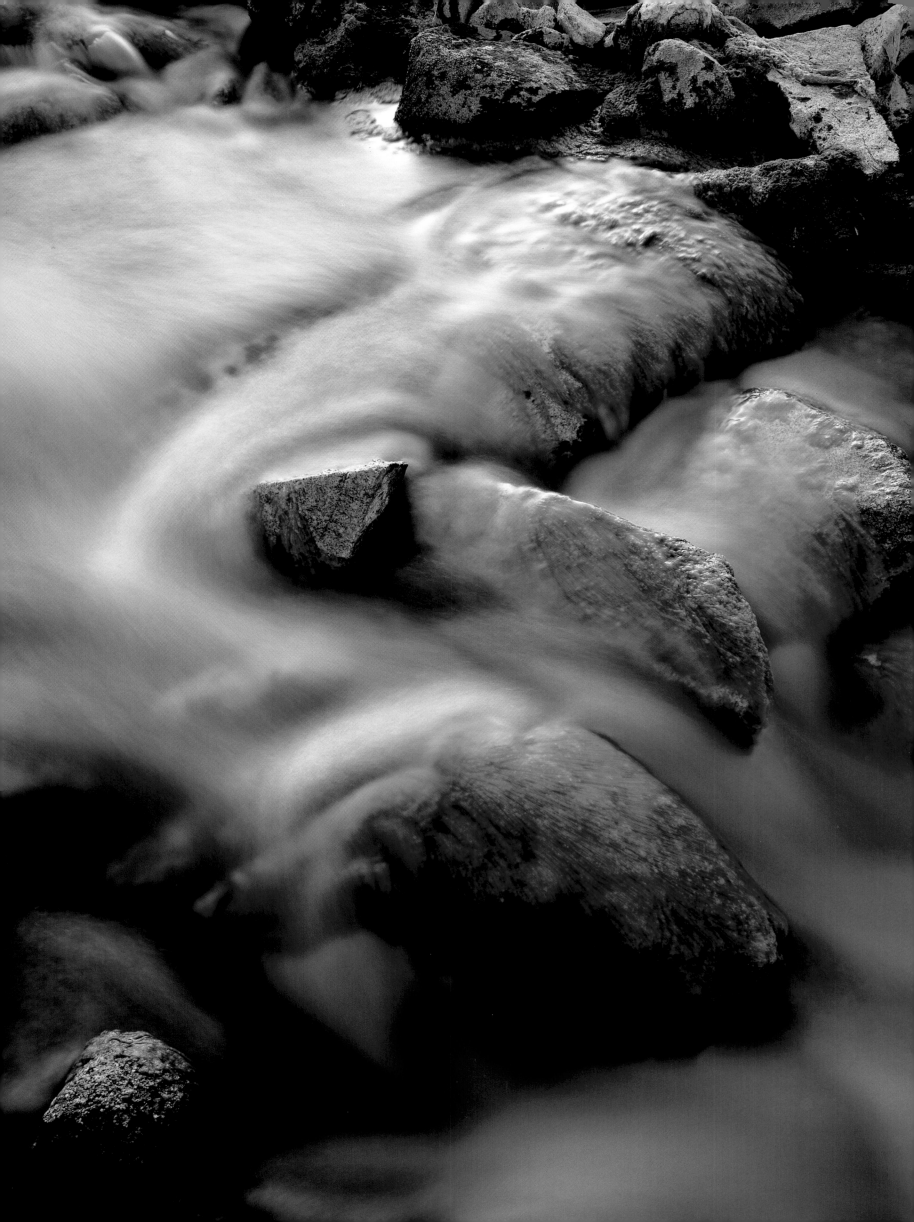

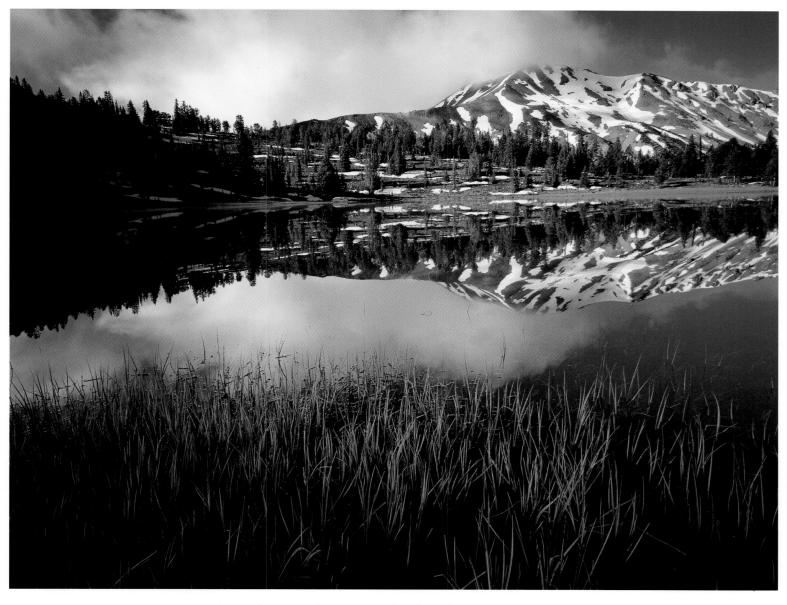

◁ Big Boulder Creek, carrying the flow from a panoply of lakes in Big Boulder Basin, tumbles over moss-covered granite rocks. △ Fresh frost coats grass on the shore of Fourth of July Lake, gateway to a series of high lake basins in the White Cloud Mountains.

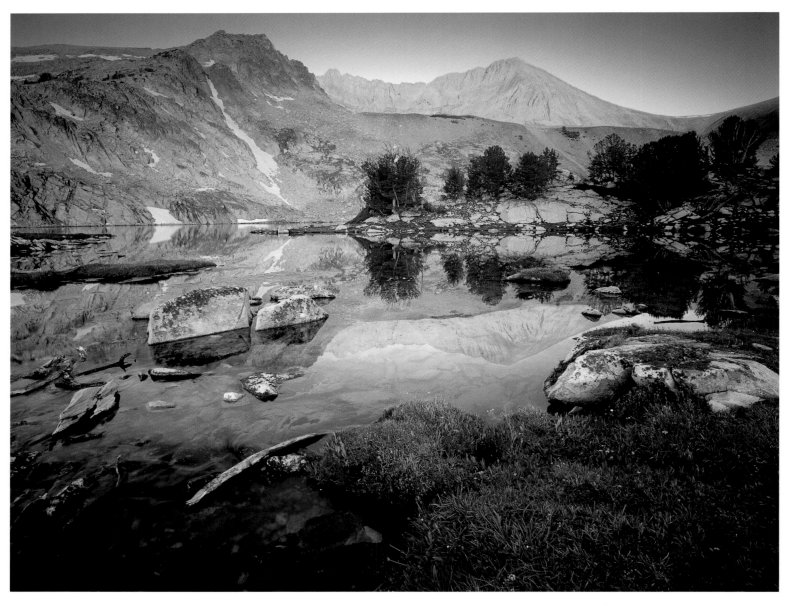

△ The early morning rays from an August sunrise turn an unnamed flank of white granite into bronze above Sapphire Lake.
▷ A small patch of buckwheat grabs a toe-hold in a tiny crevice above the upper Twin Lake in the Sawtooth Wilderness.
▷▷ Little Redfish Lake reflects a frigid October morning scene.

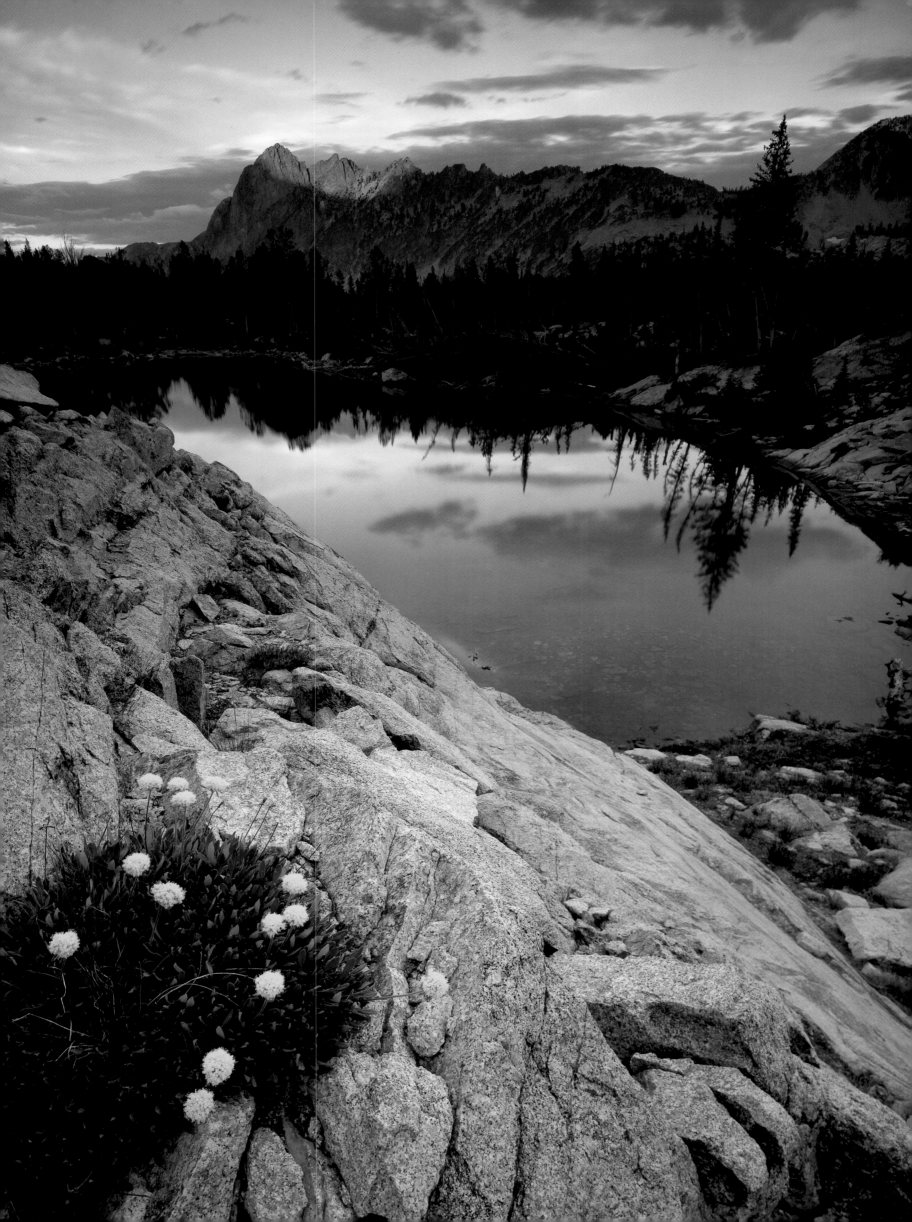

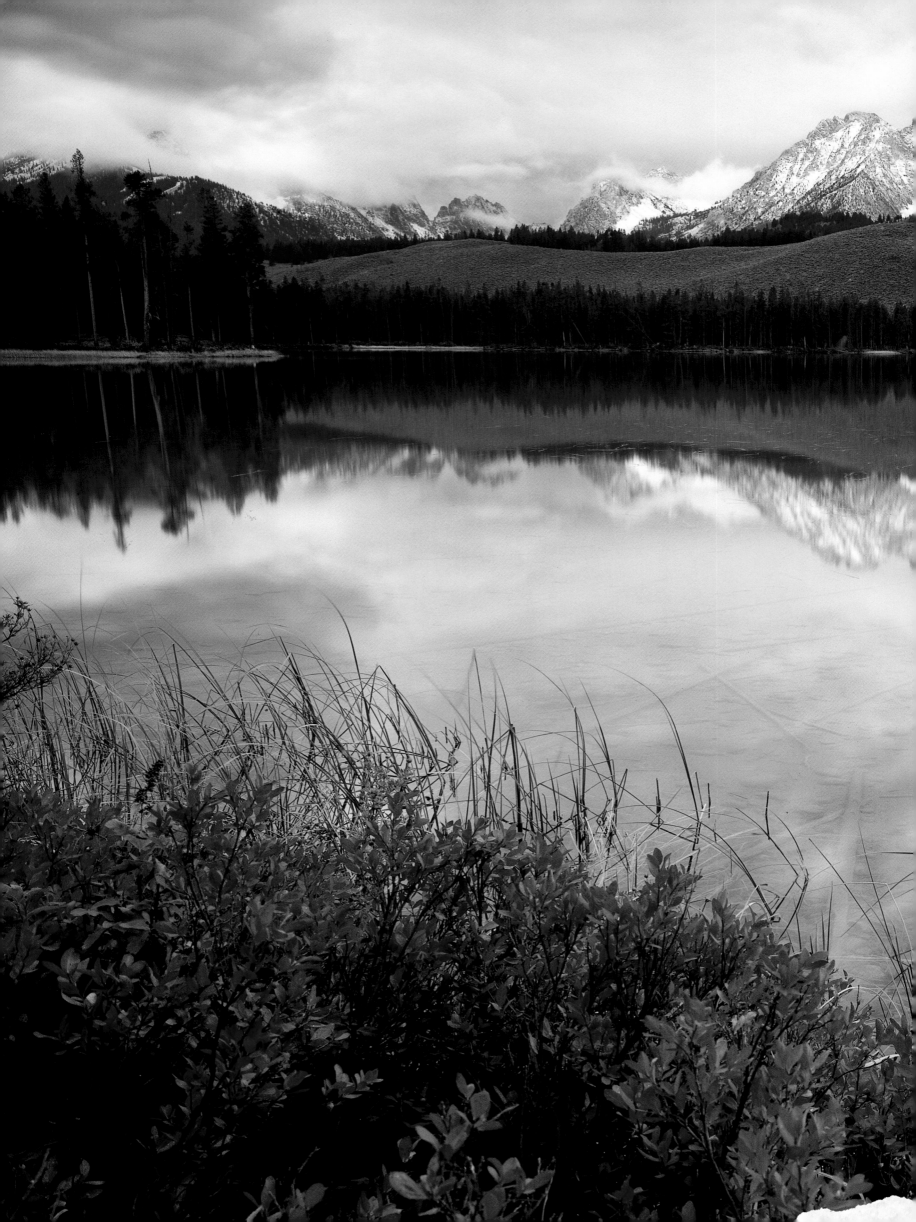

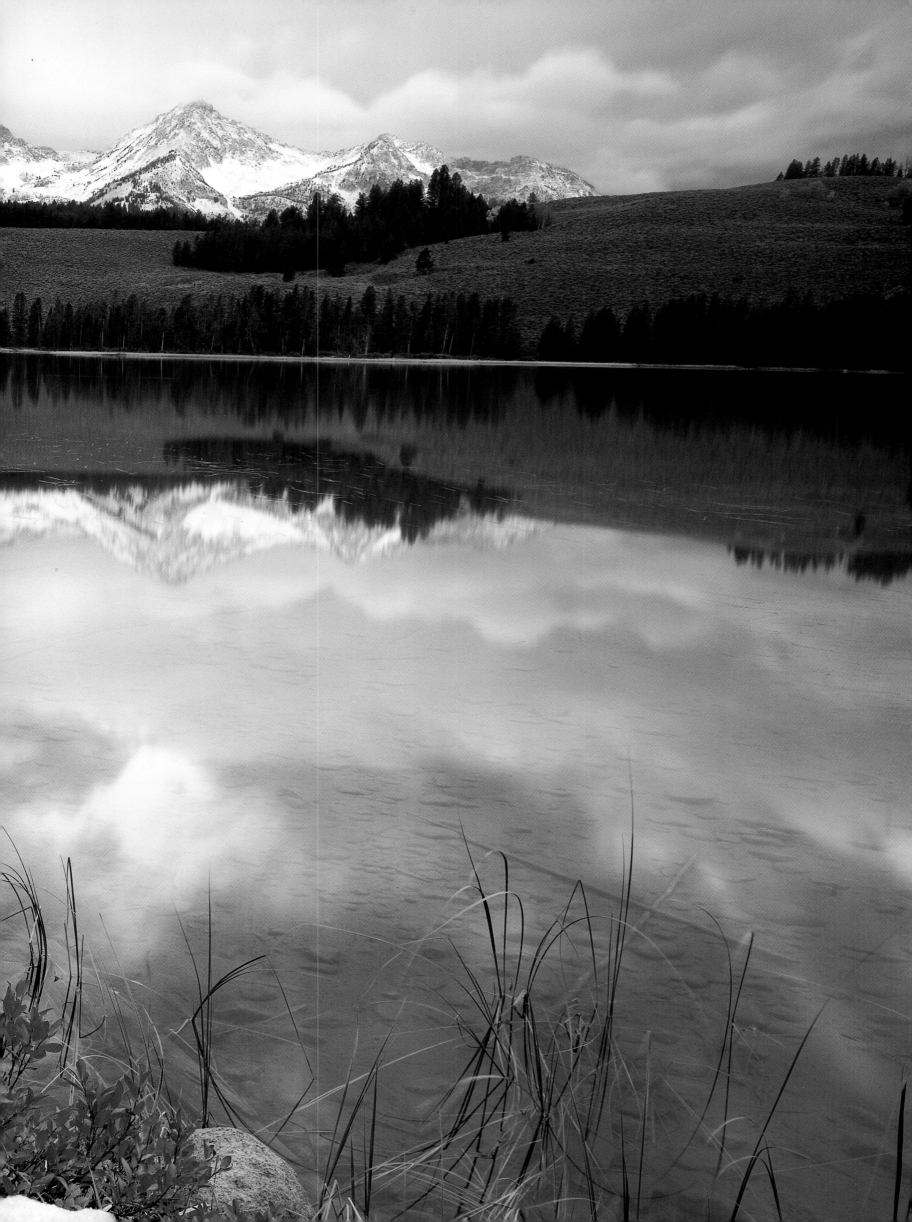

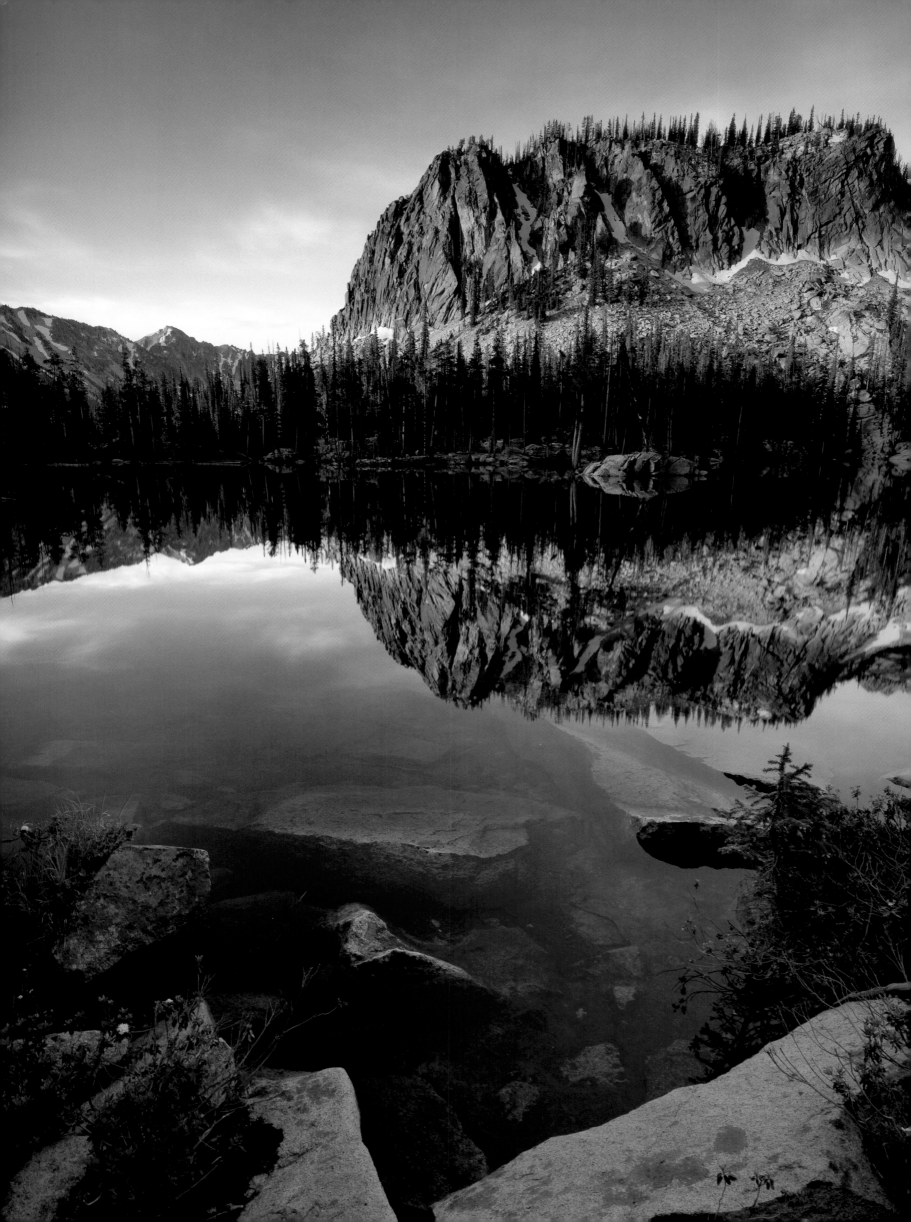

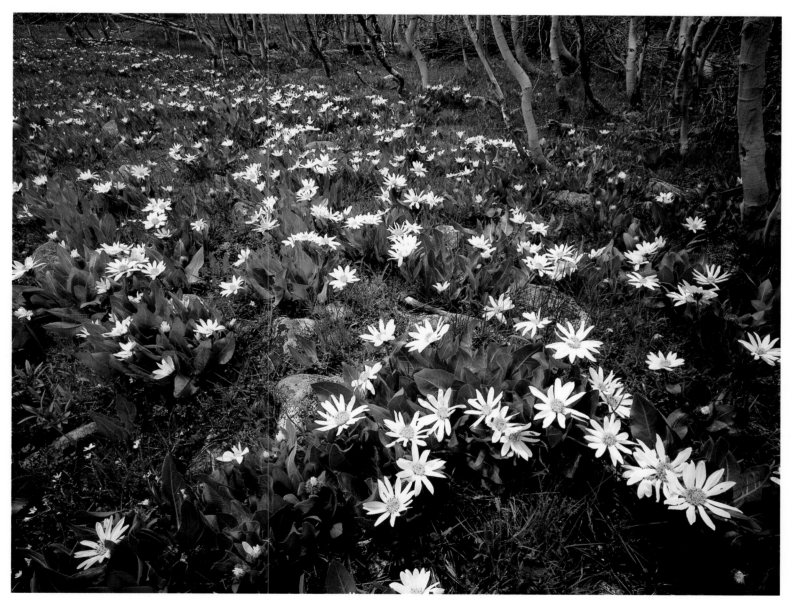

◁ A July sunrise warms up a mountain lake near the Finger of Fate
at the edge of timberline in the Sawtooth Wilderness. △ A robust
stand of wyethia adorns a marshy meadow in the Sawtooth Valley.

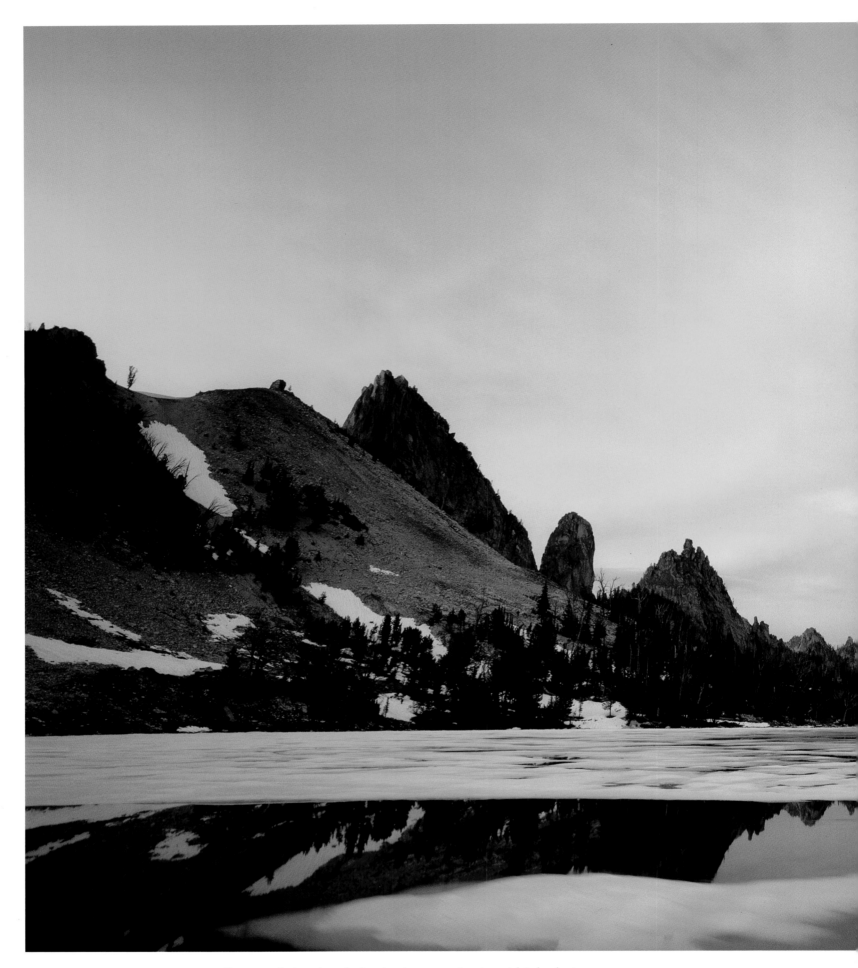

△ Summer is just barely beginning to arrive in mid-July during an alpenglow moment at Harbor Lake in the Big Horn Crags. The backbone of Fish-Fin Ridge reflects in Harbor Lake, named by a Forest Service crew in the 1930s for two rock dikes that extend into the lake, creating the appearance of a natural harbor.

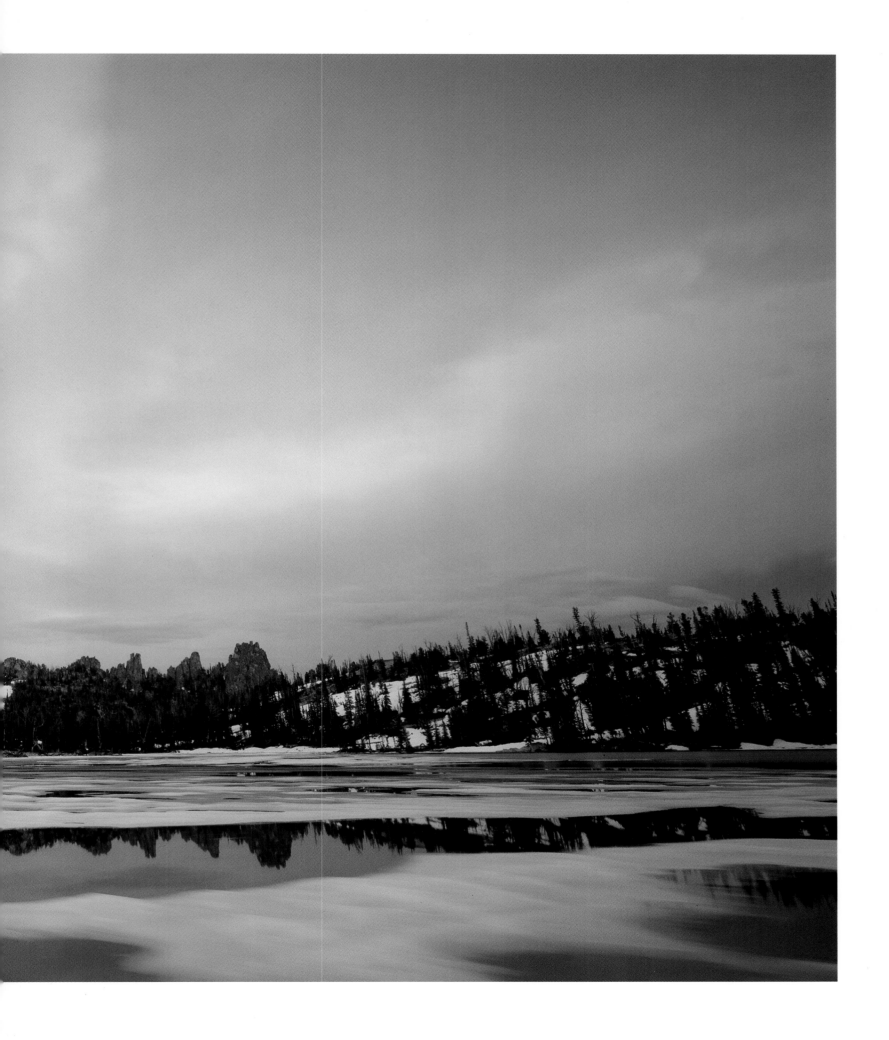

△ False huckleberry hints at the first wave of fall weather in October on the shore of Little Redfish Lake, named for the sockeye salmon that used to spawn there. ▷ Near Fourth of July Creek on the lower flanks of the White Cloud Mountains, aspens begin to exhibit their fall foliage in September.

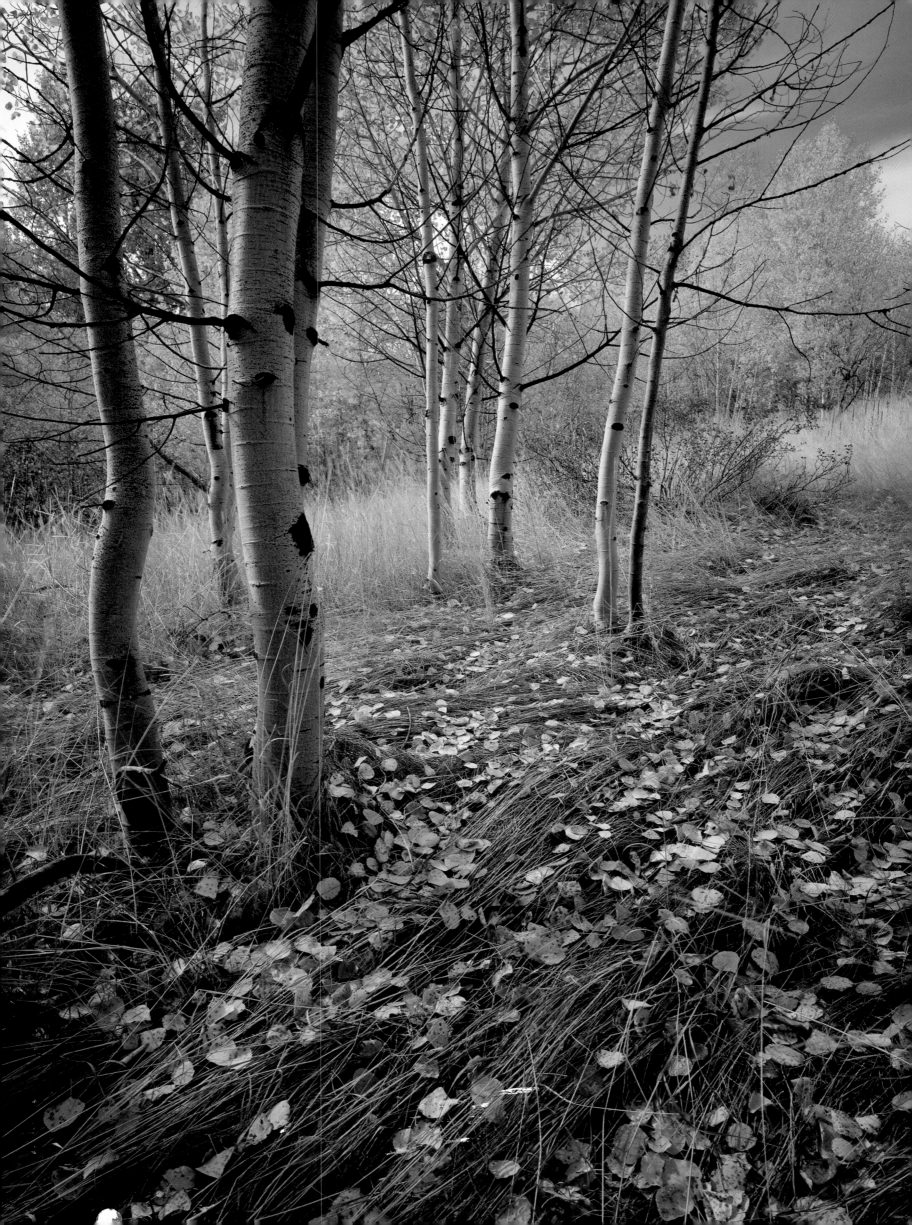

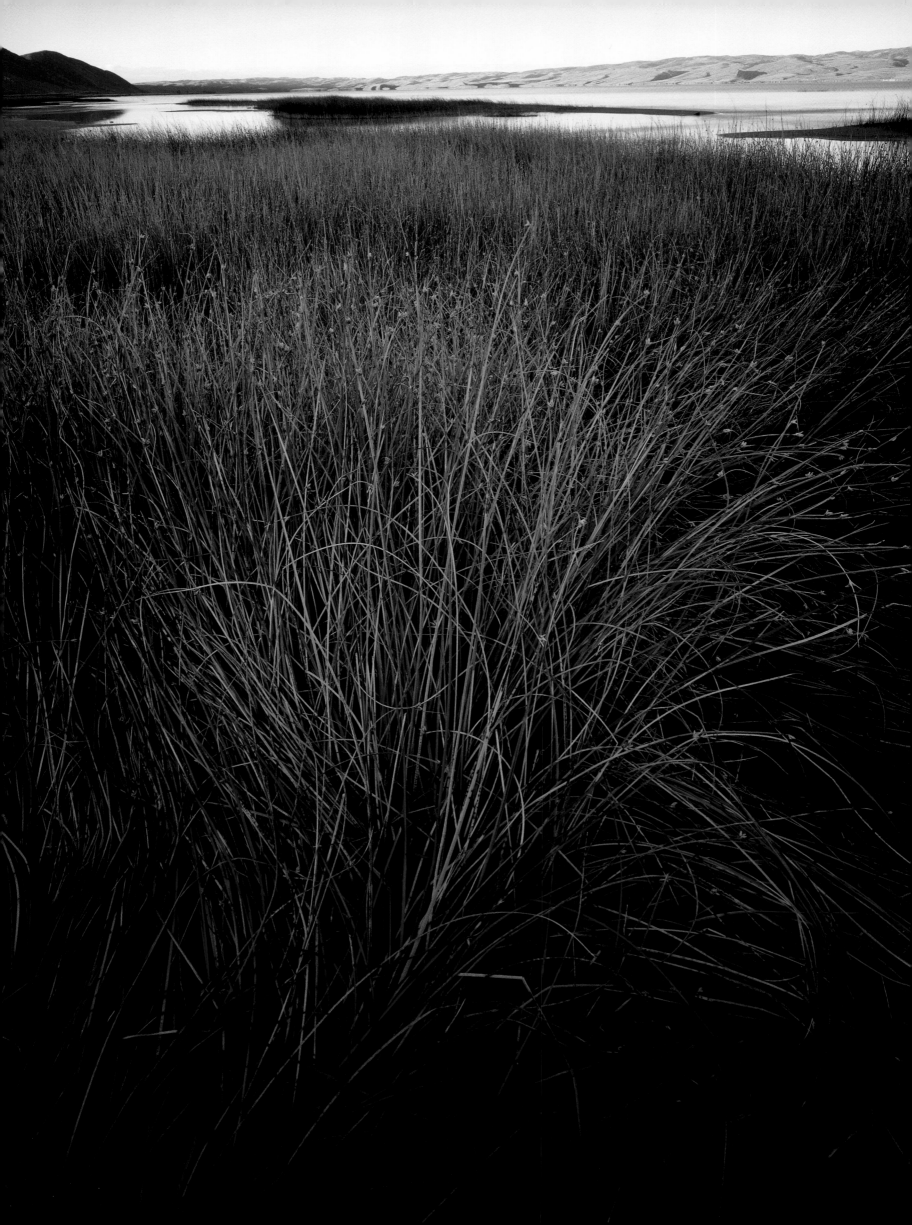

Upper Snake, Bear River

◁ Knee-high grass fills in the
east shoreline of Bear Lake
near Bear Lake State Park.
△ △ Morning dew hangs
on the tips of a fir tree in the
Caribou National Forest.
△ A fly-fisherman angles
from his float tube in an
early morning outing on
Henry's Lake, where hybrid
rainbow trout grow larger
than twenty inches.

Twenty miles west of Yellowstone National Park, the outer crust of the Henry's Fork caldera, an ancient volcanic crater, rises like a circular dish at the boundary of Idaho, Montana, and Wyoming. Every drop of water and every snowflake that falls on the Idaho side drains into the natural bowl formed by the caldera, a big, blue basin of clear water known as Henry's Lake.

In the wee hours of a frosty fall morning, a half hour before sunrise, die-hard fly fishers, draped in a blanket of fog, launch their float-tubes at the north outlet of Henry's Lake. They look goofy, in their rust-colored neoprene waders and black fins, as they awkwardly shuffle down the boat ramp with a wad of fly fishing gear and their bulky float-tubes. All this, just to feel a feisty twenty-five-inch hybrid rainbow make a deep run and zip the fly line off the reel. Zip-zip-zzzzzing!

On the other end of Henry's Lake, a tiny trickle of water courses through the outlet—the birth of the Henry's Fork River. Small clouds of steam rise off the water as the stream enters an expansive valley, where hundreds of cattle graze on lush grass. Snowcapped Sawtell Peak, a hulk of a mountain ninety-five hundred feet above sea level, is a signature icon to the west. The Henry's Lake Mountains form an impressive upslope sweep to the east and north. The two ranges frame a classic mountain valley welcoming travelers to the splendor of Henry's Fork Basin.

The legendary Henry's Fork does not become a river, *the* river known by die-hard anglers throughout the world, until it picks up a gushing natural spring, known simply as Big Springs, above Mack's Inn. One of the forty largest springs in the nation, Big Springs spouts 120,000,000 gallons of water every day, at a constant fifty-two degrees. The water bubbles from the earth with pristine purity in the thick timberland on the edge of the Targhee National Forest. At a wooden walk bridge just below the springs, people gawk at the beautiful water, the small obsidian pebbles in the riverbed, and the bright green aquatic plants that bend and wave with the current. Below Big Springs, the nutrient-rich Henry's Fork River winds through Island Park to Harriman Park and Millionaire's Hole, a prime fly fishing spot with fetching views of the Tetons. Even if you're not a millionaire, you may feel like one in this storybook setting.

In the opposite corner of southeast Idaho, a pebble's throw from the Utah and Wyoming borders, another lovely lake shimmers in the evening light. A lone motorboat carrying bait fishermen cuts a V-shaped ripple through Bear Lake as it heads into Fish Haven on the eastern shore. The color of Bear Lake is striking—an emerald green that brings to mind images of the Caribbean. But there's no salt in this twenty-mile-long lake, just a ton of soft, white sand, waiting to sift through your toes.

Hinting at the cultural and geologic history of the Bear River Basin, half of Bear Lake fits inside the Utah state line, the other half inside Idaho. Geologists postulate that, in a geologic quirk, the Bear River's course was pushed into Utah by basalt lava-flows six hundred thousand years ago. The Bear used to drain into the Snake by way of the Portneuf River near Lava Hot Springs. By quirk or by design, the course of the Bear River says much about this corner of Idaho, where the Utah influence is heavy, both from a cultural and a landscape point of view.

In the mid-1800s, Brigham Young sent some of the first Mormon followers into the Bear Lake and Bear River region to establish the first white settlements in Idaho. Franklin Richards, a Mormon pioneer, staked out the first township in Idaho in April of 1860, two years before transient miners struck gold near Idaho City and Florence. The hard-working Mormons single-handedly civilized this corner of the state by doing what they did best—farming. Historians note, however, that the

Mormons became Idaho pioneers by mistake, the result of a surveying blunder. Folks like Richards had intended to settle their townships in northern Utah. The Utah legislature even incorporated Franklin as a Utah town in 1868. But when a federal surveyor came through in the early 1870s, he informed the Mormons that the town was located inside Idaho. It was a momentary blow but, as a result, the Mormons established a population base in Idaho that remains strong to this day. Census surveys indicate that more than 90 percent of the residents in Malad City, Soda Springs, Montpelier, and Rexburg are adherents of the Mormon faith.

In the upper tiers of eastern Idaho, the main trunk of the Snake River, commonly known as the south fork, pours into Palisades Reservoir at the Wyoming border. Below Palisades Dam, the south fork cuts an impressive, incised canyon from Swan Falls to Heise. Born at the southern end of Yellowstone National Park, the Snake drains the eastern face of the mighty Tetons before it cruises by Jackson Hole and bends into Idaho. The river is strikingly pure, nutrient-rich, and cold in the south fork reach. It supports thrifty runs of Yellowstone fine-spotted cutthroat trout, beefy brown trout, rainbow trout, and white-fish. No matter if the fish are biting, a float trip on the south fork is always a relaxing and exciting experience because it's like a visit to a wildlife park. More than a dozen pairs of bald eagles reside in the canyon year-round. The majestic birds perch on the highest branches of old-growth black cottonwood trees and search the south fork's cobalt-clear water for a fresh meal. Ospreys, peregrine falcons, white pelicans, golden eagles, and red-tailed hawks also are frequently seen on the south fork, along with one of the higher densities of songbird populations on any western river. Big bull moose are regular visitors to the grassy banks of the south fork, too.

To hike above the south fork canyon provides polychromatic views of a fascinating transition zone from thick forests in the Palisades mountain range, past the south fork's cottonwood-lined basalt canyon, to yellow rapeseed fields and aspen groves on the rolling uplands to the south. From a low peak, maybe one thousand feet above the river, the south fork canyon looks like a wide crack in the earth, with the silvery peaks of the Palisades above, and verdant farmland below. As the sun drops lower in the sky, the shadows of rump-like foothills grow longer, and the colors take on a warm and vivid feeling.

Great fishing, tourism, and the Mormon church are not the only common elements that knit together southeast Idaho. In the early 1800s, British and French-Canadian fur trappers found a bounty of beaver and wild game throughout the region. Andrew Henry of the Missouri Fur Company landed by happenstance in the Henry's Fork Basin while fleeing the Blackfeet. He established one of the first trading centers in the West, in 1810, at Fort Henry, near present-day St. Anthony. When Donald MacKenzie of the Hudson's Bay Company first visited the Bear Lake region in 1818, he named it Black Bear Lake and Black Bear River for the abundance of black bear. In the heyday of the beaver-trapping era, mountain men held wild gatherings for trading, boozing, womanizing, and fighting, in both corners of eastern Idaho and over the hill in Jackson Hole.

A terrifying knife battle between two angry mountain men couldn't begin to compare to the violent geologic events that shaped southeast Idaho. More than two million years ago, a major volcano erupted from a giant crater in the Henry's Fork region. The eruption spewed rhyolite lava and ash into the sky in copious quantities for several days, blanketing six thousand square miles. It was the first of several volcanic eruptions in the region that would mold the landscape of the Henry's Fork Basin and Yellowstone National Park. A second volcano, which issued forth from the Henry's Fork caldera 1.2 million years ago, laid down towering piles of ash in the location of Upper and Mesa Falls. After the Pleistocene age, when the Henry's Fork River began to carve its path toward Island Park, it eroded the two-tiered falls, which now plunge a combined length of 176 feet in a quarter-mile. In the Henry's Fork Basin today, the violence of early geologic events has been erased, and tranquil forests and pure waters remain.

The Wasatch, Caribou, Black Pine, and Portneuf mountains developed over many millions of years as "basin and range" mountain blocks. They overlie a larger geologic feature known as the Overthrust Belt, which extends into Wyoming and Utah. These mountains of old sedimentary rock rose from the earth's crust in parallel fashion, all trending northwest, coinciding with fault lines in the valley bottoms. More recent basalt lava-flows formed box-like canyons along creeks and rivers. Natural mineral springs, hot springs, and geysers also play a prominent role in the region. Geologists attribute the high density of springs in the region to the abundance of faults—deep fissures in the earth's crust. When water trickles into the fissures, it falls toward the earth's molten core, where it heats up and then shoots back to the surface as hot springs or, in rare cases, as a geyser. Soda Springs in Caribou County is noteworthy for its carbonated springs, which form travertine terraces and pools, and its man-induced geyser, which erupts as regularly as Old Faithful. Travelers on the Oregon Trail made it a point to stop at Soda Springs to soak in the hot springs.

In the 1950s, the Monsanto Company opened a plant to process elemental phosphorous—used as a fire retardant and in the herbicide *Roundup*—and phosphoric acid, an ingredient in *Coca-Cola*. With about six hundred jobs, Monsanto is the area's largest private employer. Mines in eastern Idaho and western Wyoming feed the plant from one of the nation's largest phosphate reserves.

Another singular geologic feature, the City of Rocks, near Oakley, is a national reserve and historic landmark commonly visited by rock climbers today. In pioneer times, it was a major junction point for wagon trains heading from Salt Lake to Oregon via the Kelton Road, and for emigrants bound for California on the California Trail. Many travelers painted their initials with axle grease on "Register Rock"—pioneer graffiti that still can be observed today. Two dwarf-like granite peaks—The Twin Sisters—are signature icons in the City of Rocks. Though the peaks stand side by side, one sister is two-and-a-half billion years old—ancient, as rocks go—while the other rose from the earth's crust a mere twenty-five million years ago.

Life in quiet southeast Idaho today belies the tumult that shook the land in earlier times. Agriculture, tourism, and mining are key economic mainstays. In the summer, Idaho and Utah residents flock to Bear Lake—the only sizeable body of water for miles—to camp, fish, waterski, and drink raspberry shakes from local berries. Every fall, hunters stalk mule deer in the colorful mountains nearby. On the fertile land bordering the Bear River, farmers raise hay, grain, dairy cows and mink. Cattle ranching and growing hay are the main agricultural pur-suits in the Henry's Fork Basin, while the tourists focus on viewing wildlife in Harriman State Park, fishing, hunting and all kinds of outdoor recreation in the Targhee forest.

The mix of tourism and agriculture gives a tranquil feeling to the pastoral setting of eastern Idaho, a coexistence as smooth as the glass-like surface of Henry's Lake on a still morning.

> ▷ *Quaking aspen fills the draws and lower slopes*
> *of the Targhee and Caribou National Forests.*

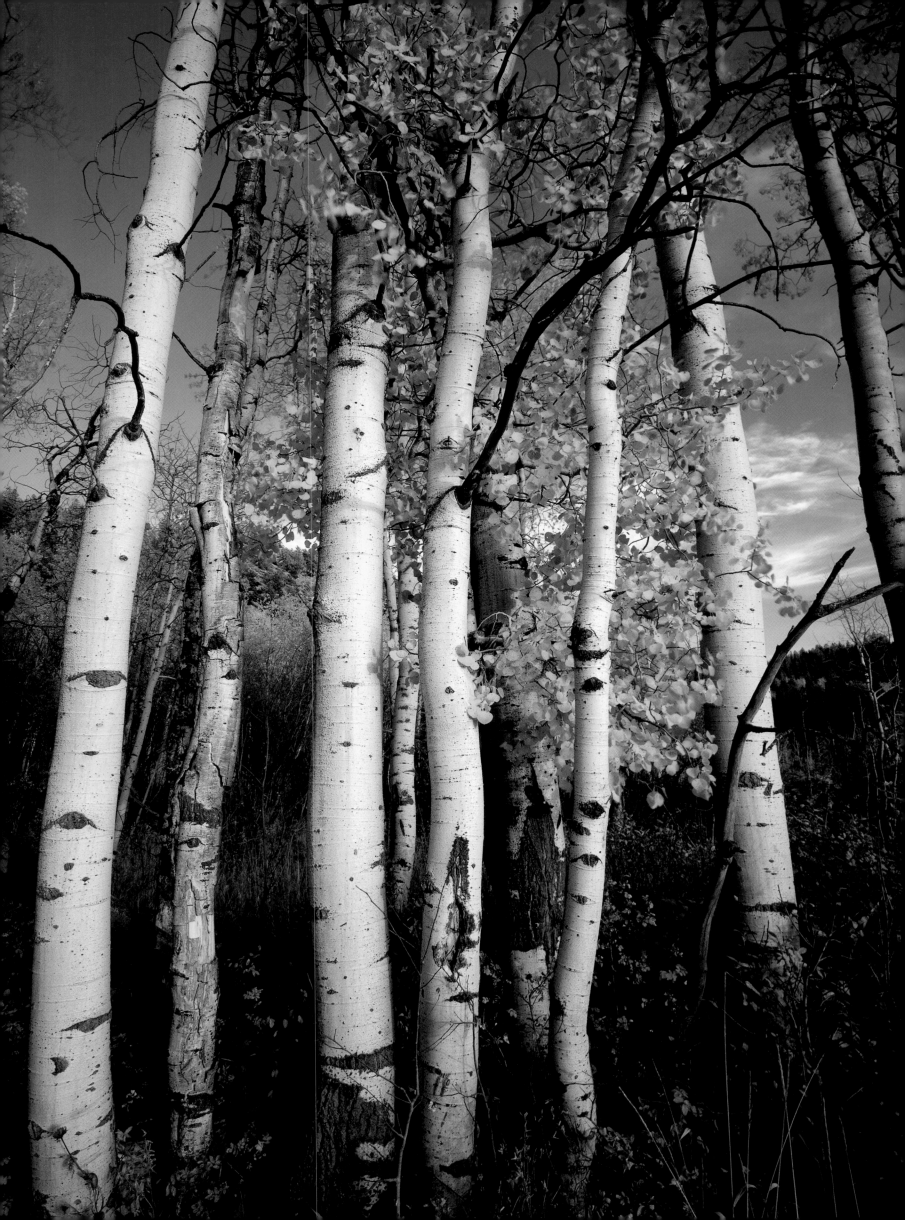

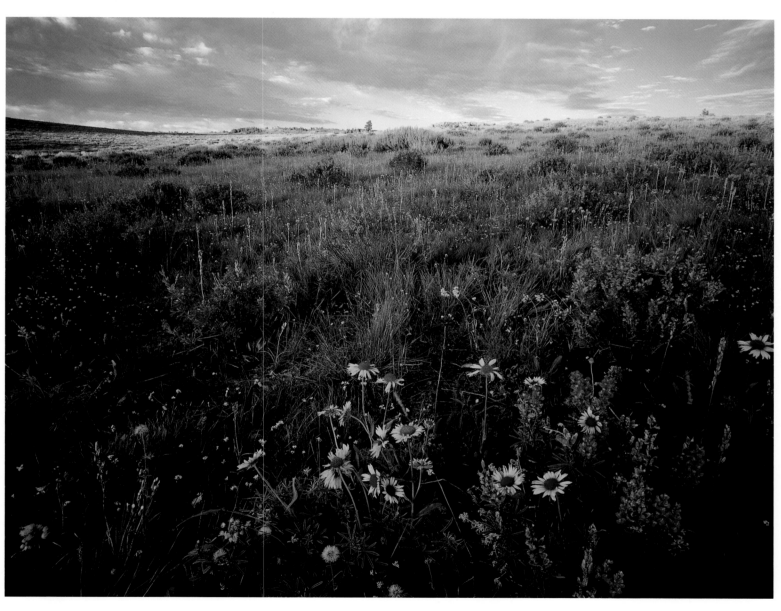

◁ In early fall in the Caribou National Forest, big-toothed maples turn whole mountainsides flaming red. △ This wind-swept meadow nearly hides the fact that the Continental Divide crosses here.

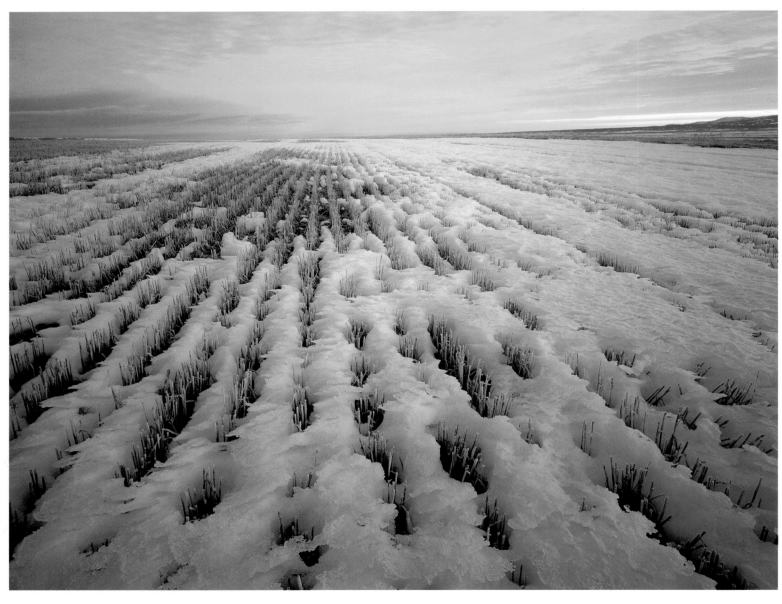

△ At six-thousand-feet elevation, near Driggs, a winter sunrise colors the upper Teton Basin. A short growing season limits farming in the valley to grain and potatoes. ▷ The Saint Anthony Dunes were formed by winds from the south that blew silt and sand into a massive bank of dunes extending for thirty miles in eastern Idaho.

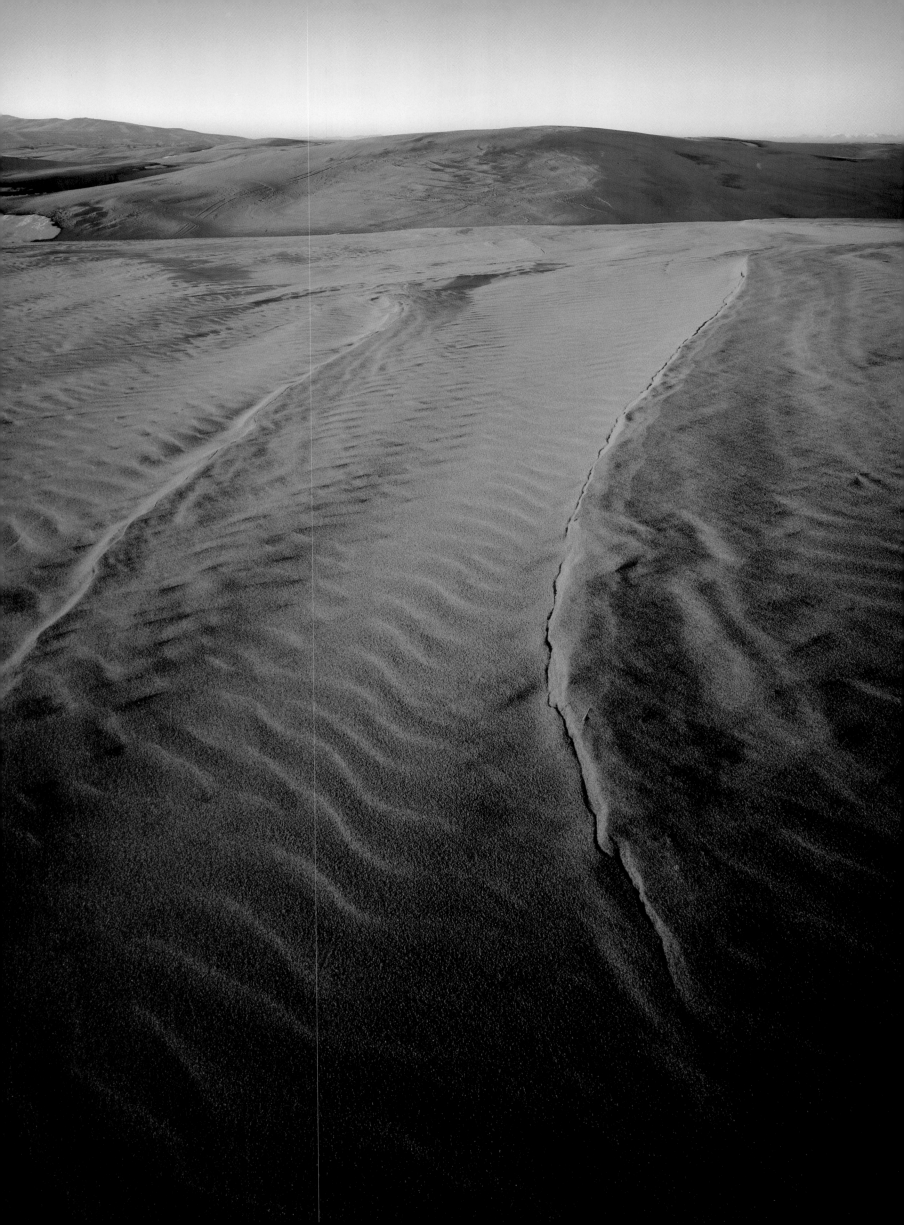

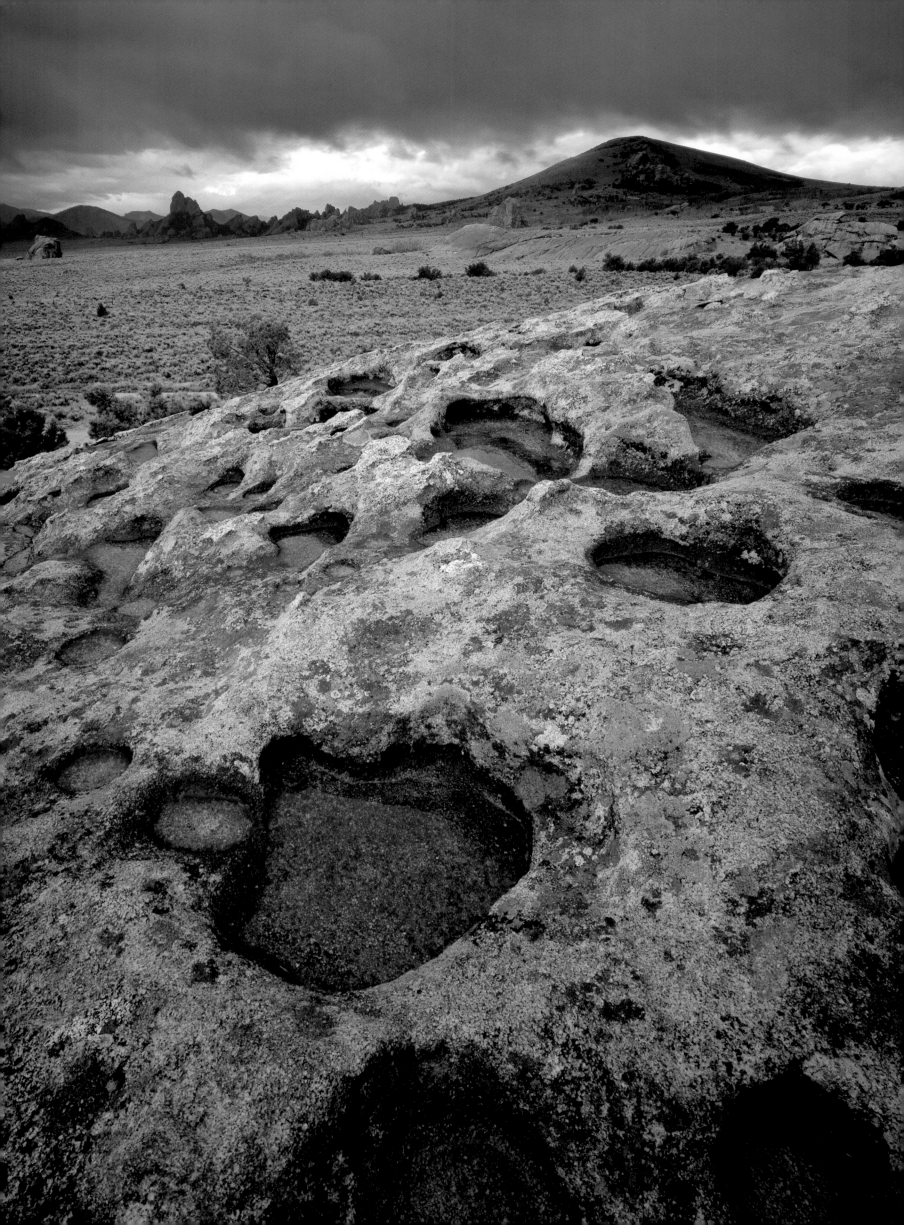

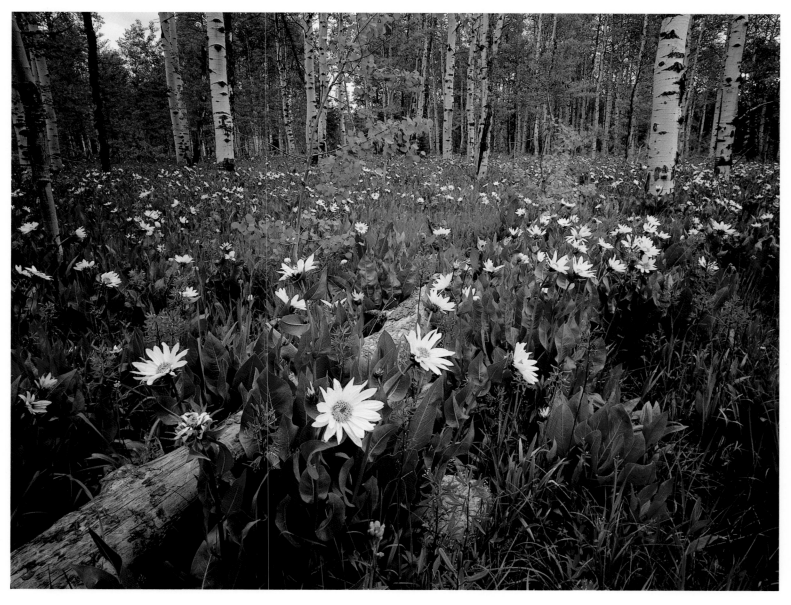

◁ The City of Rocks is a unique geologic formation that attracts the best rock climbers in the nation to this remote corner of Idaho.
△ Summer comes late to Island Park in the upper Henry's Fork Basin, but when it springs, a rich variety of flowers, such as these wyethia and camas, bloom with a vengeance.

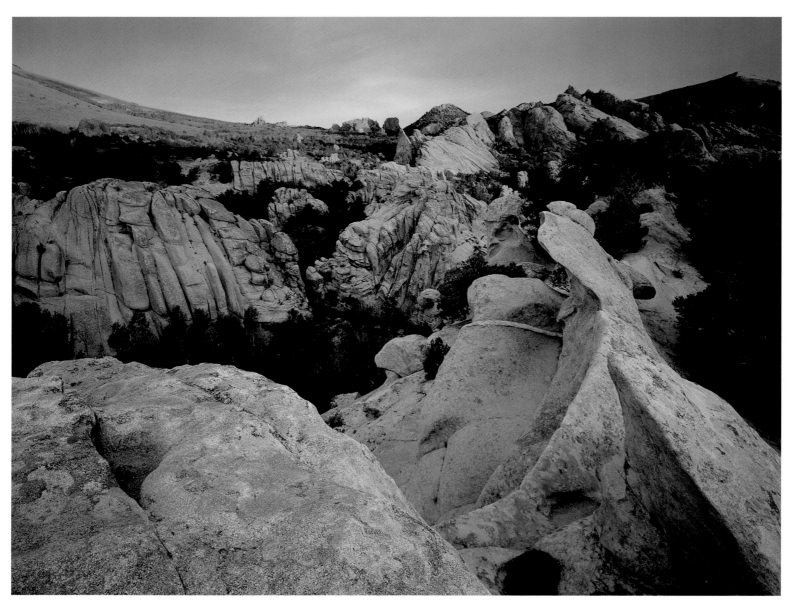

△ In the 1860s, the City of Rocks must have provided inspiration to California Trail emigrants because many of them paused to inscribe their initials in the granite with axle grease.

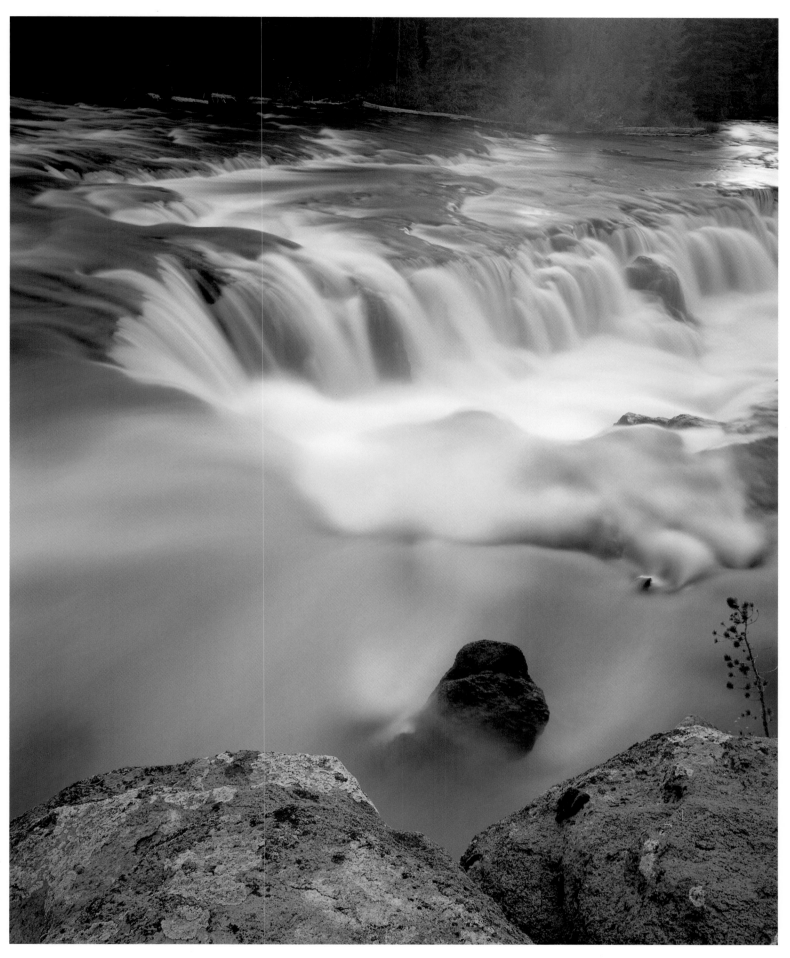

△ Sheep Falls is a rare cataract on the mostly smooth Warm River, a tributary of the Henry's Fork. The fifteen-foot falls pour evenly over the shelf-like mantle in the river.

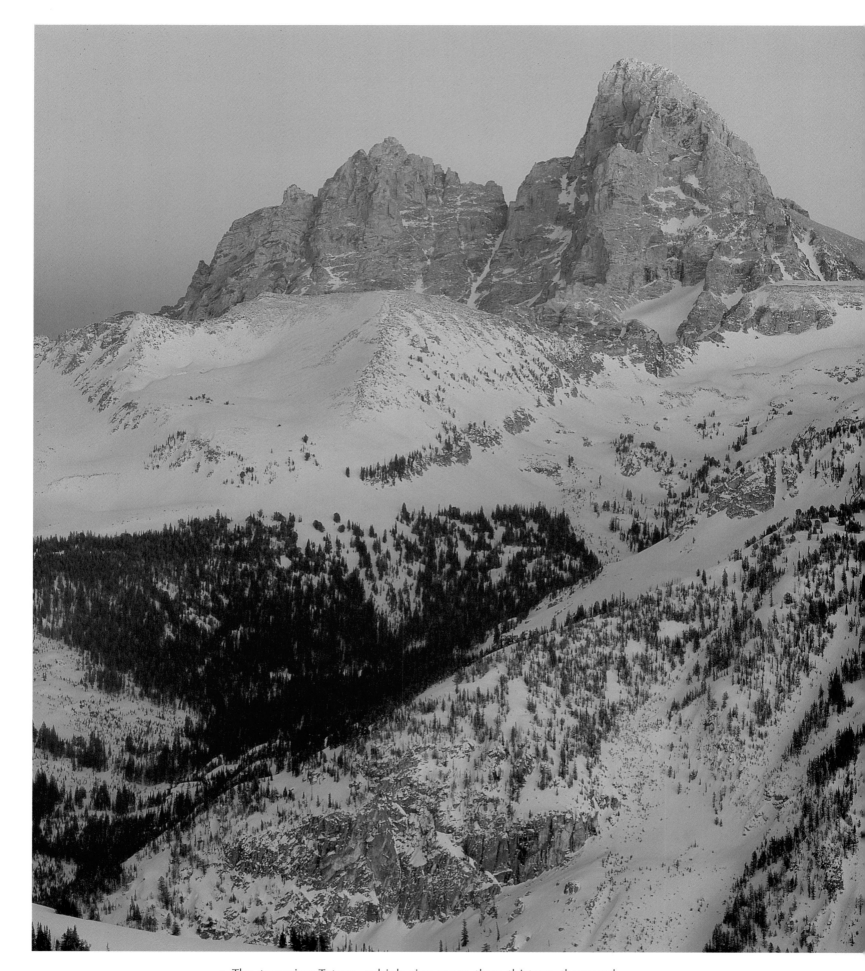

△ The towering Tetons, which rise more than thirteen thousand feet above sea level, actually rest in Wyoming. But eastern Idahoans, who seemingly can reach out and touch them from their farms in Ashton or the mountains in Island Park, quite naturally claim the west-facing view as their own.

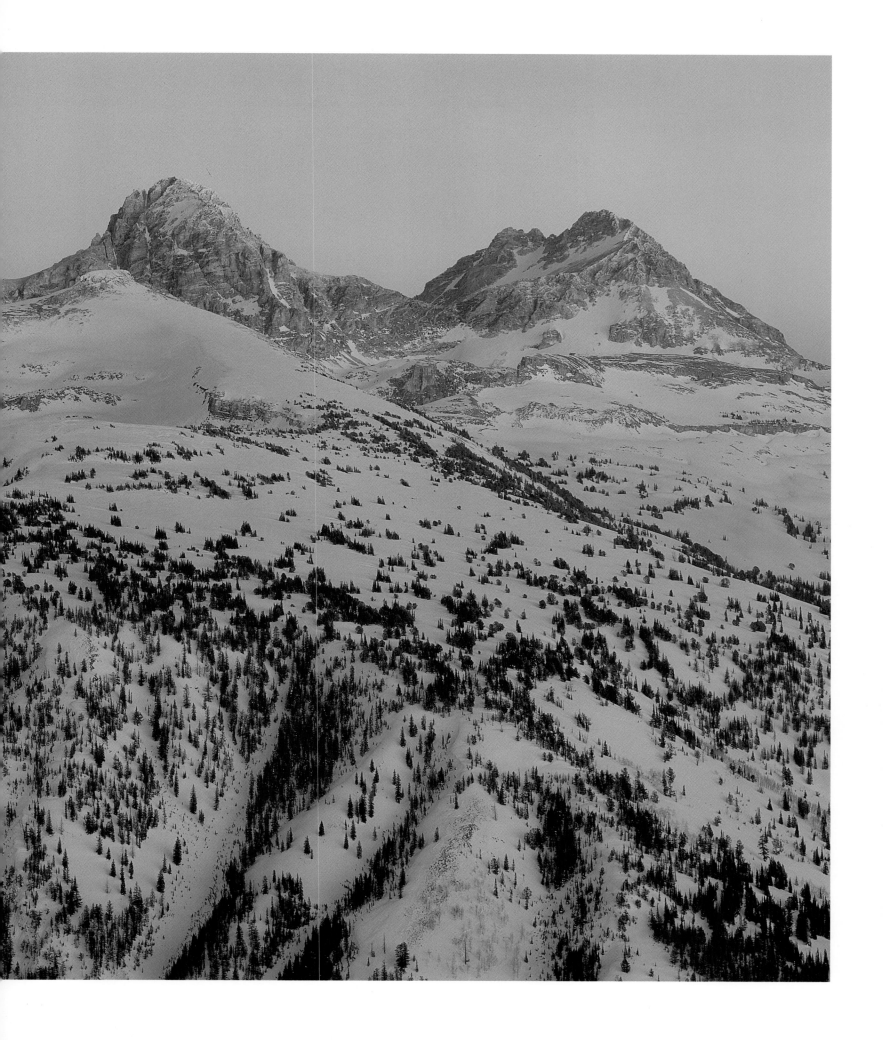

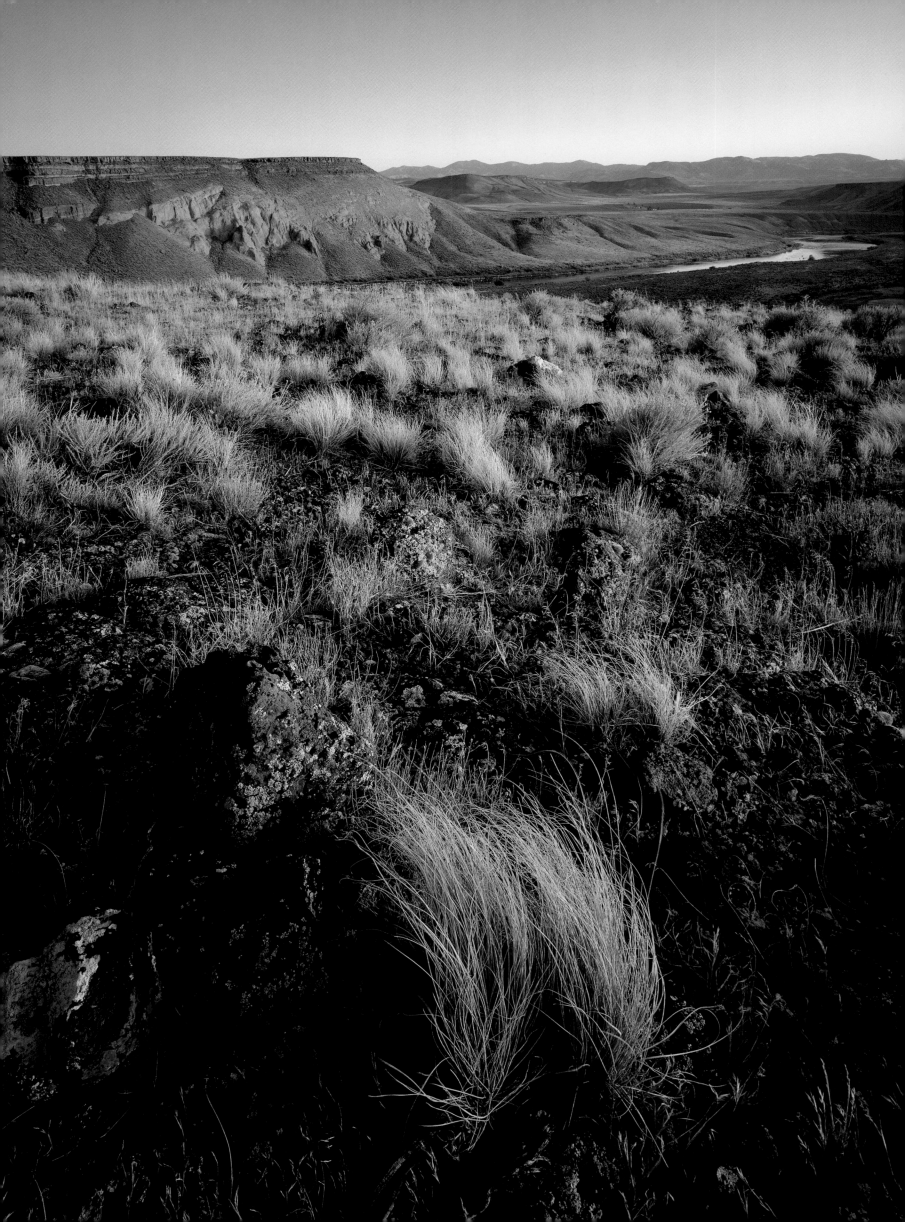

The Snake River Plain

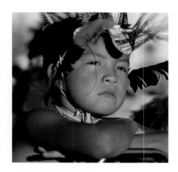

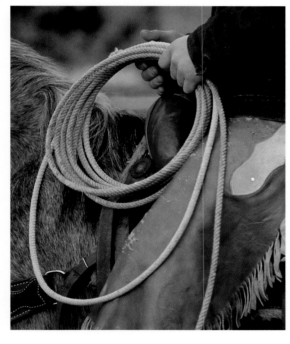

◁ *Leaving the deep canyon associated with the Birds of Prey Natural Conservation Area, the Snake River winds toward the farm country on the western edge of the Snake River Plain.*
△△ *A young Shoshone-Bannock boy learns skills as a warrior-in-training.*
△ *Genuine cowpokes run cattle on the Snake Plain.*

About ten miles northwest of St. Anthony, seemingly endless fields of juniper, sagebrush, and bunchgrass unfold to the west, as a golden sun dips toward the horizon. Like a mirage, the desert landscape suddenly dissolves into low mountains of sand that extend as far as the eye can see. On a cool February evening, the sun highlights streaks of snow on the wind-whipped sand ridges. Tiny particles of obsidian, feldspar, quartz, and mica sparkle in the light on the highest points of the dunes, and low-lying pockets fall into dark shadows.

A favorite playground for hikers and dune buggies, the St. Anthony Dunes are the product of wind-blown debris from Ice Age lakes just to the south, in the vicinity of Market Lake and Roberts. As recently as twelve thousand years ago, as the ice melted and large lakes evaporated, northeast winds blew soil and rock particles into three distinct groups of sand dunes that roll like ocean swells through pockets of sagebrush for thirty miles in the upper far-eastern corner of the Snake River Plain. Like many enchanting features of the plain, such as the nearby Menan Buttes, Hagerman Fossil Beds, and Craters of the Moon National Monument, the dunes are proof of a fascinating and dizzying series of events that shaped this southern arc of Idaho.

With its many nationally unique features, the Snake River Plain is a living museum of natural wonders. The 212-foot Shoshone Falls, Thousand Springs, and the Snake River Birds of Prey Area—like priceless paintings on nature's wall—are easily enjoyed by Idahoans and tourists alike.

"The grandeur and originality of the views, presented on every side, beggar both the pencil and the pen," wrote Captain Bonneville in 1834, as he toured the Rocky Mountain West. "Nothing we had ever gazed upon in any other region could compare in wild majesty and impressive sternness, with the series of scenes which here at every turn astonished our senses, and filled us with awe and delight."

Beyond its magical natural features, the Snake River Plain is the largest expanse of relatively flat ground in Idaho alongside the state's most voluminous source of water. Consequently, it has been a natural gathering place for animals and people for thousands of years. Mormon pioneers and other white settlers had to tap-dance around natural obstacles to work their own magic on the plain. From the late 1800s to the 1950s, pioneers toiled to bring three million acres of dry sagebrush into bloom. They cleared the land of rock and sage to set up homesteads; they built thousands of miles of canals; they pumped water out of the five-hundred-foot-deep Snake River canyon and the Snake Plain Aquifer to keep crops watered during the dry, hot summers. With the assistance of influential congressmen, the Idaho Power Company and the U.S. Bureau of Reclamation built a series of dams for hydropower and irrigation. Beginning in 1928, fish farmers took advantage of the pure springs near Hagerman to create the world's largest production center for farm-raised trout. J.R. Simplot, Idaho's billionaire "spud king" and the most successful pioneer of them all, made a fortune farming, ranching, mining, and manufacturing on the plain. Simplot was instrumental in associating Idaho with "world famous potatoes." Idaho farmers consistently produce the nation's largest potato crop, valued at $525 million a year.

Settlers had to overcome great odds to tame portions of the plain. Journals from Oregon Trail emigrants told how the two-track wagon route on the south and north sides of the Snake River canyon was littered with abandoned wagons, equipment, and graves. The biggest dilemma was finding a place to cross the Snake River canyon, or finding a way into the canyon to retrieve water. Author Washington Irving thought it wasn't

91

possible to civilize the plain, based on his description of the Twin Falls area as "a land where no man permanently resides; a vast, uninhabited solitude with precipitous cliffs and yawning ravines, looking like the ruins of a world; vast desert tracts that must ever defy cultivation and interpose dreary and thirsty wilds between the habitations of man." No wonder they call the Twin Falls area the "Magic Valley."

The Shoshone Indians had a good life in the Snake River Plain, living off fish, camas roots, berries, and wild game. They set up fish weirs at the base of Salmon Falls and Shoshone Falls to catch chinook salmon. Both falls blocked the huge, forty-pound oceangoing fish from migrating farther upstream. Mostly peaceful, the Shoshone were eager to barter with fur traders and Oregon Trail emigrants. Today, the tribes reside on the Fort Hall Reservation near Pocatello.

Following portions of the Oregon Trail across the Snake River Plain, Union Pacific Railroad built the first rail line across southern Idaho in the late 1880s. Today, the plain is a major transportation route for motorists and trucks on I-15 and I-84.

Small farm and ranch towns dot the plain, along with several medium-sized cities—in Idaho terms—such as Rexburg, Idaho Falls, Blackfoot, Burley, Twin Falls, Glenns Ferry, and Mountain Home. Pocatello is tucked in a natural bowl in the Portneuf Mountains, on the fringe of the plain. "Pokey" rivals Idaho Falls for the state's second-largest city (both have in excess of forty-five thousand people), and has long been a railroad center and the home of Idaho State University. Idaho Falls has a vocational college and has become the region's shopping mecca. About eight thousand Idaho Falls and Pocatello residents work at the Idaho National Engineering and Environmental Laboratory, a federal nuclear research lab located sixty miles away in the Arco desert. Launched in the late 1940s, the lab lit up Arco with atomic power in 1951. INEEL scientists today work on a variety of environmental and medical research projects, and the lab is a temporary holding site for nuclear waste.

On the north and south flanks of the plain, ranchers raise cattle and sheep in deep mountain valleys near towns like Mackay, Fairfield, Terreton, and Albion. When the grass greens up in spring, they drive the animals from the home ranch into the mountains, eventually reaching heights of ten thousand feet. In September, they trail the fattened-up critters back home; many of the animals are then sent back east for slaughter.

Up the Wood River Valley, the tourist mecca of Sun Valley remains one of the world's leading winter and summer resorts. Compared to the other communities nearby, Sun Valley is an enclave of liberal thought and a refuge for musicians and Hollywood celebrities. The ski area has maintained a top-notch world rating and draws 450,000 skiers a year to its finely manicured slopes and castle-like lodges on Bald Mountain. Just to the south, near Picabo, the gin-clear waters of the world-famous Silver Creek Preserve lure expert brown-trout anglers and bird hunters. Novelist Ernest Hemingway enjoyed Sun Valley and Silver Creek long before they gained national prominence, but curiously, he never wrote about either. Hemingway committed suicide at his Ketchum home in 1961.

All told, the Sun Valley jet set, Snake River Plain farmers and ranchers, the Shoshone-Bannock tribes, Ph.D.-level engineers at INEEL, Danish dairy farmers, and thousands of Hispanic farm laborers make for a diverse set of people who populate the plain—a mix almost as diverse as the landscape itself.

Spectacular volcanic eruptions, oozing basalt lava flows, and flooding of biblical proportions all contributed to the landscape we see today on the Snake River Plain. A series of volcanoes from twelve million to one million years ago spewed copious amounts of rhyolite and basalt into low basins in the plain. The eruptions started on the western plain and drifted east to Yellowstone National Park. The eight-hundred-foot-high Menan Buttes near Rexburg are two notable examples of dormant volcanoes. Less-explosive events of basalt lava issuing forth from the earth's crust created natural dams, backing up water in large pools across the plain. This series of lakes was known as "Lake Idaho." About a million years ago, the lakes began to flood into a tributary of the Salmon River. As water cut north along the Idaho-Oregon border, it created a new escape route for the Snake River out of Idaho in Hells Canyon.

The most recent eruptions of basalt on the Snake River Plain occurred east of Carey, in the vicinity of Craters of the Moon National Monument, about twenty-one hundred years ago, a hundred years before the birth of Christ. An estimated eight cubic miles of lava erupted at Craters, making it one of the largest lava fields in North America. A hiking or cross-country ski outing in Craters gives visitors a unique feeling as they look at piles of lava rock, odd-shaped monoliths, ice caves, and three large buttes that dominate the skyline.

One of the most exciting events on the Snake River Plain, the Bonneville Flood, occurred fifteen thousand years ago. During a period of glacial melting, Lake Bonneville—the predecessor of the Great Salt Lake—flooded to such a height that it spilled through Red Rocks Pass, south of Pocatello, and quite suddenly began to pour water into Idaho. Geologists estimate that a five-hundred-foot-high wall of water roared down the Snake River, creating Shoshone Falls and deepening Hells Canyon.

During all of the geologic activity on the Snake River Plain, as much as one billion acre-feet of fresh water was trapped underneath a mile-thick mantle of lava rock, forming the Snake Plain Aquifer. The Big Lost and Little Lost Rivers are the two principal feeders of the aquifer as they disappear into the earth's crust near Arco. Nearly 150 miles away, a fountain of freshwater springs, known as Thousand Springs, issues from the north bank of the Snake River canyon, near Hagerman. The springs are the outlet for the aquifer. Most of the springs are piped into fish hatcheries to raise trout and catfish.

The Snake River is frequently referred to as the "lifeblood" of Idaho. On the Snake River Plain, the river has to be all things to all the people, as it fuels the agricultural economy and powers the cities and industries. As more people move into Idaho, and as an increasing number try to win a share of the river for fishing, whitewater boating, and sightseeing tours, it becomes more of a challenge for the Snake to serve everyone. But this is a dynamic region where people—consciously or unwittingly—depend on the cooperation of others for a successful outcome. Just as the Snake is connected to its tributaries, springs, and aquifers, the people of the plain are connected by the river.

On a summer evening, the sunset forms a giant arc of color in the western sky. A bright orange band hangs over silhouettes of distant mountains on the horizon, while ribbons of purple, red and pale blue stretch from Hagerman to Craters of the Moon. In a matter of minutes, the colors dissolve into an oval that ties together all corners of the Snake River Plain. It seems apparent, at this moment, despite all the earth-shaking events—the fire, ice, flooding, and weather—that have rocked the plain for millions of years, the Snake River Plain survives to see another day.

Perhaps that's a kernel of wisdom for people to ponder as they look up at the sky and around at the land and watch the colors light up the living museum.

> ▷ *The Big Lost Valley carries snowmelt from 12,662-foot Borah Peak and 12,228-foot Leatherman Peak.*

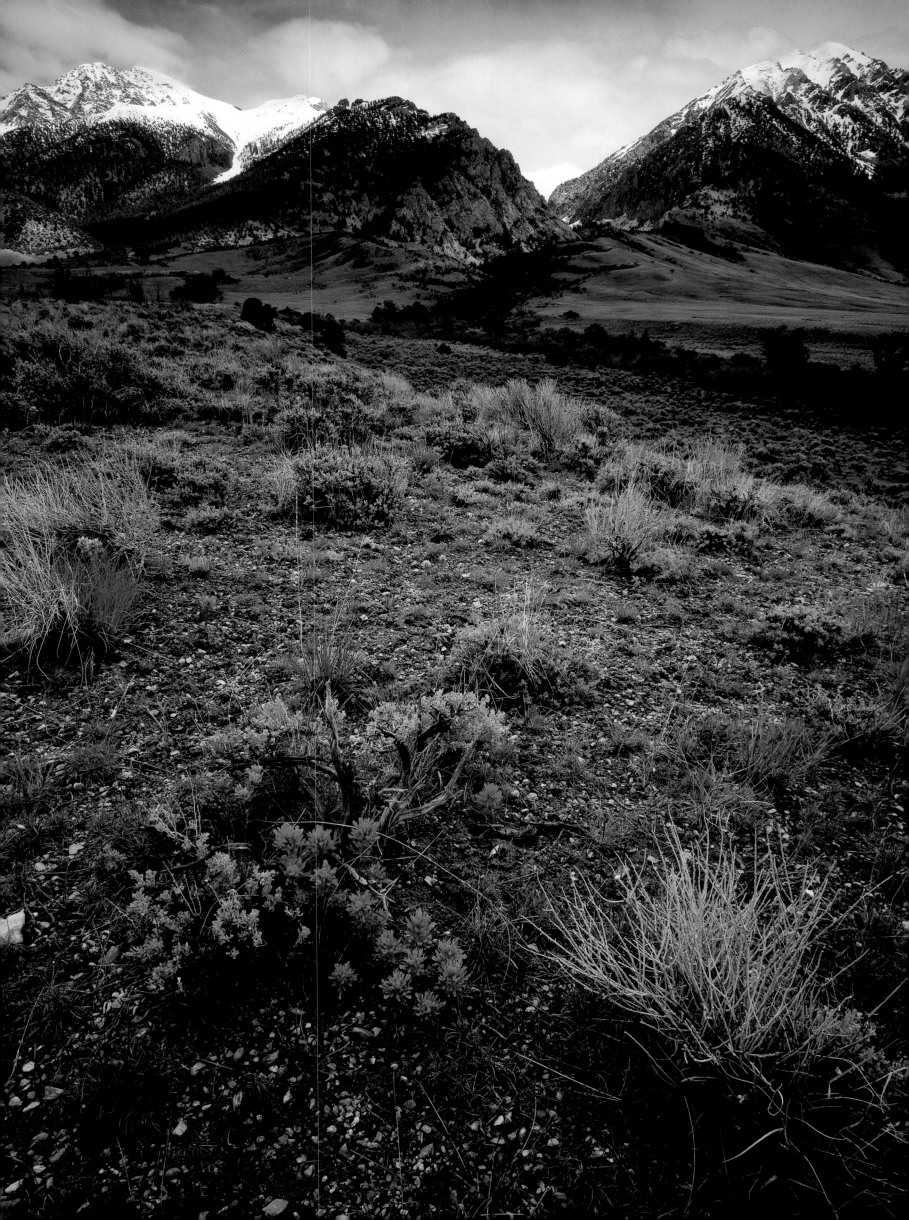

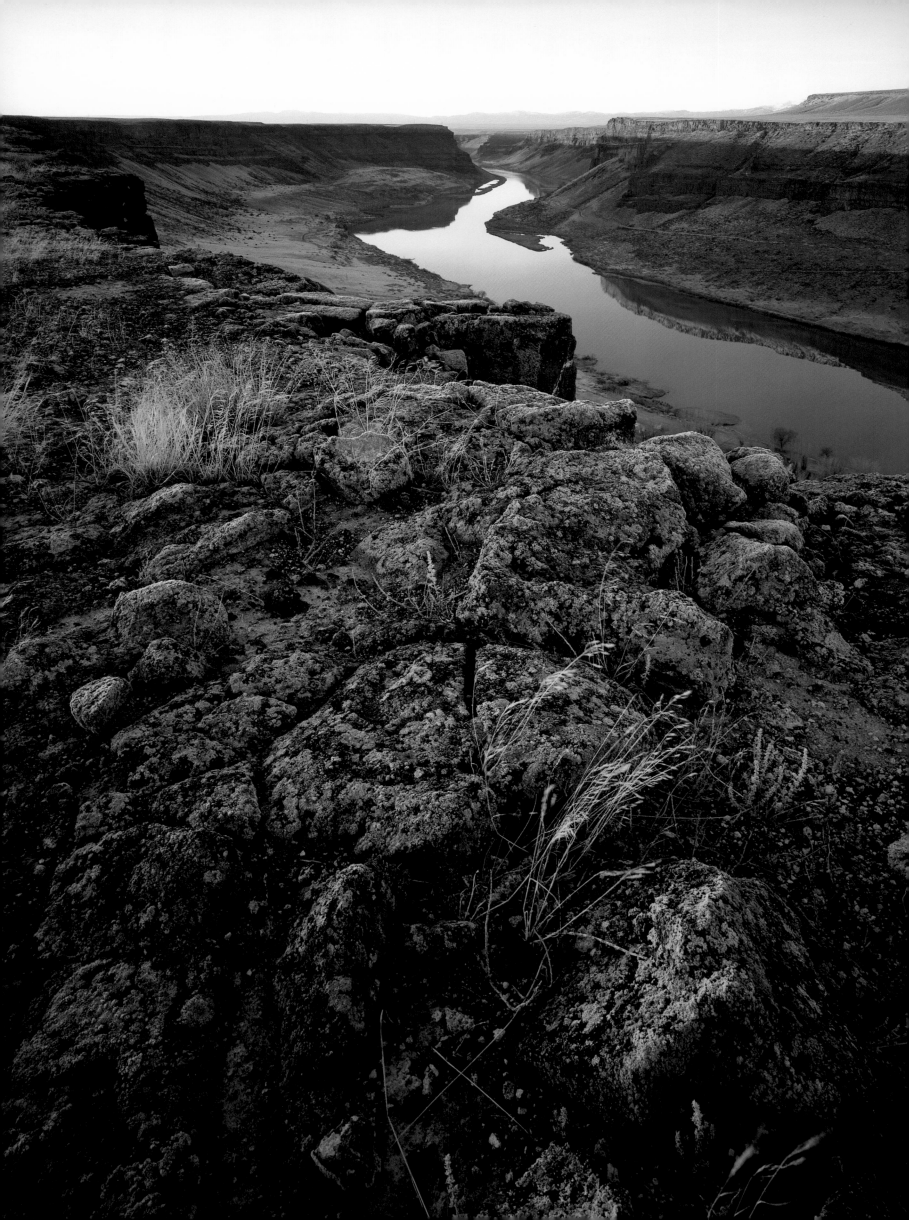

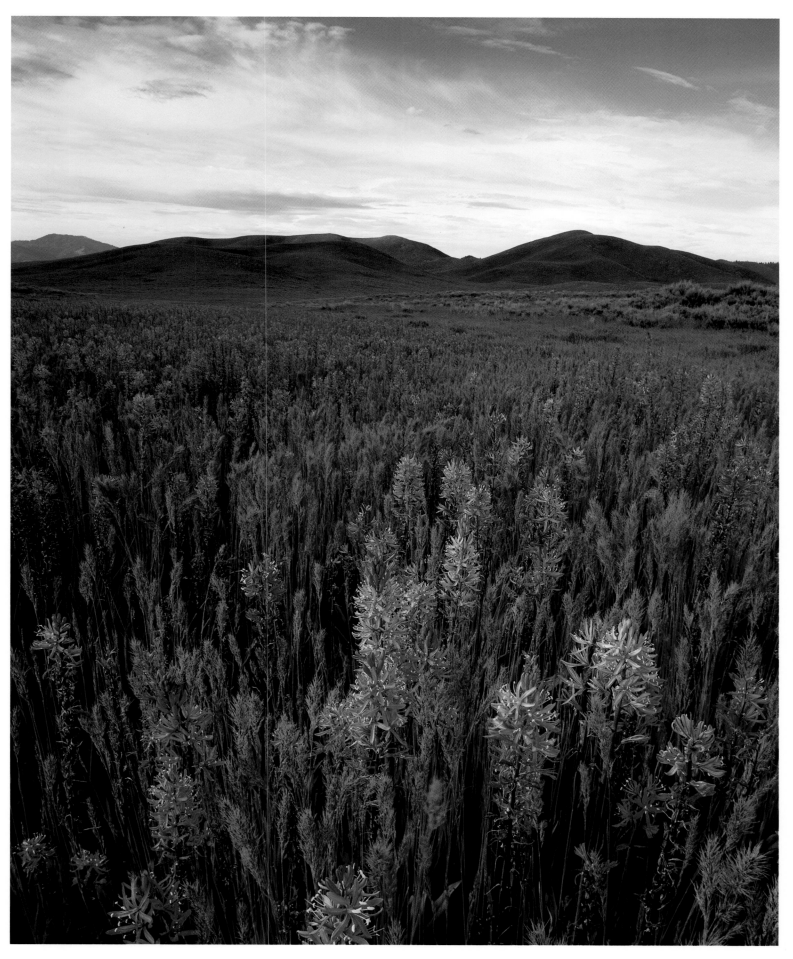

◁ The nation's largest population of birds of prey nest in the cliffs along the Snake River. △ Come May, southern Idaho's Camas Prairie, situated in a moist valley bounded by the Bennett Hills and the Soldier Mountains, demonstrates the aptness of its name.

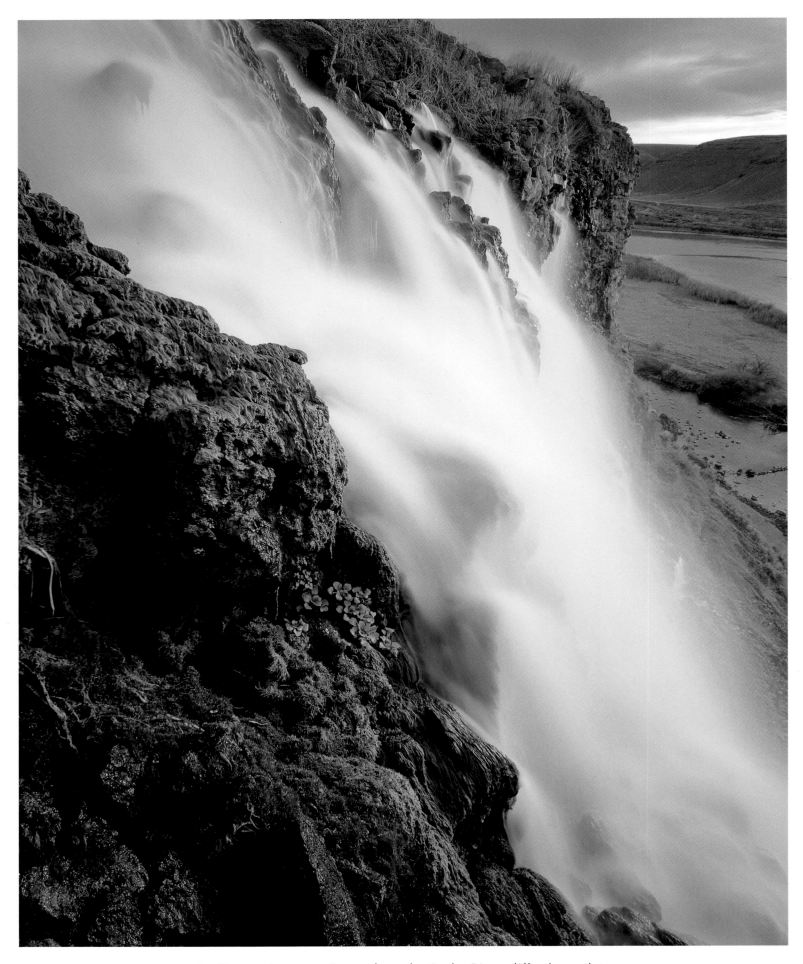

△ Pure spring water issues from the Snake River cliffs, the outlet for the Snake Plain Aquifer, in the Thousand Springs region near Hagerman. ▷ A clutch of rabbitbrush blooms in Craters of the Moon National Monument, an eighty-three-square-mile museum of lava rock protected in 1924 by President Calvin Coolidge.

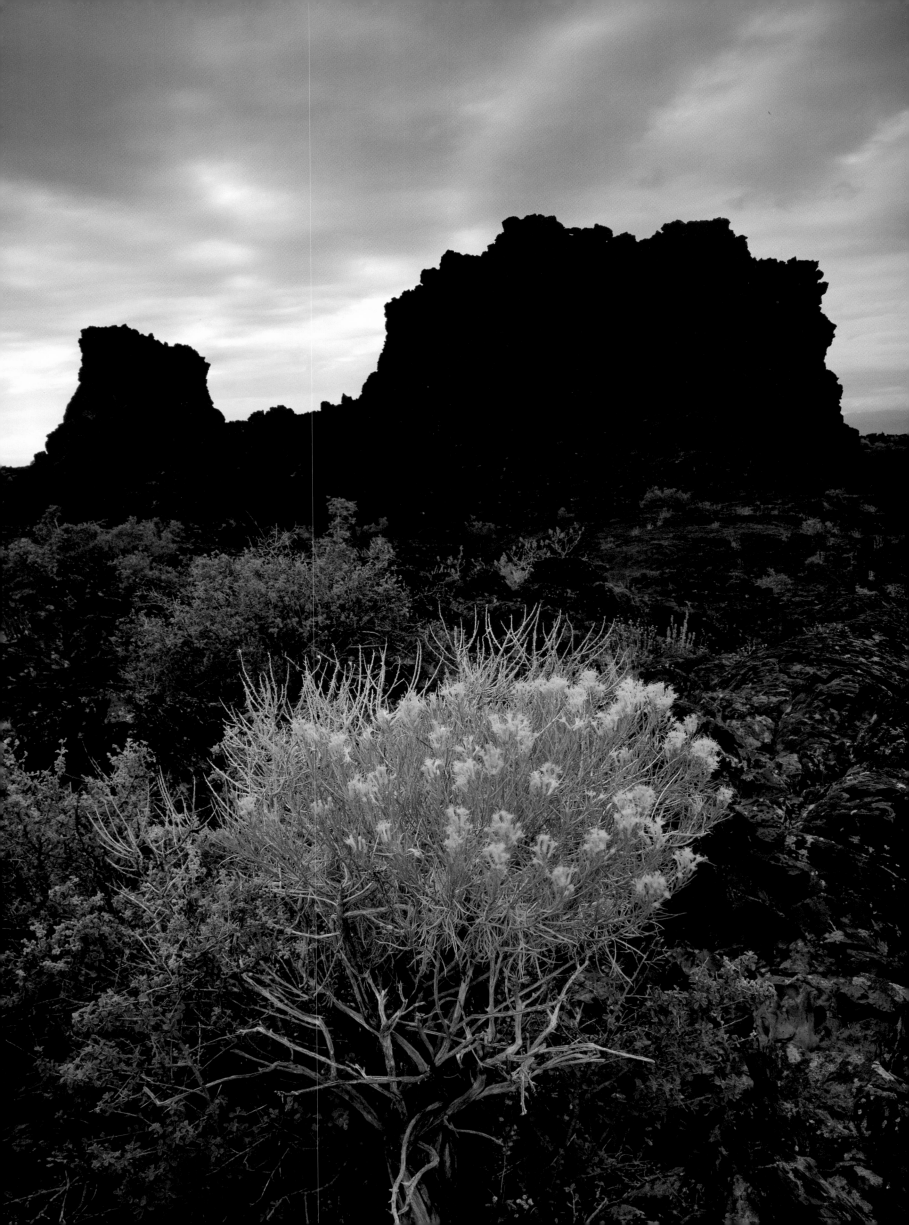

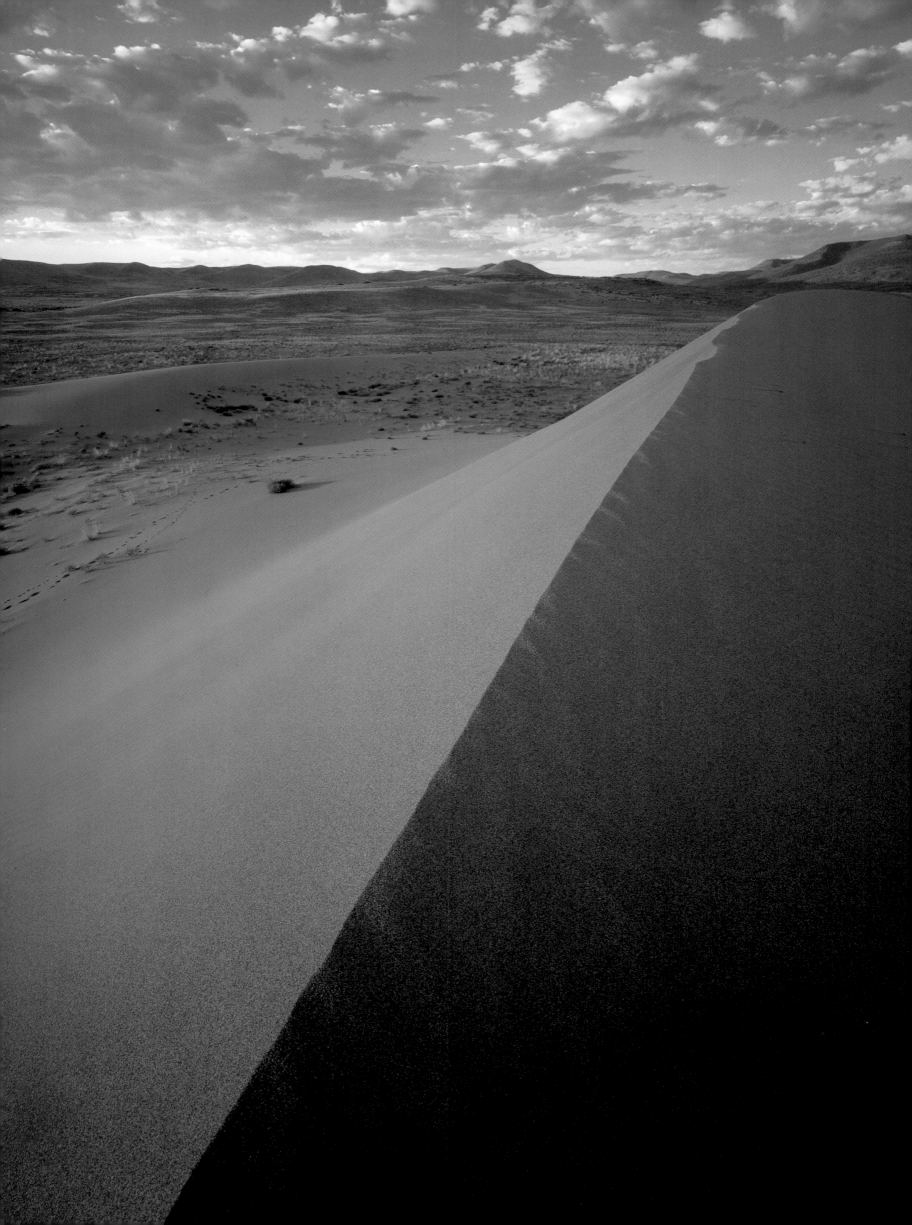

◁ The Bruneau Sand Dunes rise 470 feet above the Snake River Plain. △ Wind and weather etch a masterpiece in the dunes, which cover four square miles. ▷▷ The Lost River Range is called a "basin and range" fault block, meaning that, over millenia, the peaks have risen during a series of earthquakes. The fault is still active.

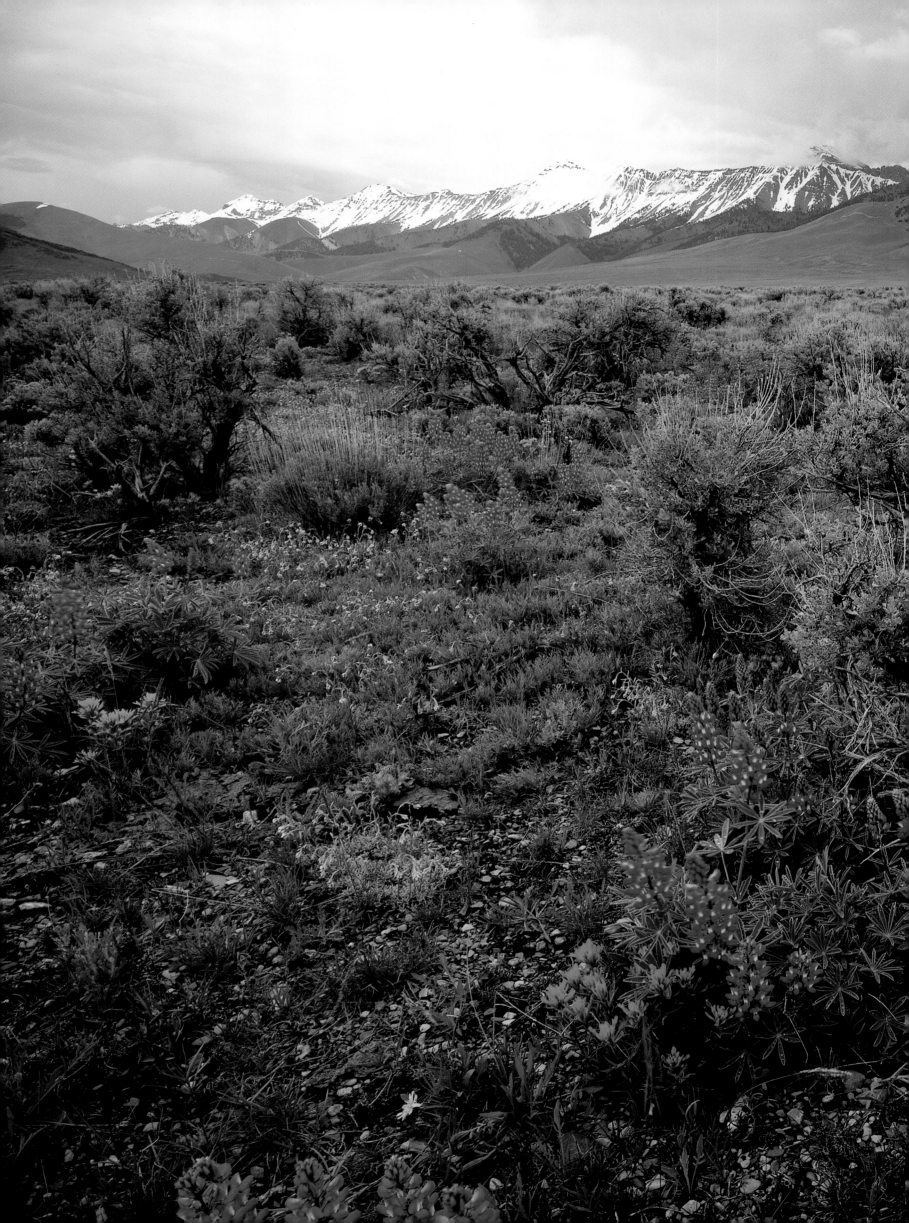

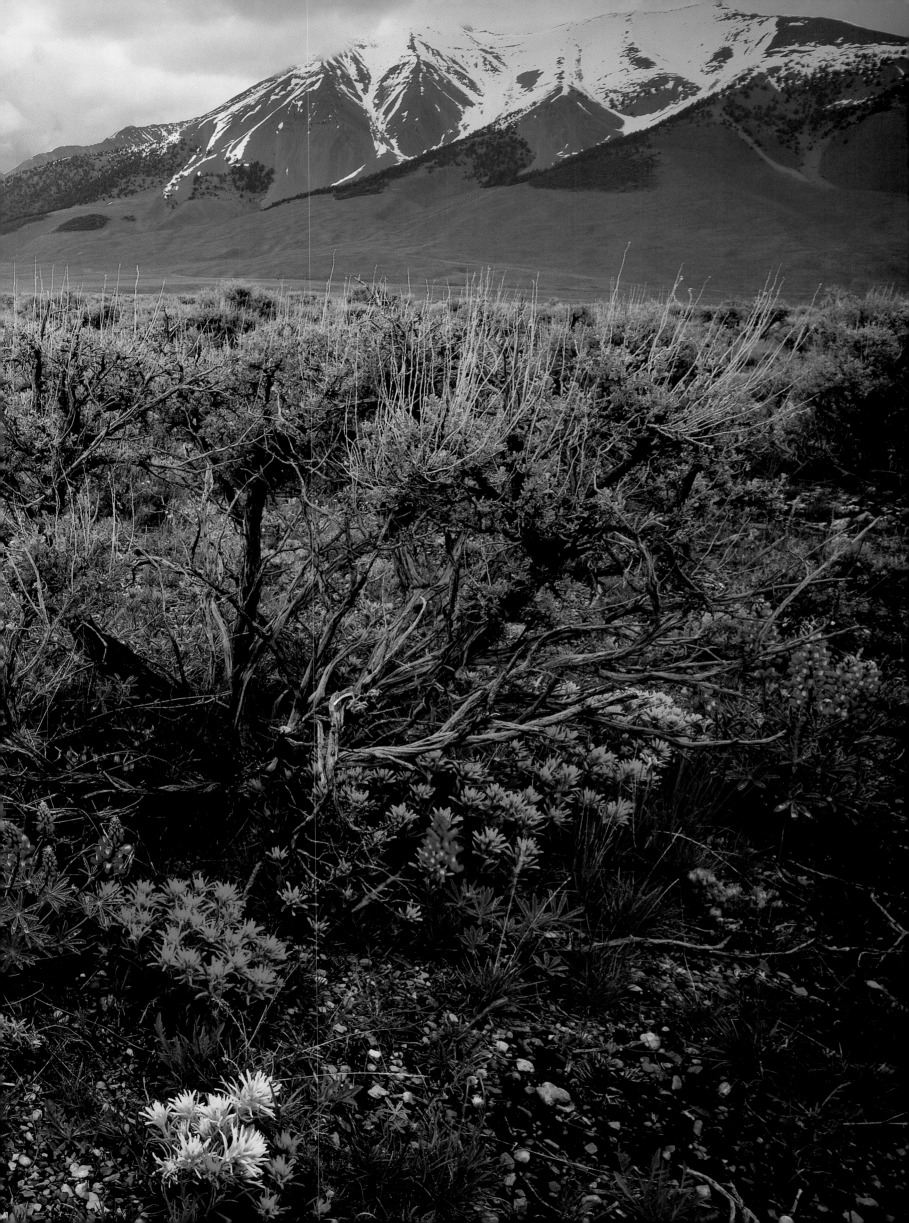

△ Protected by a 2,840-acre state park, the Bruneau Dunes are one of the most popular tourist stops in southwest Idaho. ▷ A sweeping granite flank in the Pioneer Mountains reveals a vertical crack that extends for six hundred feet in a ten-thousand-foot basin. ▷▷ Balsamroot and lupine illuminate the Ketchum foothills.

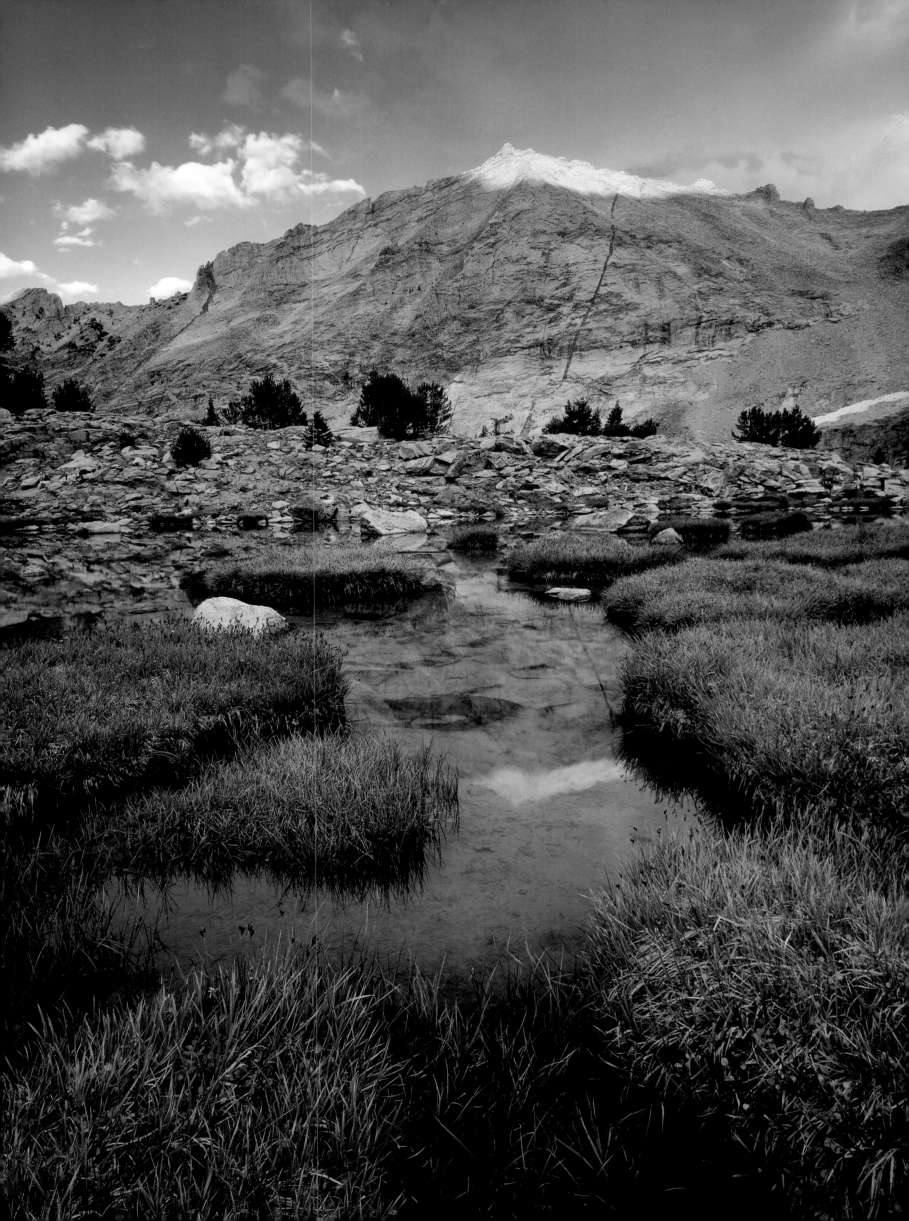

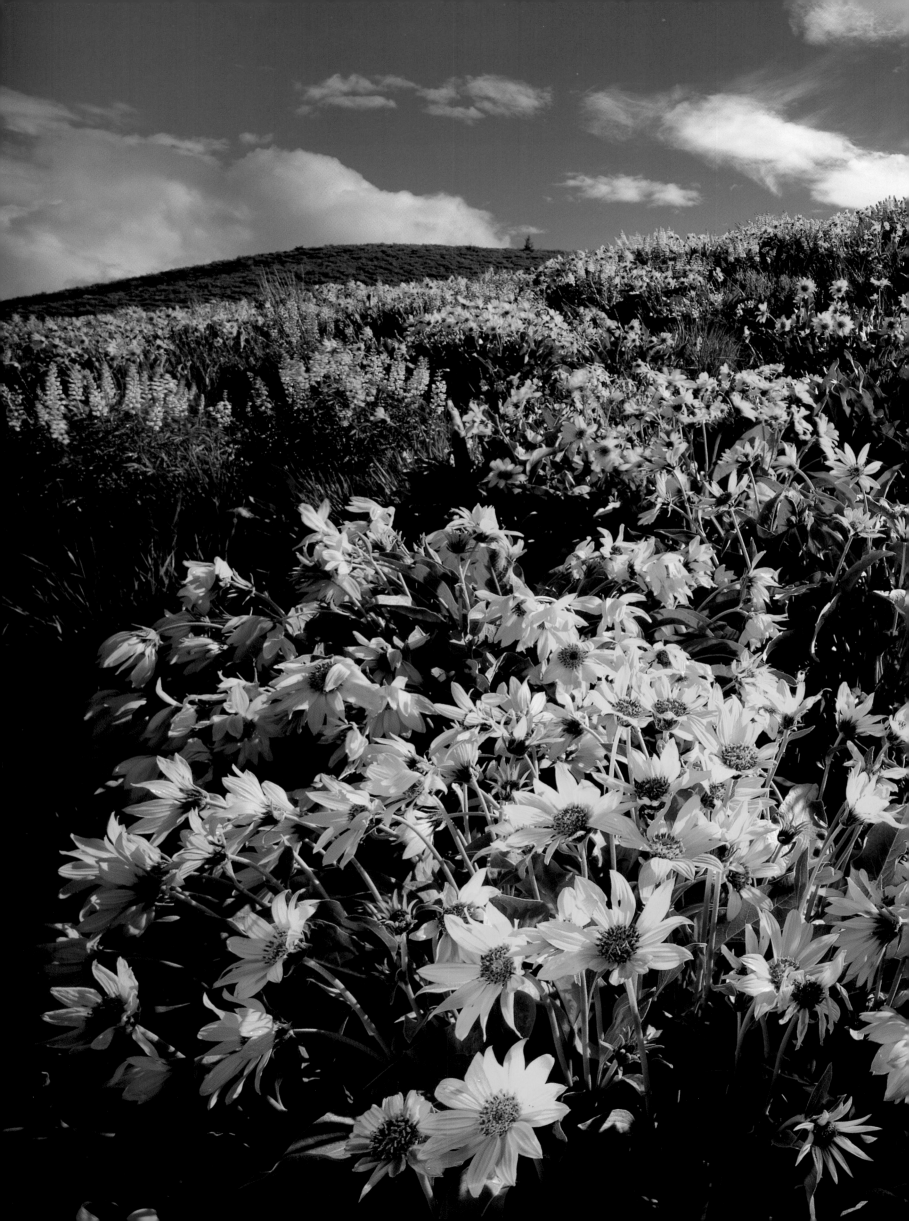

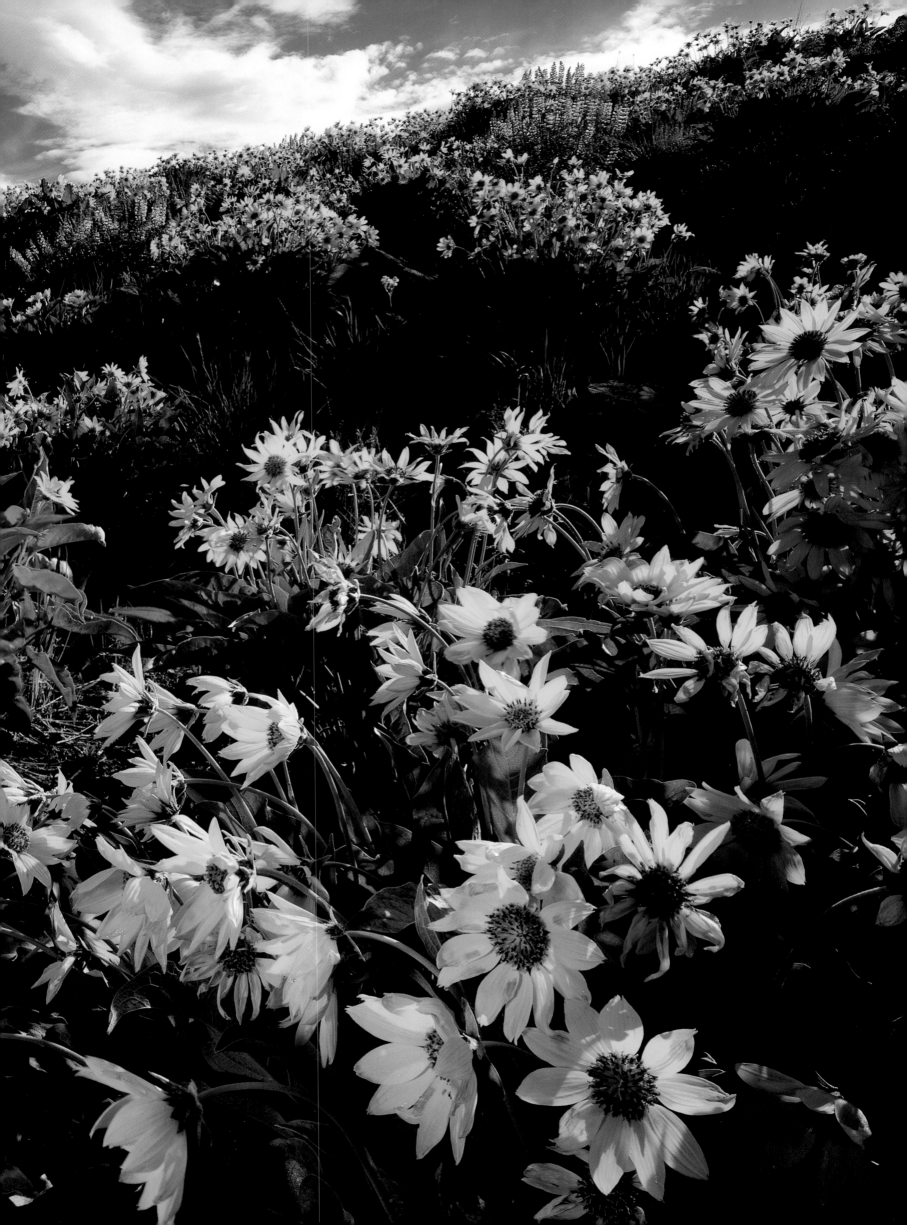

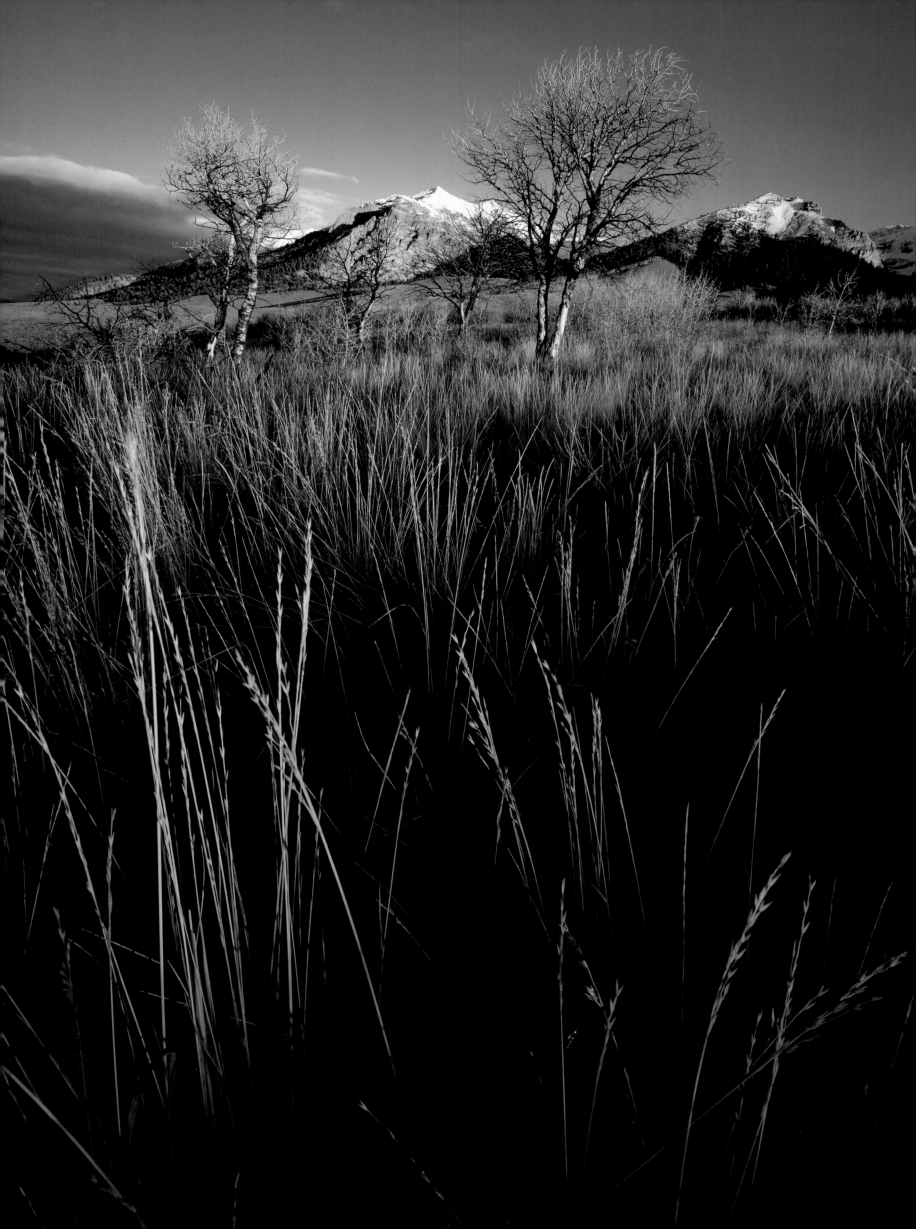

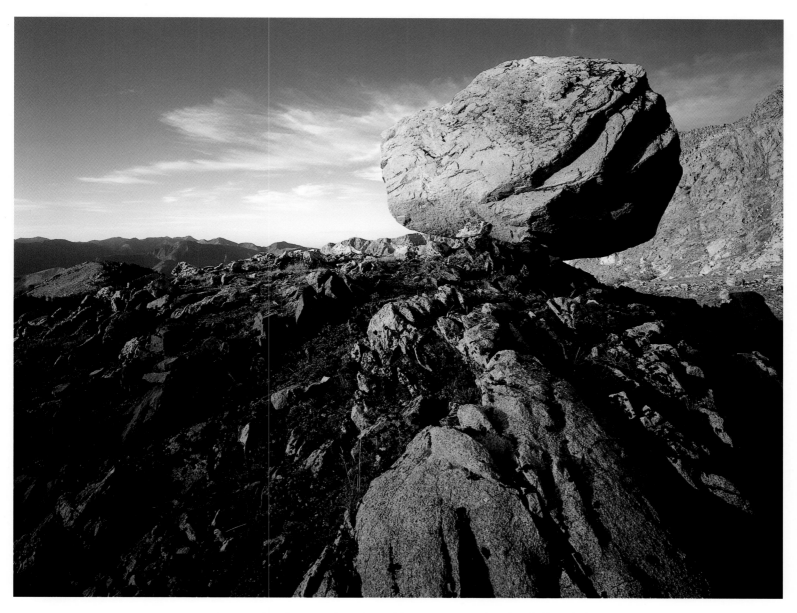

◁ A morning breeze bends golden grass in the foothills of the Boulder Mountains, north of Sun Valley. △ A granite boulder teeters on a rocky shelf next to Goat Lake in the Pioneer Mountains. ▷ ▷ May flowers and buckwheat dot an otherwise austere scene near Inferno Cone at Craters of the Moon National Monument.

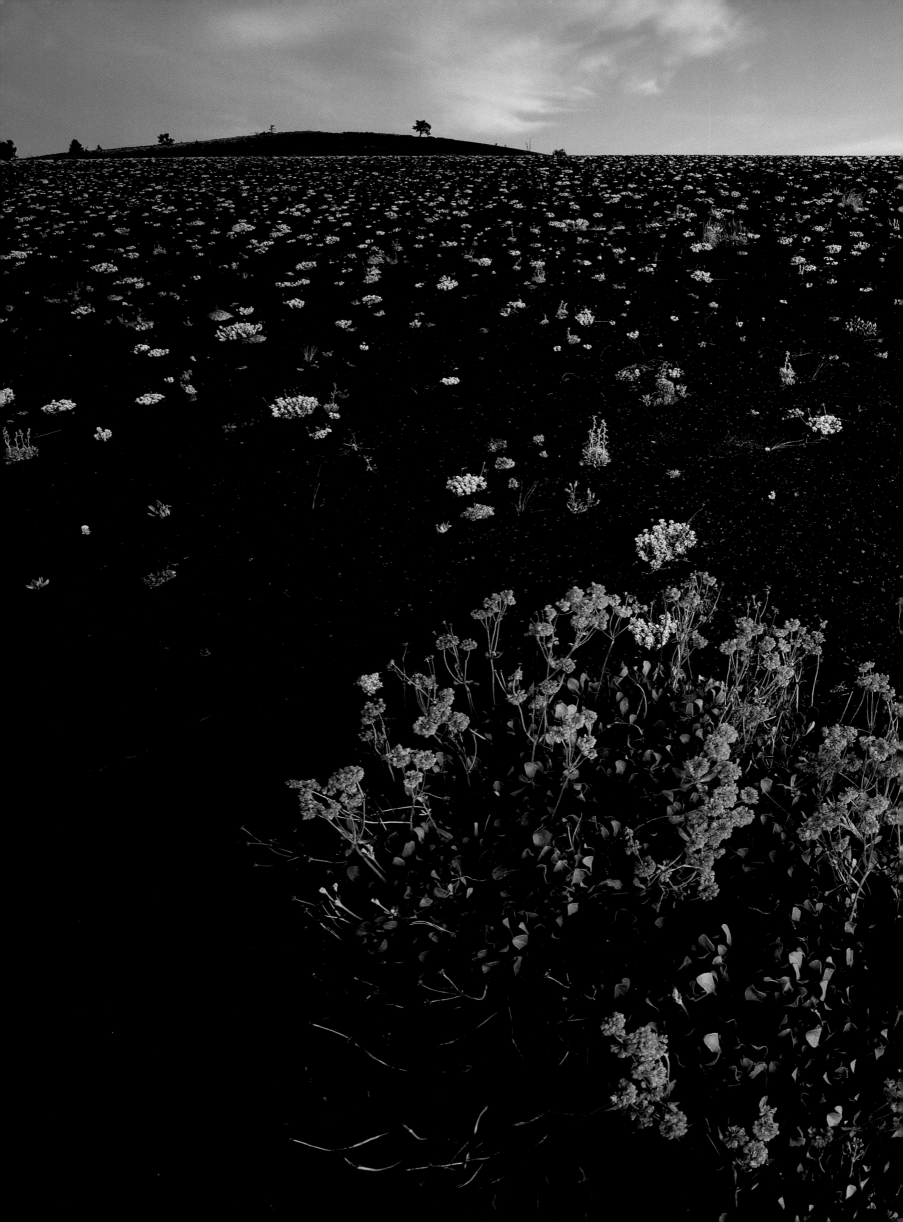

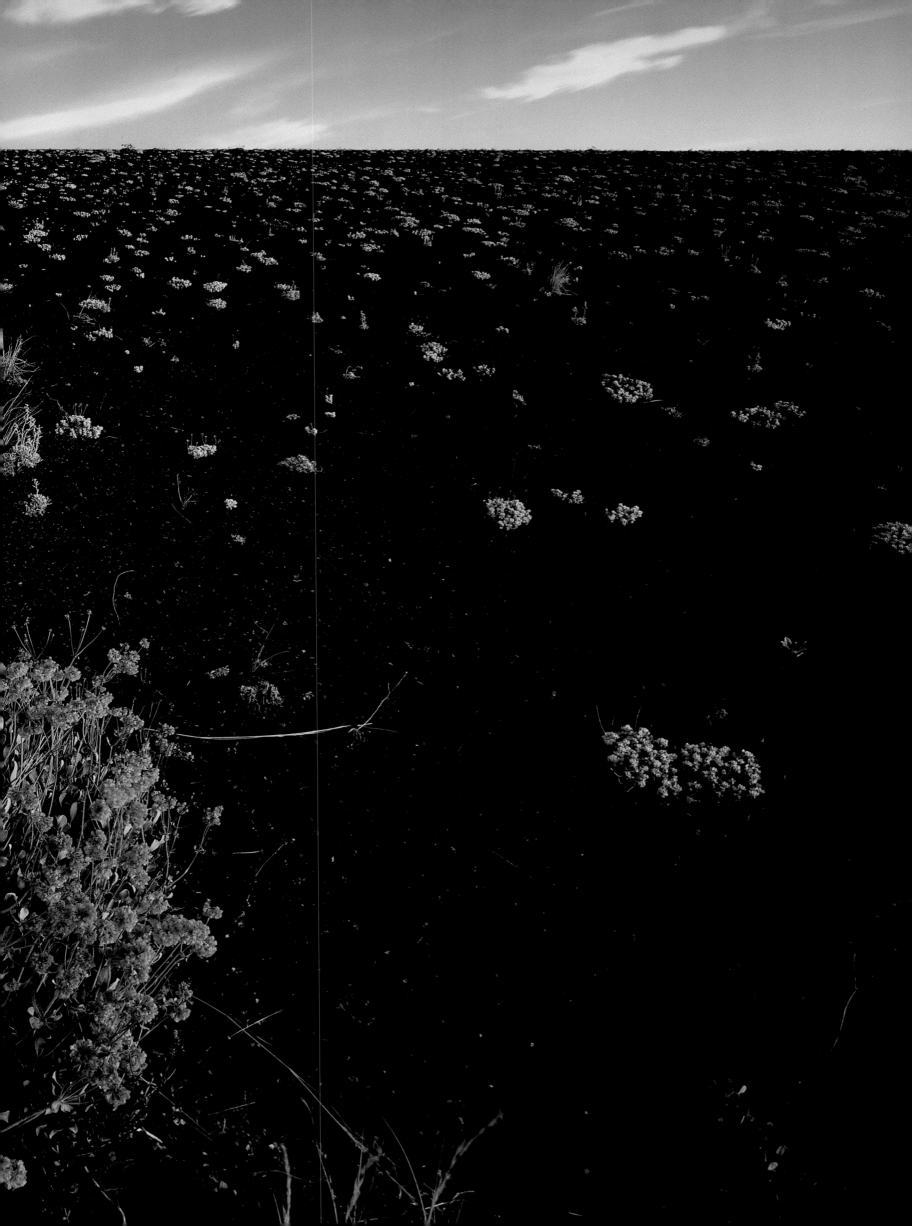

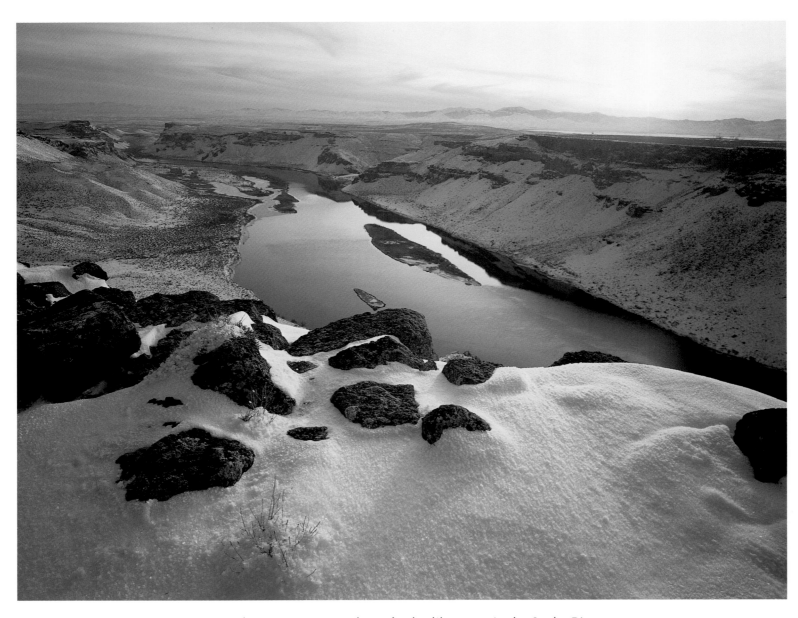

△ A February storm puts down featherlike snow in the Snake River Birds of Prey Area. More than six hundred pairs of eagles, hawks, falcons, and owls nest in the canyon. ▷ In November, a thin layer of snow brings with it the promise that winter may seal off the Big Wood River below the Boulder Mountains.

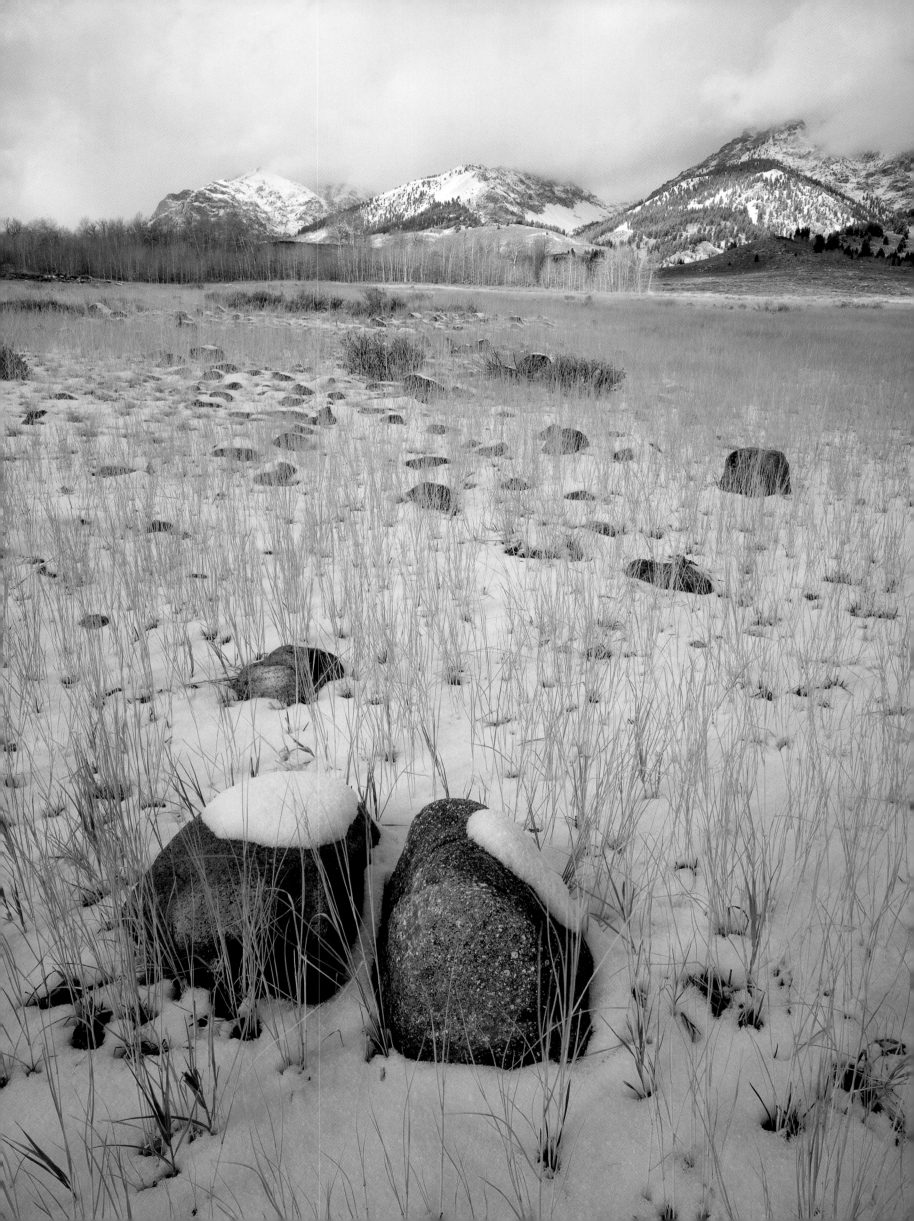

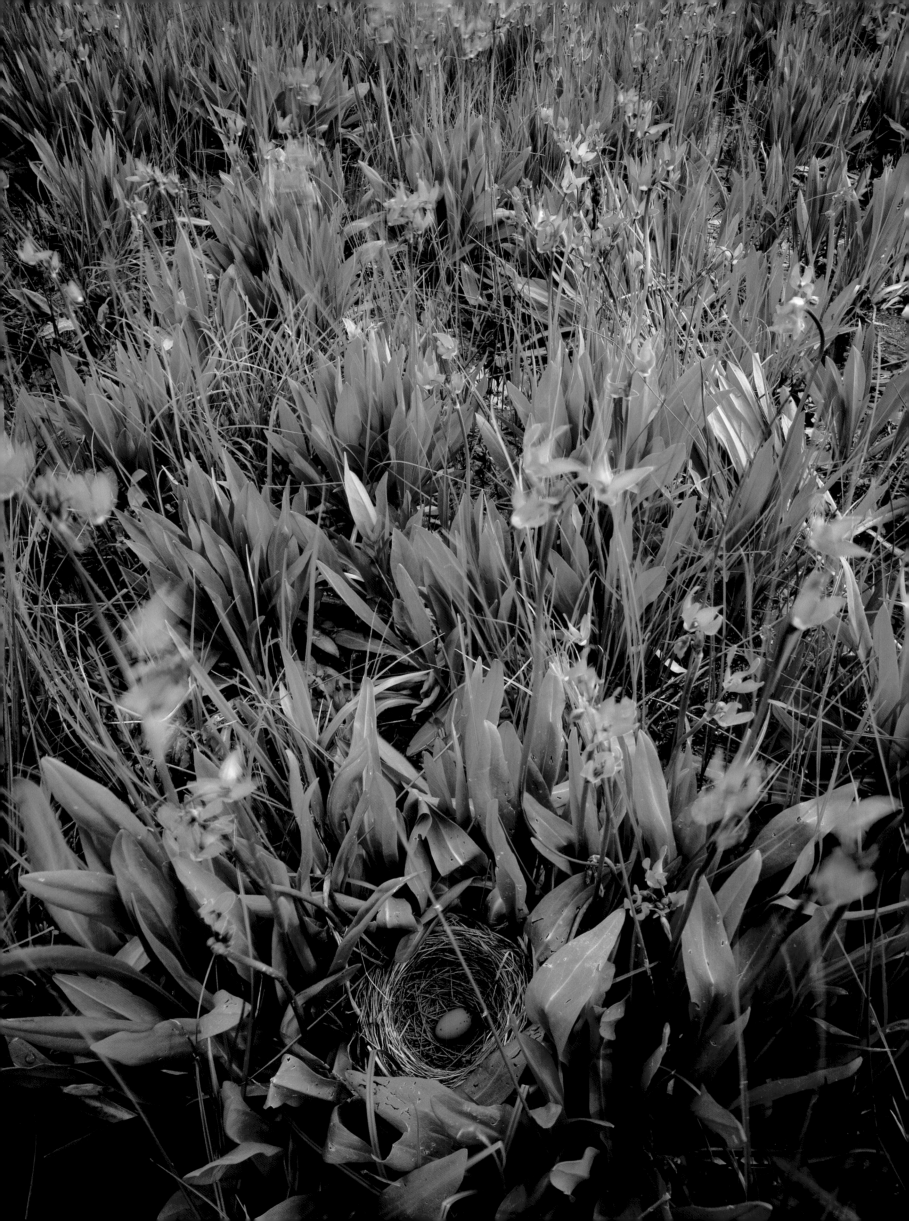

Big City,
Piney Forests

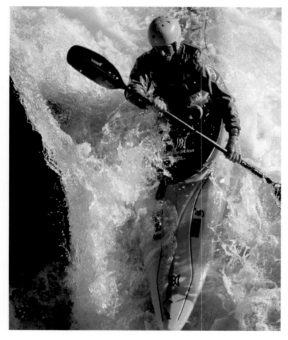

◁ *A sparrow's nest lies
almost hidden in a field
of shooting stars in Long
Valley, near McCall.*
△ △ *Farming is the
anchor of the economy
in Treasure Valley, where a
variety of crops are grown.*
△ *Daredevil kayaker
Grant Amaral negotiates
Big Falls, a twenty-five-foot
cataract on the south fork
of the Payette River.*

On the west side of the Sawtooth Wilderness, steep granite walls and glistening high mountain lakes form the headwaters of the Boise and Payette River basins. If you trace the watershed divide to the north, it follows a series of fin-like mountain ridges toward the source of the Weiser River near New Meadows. Like a giant curved arm, the divide wraps three river basins—the Boise, Payette, and Weiser—into a compact region. Within 150 miles, each of these major rivers tumbles more than six thousand feet, from high mountain peaks into the desert, on a diagonal course for the Snake River. As they make this relatively quick trip to the Snake, they pass through a rich web of natural resources, a microcosm of Idaho.

Born in the wilderness, the rivers cascade through granite mountains surrounded by dense forests of pine and fir. Then, quite suddenly, they break out of the trees into cities, towns, and lush agricultural valleys in the desert lowlands. Agriculture is big in the lower valleys because, much like in the Snake River Plain, the rivers are put to work and the water is spread among hundreds of farms, ranches and dairies, creating an oasis in the desert. Idaho City, once the state's most productive gold-mining district, is now a rustic hideaway just forty-five miles from the state's largest city. In all three river basins, we find active logging operations. We see many different varieties of crops on farms, especially seed crops and sugar beets, and full-fledged cattle and sheep ranching.

Steam rises over dozens of natural hot springs. Blue-ribbon trout fishing, wilderness trail rides, world-class whitewater boating and sturgeon fishing dot the waterways. We see the Oregon Trail. We get a peek at the Switzerland-like beauty of glaciated Panhandle lakes in Payette Lake, a deep-blue pool framed by white granite peaks. We revisit diverse geologic formations that underpin many parts of Idaho. We see rural communities that shun the big city atmosphere in Boise: towns like Horseshoe Bend, Cambridge, and Yellow Pine; towns that have more in common with the mountain folk in St. Maries, Salmon, and Elk City than with the city slickers.

And then, we see something different: Idaho's capital—Boise—with 145,000 people and counting, is a manufacturing, trade, and industrial center that is far more sophisticated than its population would suggest. The adjoining communities of Kuna, Star and Meridian, once low-key farm towns, are quickly becoming suburbs. The Nampa-Caldwell area is the second-largest urban center in the region. To the west of this quick brush with city life, 350,000 acres of farmland in the Treasure Valley stretch downslope toward the Snake River, all irrigated by snowpack runoff in the Boise River and Payette River.

Near Fruitland, a trio of rivers pours into the Snake just a few miles apart. A bit downriver at Farewell Bend, the Snake says good-bye to southern Idaho, takes a ninety-degree turn, and heads directly north for Hells Canyon. The Snake is still a "working river" for the next hundred miles, as it swells behind a series of three dams and reservoirs to produce electricity for the Idaho Power Company. Brownlee Reservoir, by far the largest of the three, is nearly sixty miles in length. Below Hells Canyon Dam, the Snake is set free again for about sixty-five miles to Lewiston, where the river plunges through the biggest whitewater rapids in the state, with waves at high water as tall as a two-story house.

Diversity is the watchword in this region of Idaho, which has perhaps the state's greatest variety of occupations, lifestyles, and uses of the land. It's a mixture of bankers, attorneys, and government officials; people who work the land for a living; scholars and Ph.D.'s at Boise State University, the state's largest

institution of higher learning; electrical engineers whose know-how keeps high-tech companies such as Zilog, Micron Electronics, and Hewlett-Packard on the cutting-edge; and all kinds of folks who work retail jobs and run small businesses.

In a way, the diversity of the people, occupations, and life-styles in southwest Idaho mirrors the tremendous variety of landscapes and natural features that surround them. All three river basins pass through ecological transition zones from the Northern Rockies alpine and woodland zones to the Columbia Plateau—in short, from mountains to desert. The city of Boise adds an urban dimension to the mix, yet it is like an island unto itself. A thirty-minute drive in any direction puts you squarely back into rural Idaho—be it on the farm or in the mountains.

The geology of this region provides a glimpse of several rock formations common in Idaho. The headwaters of the Boise, Payette and Weiser Rivers rise up in forests and high peaks that are underpinned by the homogenous deposit of granite known as the Idaho Batholith. Beginning about 120,000 years ago, glaciers carved out velvety alpine basins in the Sawtooth wilderness, creating emerald-colored high mountain lakes and stiletto-like peaks. This is the setting for the headwaters of the Boise's north and middle forks, and the Payette's distinctive, turquoise-colored south fork. The Payette's north fork and the shimmering lakes surrounding McCall are each a product of glaciation. Geologists say that a large ice sheet traveled as far south as the site of the McCall airport. When the ice melted, the north fork laid down an extensive layer of rock and sand in Long Valley, a wide glen that extends for twenty-five miles between Clear Creek and McCall. The valley is flanked by two north-south mountain ranges, appropriately named West Mountain and East Mountain.

The Weiser River rather quickly departs from its granitic beginnings and dives into multiple layers of basalt. The telltale dark-brown bands and columns that line the Weiser's two main forks were laid down by multiple flows of Columbia Plateau basalt lava about fifteen million years ago. At one time, much of the Weiser basin was a part of the Seven Devils, a group of islands in the Pacific Ocean. One hundred million years ago, the islands drifted to the east and "docked" with the rest of Idaho, geologists say. In *Roadside Geology of Idaho,* David Alt and Donald Hyndman say, "The old continental margin must lie concealed somewhere beneath the flood basalt flows."

All three rivers carve through a combination of granite and basalt, but the Boise's south fork is a particularly dramatic case study. Born in the Smoky and Soldier mountains, the south fork drains through continuous granite until it meets a united front of basalt at the head of Anderson Ranch Reservoir. Below the dam, it cuts through a dramatic twenty-mile box canyon of basalt, a miniature version of the yawning Snake River canyon near Twin Falls. The south fork also boasts a blue-ribbon rainbow trout fishery and nearly continuous, intermediate-level whitewater rapids.

Prior to the arrival of white settlers, the Weiser, Boise, and Payette River valleys were frequented by sub-bands of Shoshone. They fed off big game, roots and annual runs of salmon, and trapped for furs. When the first white trappers happened on the Boise River valley, they and others to follow exclaimed "Les Bois!" referring in French to the wooded banks of the Boise River. French-Canadian trapper François Payette named the river that bears his name in 1818. Payette was a lifelong trapper in the Northwest, working for the Hudson's Bay Company. He capped his career with a colorful stint as master of Fort Boise. The naming of the Weiser basin is in dispute, but

Jacob Weiser, one of the town's founders and a ferry operator, was most likely the inspiration for the name.

After the fur-trapping era, the first Oregon Trail emigrants began to move through in the early 1840s. After traversing the dusty Snake River Plain, they were refreshed by the Boise River, fresh salmon, sturgeon, duck, and cheese, and they were regaled with tales by François Payette at Fort Boise.

George Grimes led a party of miners into the Idaho City area in 1862, and discovered gold on Grimes Creek, which began a flurry of activity in the state's richest gold-producing zone. The Boise Basin yielded an estimated three million ounces of gold over eighty years, worth more than $1 billion at 1997 prices. The Grimes Creek and Mores Creek valleys, including areas around Idaho City, would be hydraulically mined and dredged repeatedly. Chinese miners worked the area, too. Even today, it's not unusual to find scruffy characters panning for gold in the Boise Basin. Miners also worked many claims around Atlanta, on the western edge of the Sawtooth Wilderness, and over the hill, near Rocky Bar and Featherville. Several multinational corporations have expressed interest in reopening claims near Atlanta to develop a modern open-pit gold mine.

Logging came to the present-day Payette and Boise National Forests near the turn of the century, in much the same way it did in the Clearwater country—by driving oxen teams with logging equipment and boats into the forests. Logs were decked along the riverbanks, and when the spring floodwaters came, the logs were sluiced down river to the sawmills. It was back-breaking and dangerous work; drownings were not uncommon. Tall ponderosa pines as thick as a man is tall were the grist for century-long logging operations in the river basins.

Farmers developed an extensive network of ditches and canals to bring the lower valley bottoms into bloom in the late 1800s and early 1900s. Barber Dam was the first to be built in the basin, but it paled in comparison to 354-foot-high Arrowrock, the first major concrete dam in the Boise River Basin and the highest dam in the nation in 1911. Three dams would be built in the Boise Basin to store one million acre-feet of water per year—a vast amount needed to water thirsty crops like sugar beets in the Treasure Valley. Farmers and the federal government built two major dams in the Payette Basin, creating a nifty situation that today provides summer-long whitewater for recreation and irrigation water for orchards and farms. The Weiser River was not extensively developed for water storage, an issue farmers and ranchers now find wrenching in the hot summer months.

Mining wealth was the first catalyst for earnest development of Boise as a city. After the railroad came, and later, the airport and highways, Boise became an ideal location as a banking, manufacturing, and transportation center. Spud king J. R. Simplot established his headquarters in Boise, as did Boise Cascade Corporation and Morrison Knudsen. Over the years, Boise has enjoyed a disproportionate number of corporate headquarters for a small city. High-tech companies such as Hewlett Packard, Micron, and Zilog add diversity to the city's manufacturing base. After the Boise Towne Square lured department stores away from downtown, the city became more of an activity center, with an eclectic mix of specialty stores, coffee and bagel shops, chic restaurants, and brew pubs.

It seems inevitable that Boise and the Treasure Valley, which already support about one-fourth of the state's population, will continue to grow. But thanks to the region's diversity and the abundant mountain getaways nearby, the Boise Basin seems well positioned to preserve its Idaho spirit.

> ▷ *Indian paintbrush dots a mountain meadow high above Hells Canyon, in the Seven Devils Range.*

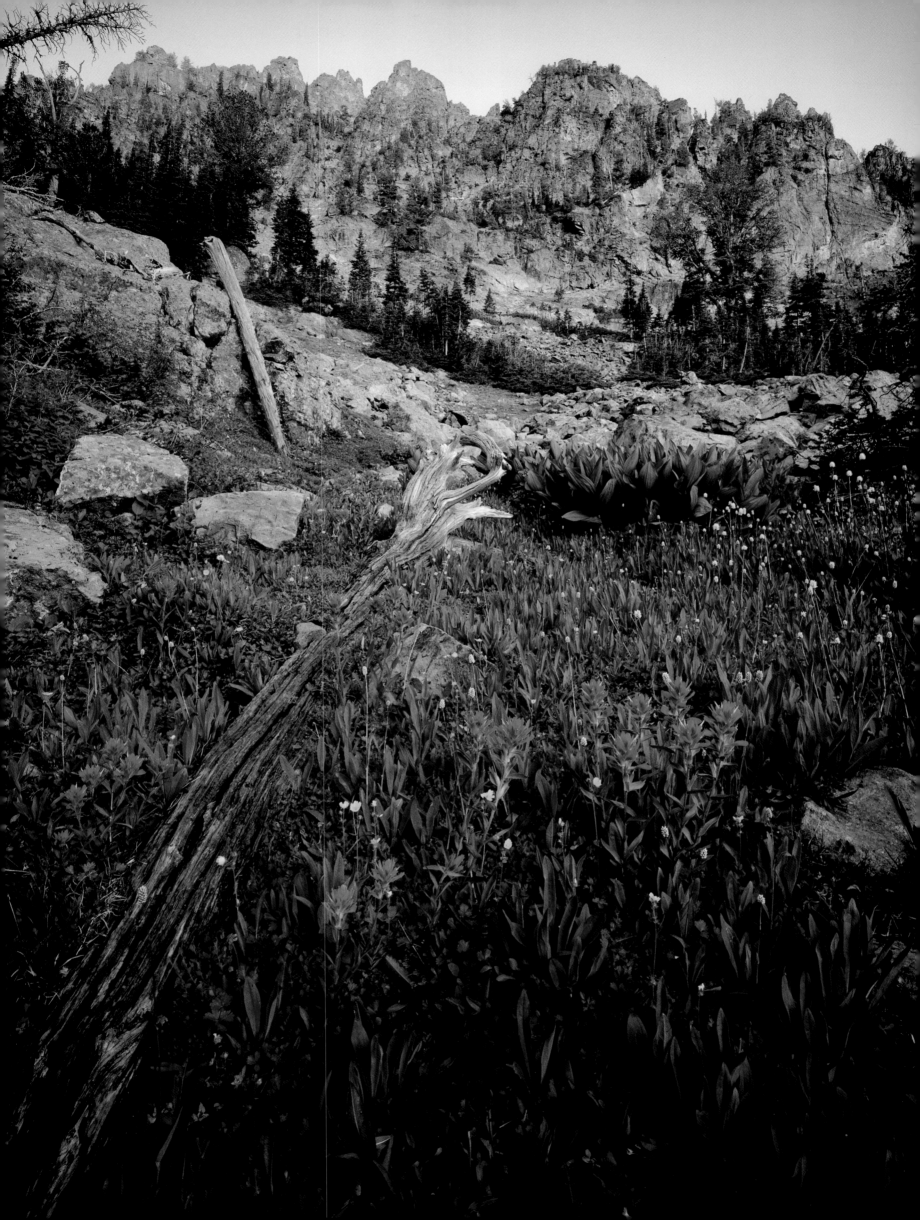

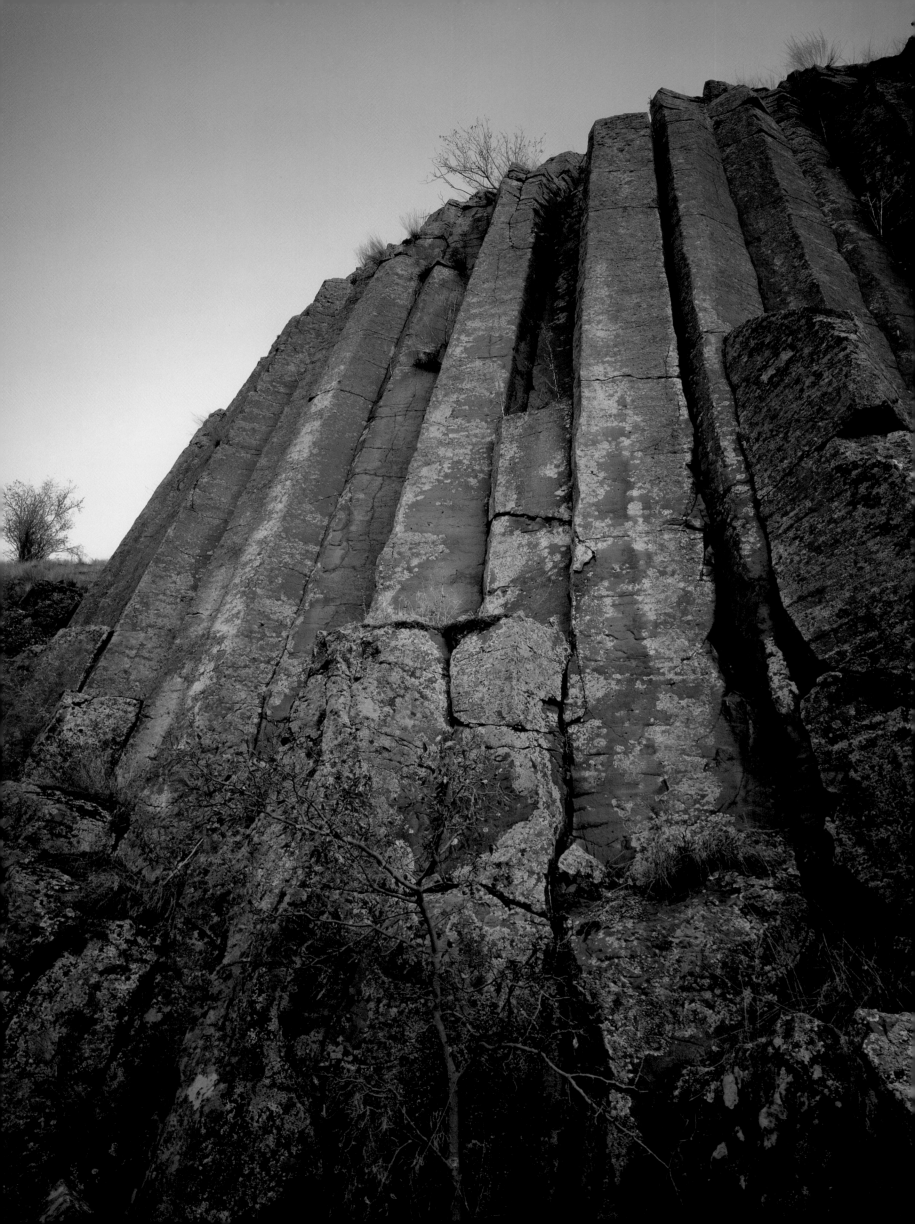

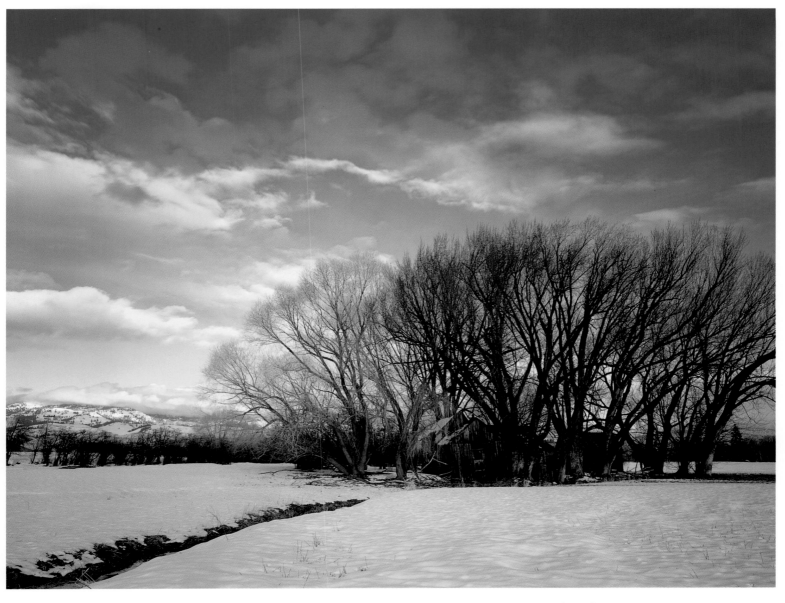

◁ Forty-foot basalt columns in Hells Canyon serve as a reminder of the oozing basalt lava flows that poured over western Idaho more than twelve thousand years ago. △ An old farmstead is protected by a cottonwood grove in the Weiser River Valley.

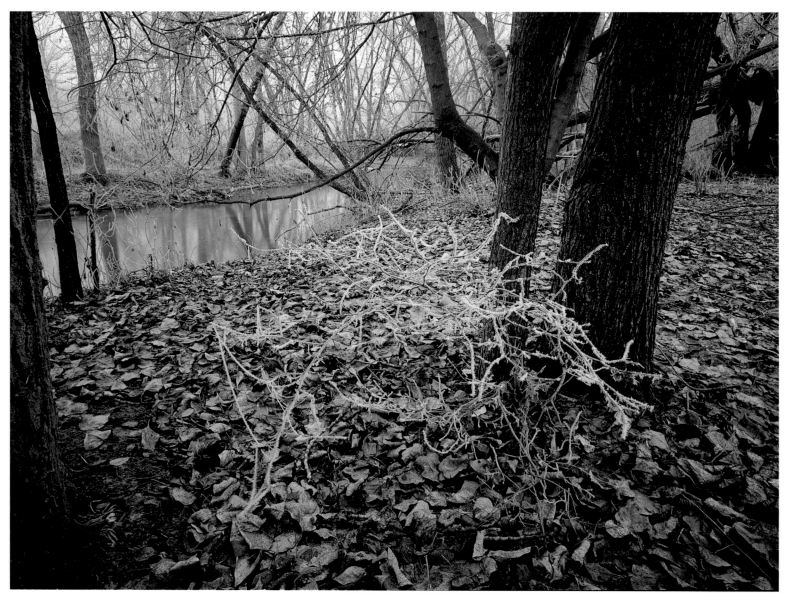

△ On Christmas morning near Boise, a thick layer of frost coats the undergrowth in a cottonwood forest along the Boise River. French-Canadian trappers named the city of Boise *Les Bois*, French for "wooded," because of the cottonwoods lining the river.

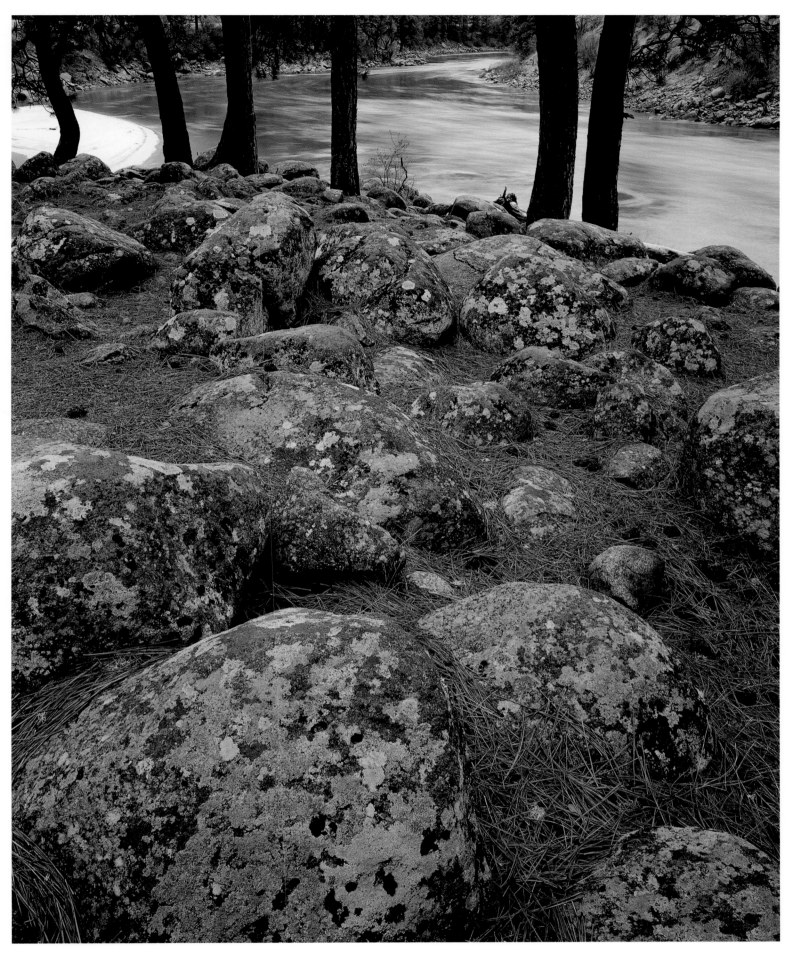

△ Old-growth ponderosa pines dominate the lower slopes of the
Payette River Basin. The north fork of the Payette River features
fifteen miles of continuous Class 5 rapids, while the south fork
tumbles down a number of Class 3 and 4 rapids; the main Payette,
pictured here, contains more friendly Class 2 and 3 rapids.

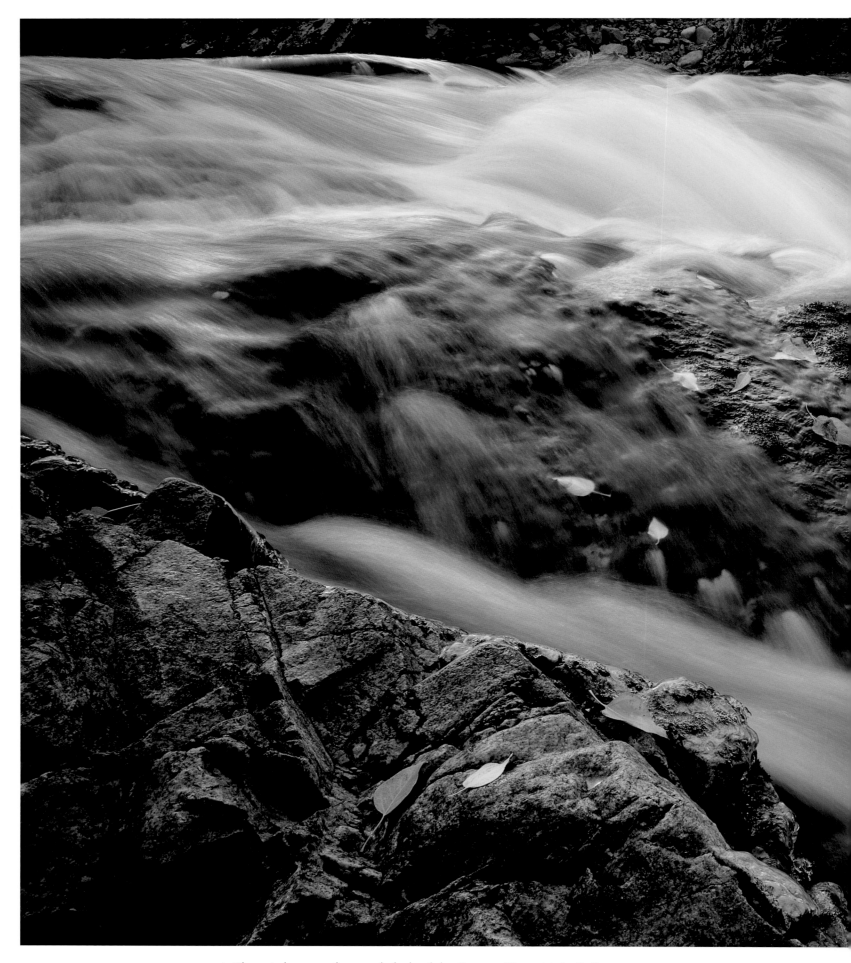

△ A Class 4 drop on the south fork of the Payette River, Little Falls Rapids roar in autumn. The pure waters of the south fork issue from the central core of the Sawtooth Wilderness.

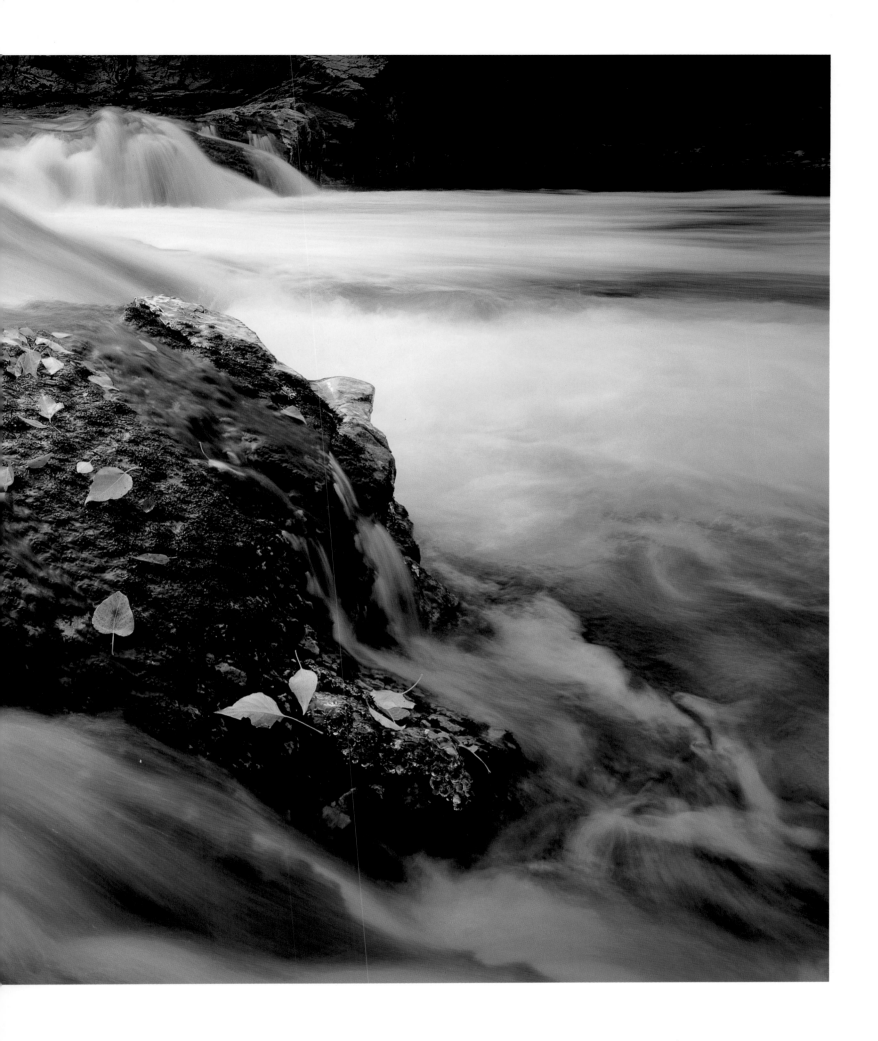

△ Although covered with snow and seemingly empty of life in winter, come spring the Deer Flat National Wildlife Refuge, near Nampa, will be a major nesting area for a wide variety of water-fowl, as well as a popular area for hunting ducks and geese.

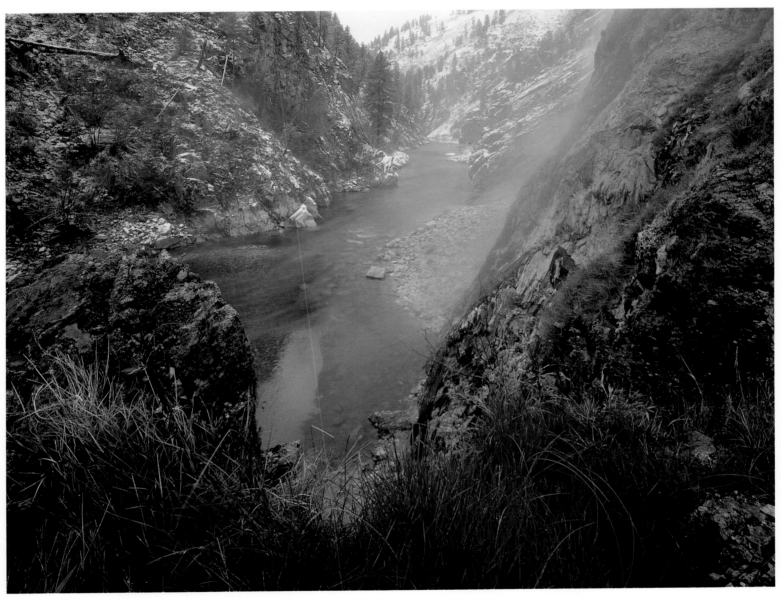

△ Along the Payette River's south fork, steam from Pine Flats Hot Springs merges with winter fog. ▷▷ The south fork of the Boise River cuts a box canyon through basalt in the Boise National Forest. The incised canyon is a popular Class 3 whitewater trip in summer, with good fly-fishing for rainbow trout along the way.

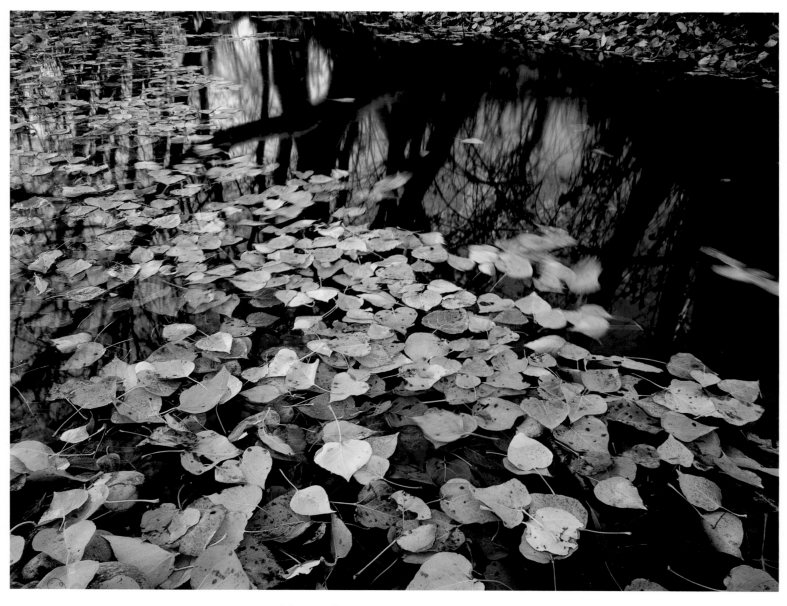

△ Cottonwood leaves float on an oxbow of the Boise River in the city of Boise. By city ordinance, a corridor of cottonwoods is maintained along the river to protect wildlife and trout habitat.
▷ Bluebells adorn a mountain slope below the Seven Devils Peaks.

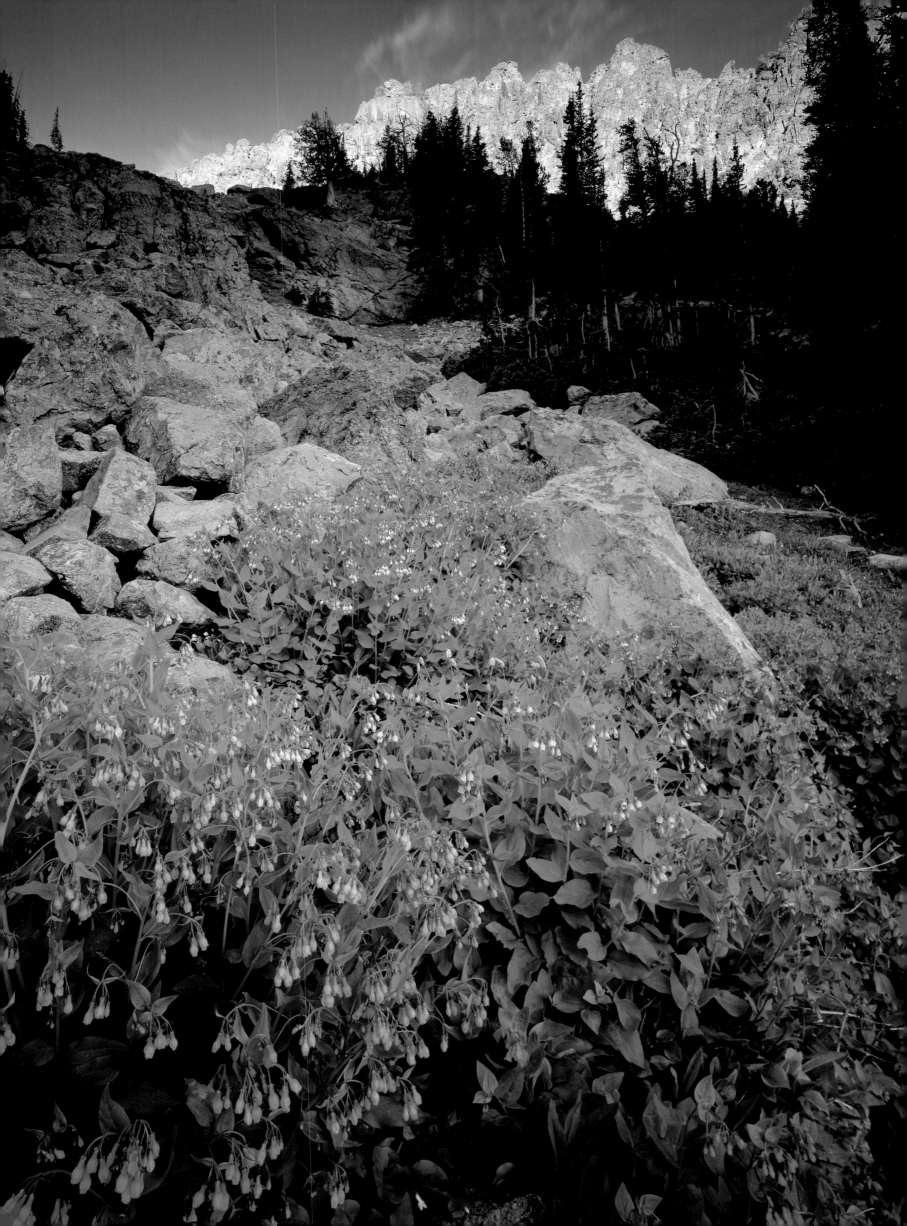

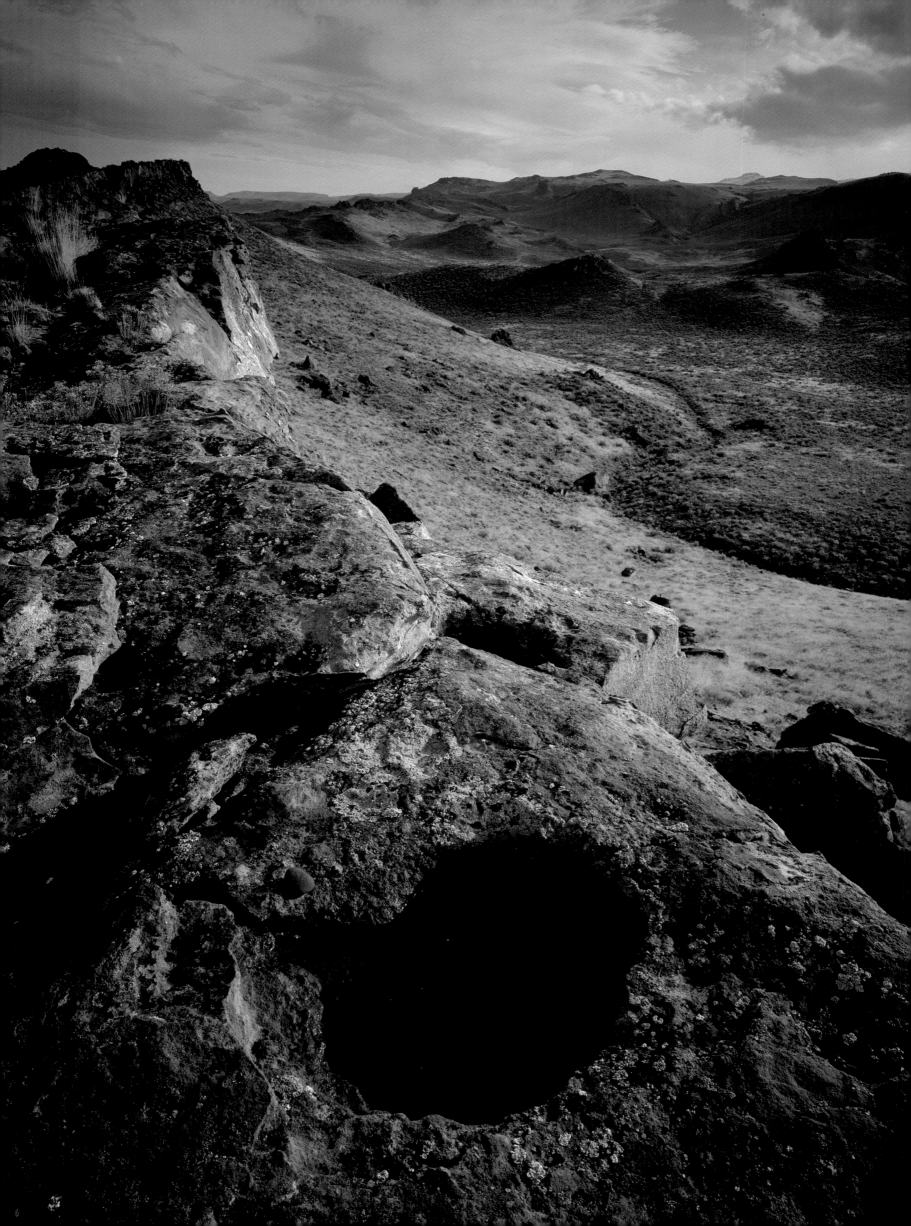

The Owyhee Plateau

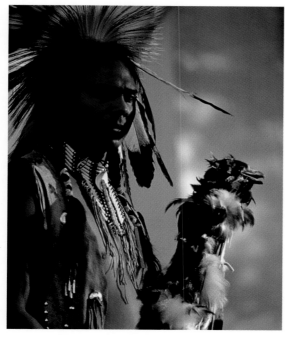

◁ *While the Owyhee Plateau occupies some three million acres of wide open landscape in the southwest corner of Idaho, it also contains many hidden nooks and caves.*
△ △ *A pair of cowboys take a rare moment to rest in an Owyhee corral.*
△ *A Shoshone-Bannock Indian holds an eagle staff during a powwow.*

Deep inside the Bruneau River gorge, a short trek from the river's edge leads into a secret side canyon. Walk just fifty feet away from the river, and the sound of moving water surrenders to complete silence . . . until a great horned owl screeches and flushes from its perch on a rock spire overhead. Much like the incised Bruneau River canyon, the grayish-blond rock walls of this side-draw rise abruptly some 750 feet, ending with a level rim at the top, as if some force of nature trimmed it with a hedge-cutter. A thin foot trail leads into the canyon through a carpet of grass, sage, and thorny wild rose bushes. Around each bend, a new set of tall rock spires comes into view. They almost seem gothic, the way they line up so uniformly along each wall, ominously looming like icons of power.

Around the next corner, several dark holes in the canyon wall come into view. Upon closer examination, the holes lead into a series of caves. Inside the arched doorway of a large cavern, the floor—a firm pile of white volcanic ash—rises steeply and then branches in two directions. Late-afternoon light peeks through a crack, indicating a possible passageway into an adjacent cave. The crack is just wide enough for a person to squirm through, but a sheer thirty-foot drop-off awaits the foolhardy explorer. The air is cool in here; sound collides off the tall ceiling so easily that anything more than a whisper forms an echo. Thousands of little bat-dung nuggets identify the most common modern-day residents.

Farther up the draw, more caves and rock arches punctuate the view in this secret place. Finally, the draw comes to a head at a thirty-foot rock cliff, a mini-grotto that turns into a raging waterfall during rainstorms and snowmelt. Let us call this place the Valley of the Caves and Spiritual Wonders.

Like many of the hidden treasures in the Owyhee desert, this magical side-canyon is virtually unknown to most Idaho residents, even those who live in nearby towns or ranches. Many small canyons in the Owyhee region remain secret because they're nearly impossible to find, much less reach. To the Shoshone-Paiute tribes who occupied the Owyhee Plateau for centuries prior to the 1860s, a secret draw was very likely a hospitable place where a small contingent of the nomadic groups could live for months at a time. Prior to the advent of hydroelectric dams, the Bruneau River supported a sturdy run of chinook salmon and steelhead, providing a seasonal source of food for the Sho-Pai people. This sub-tribe of the Shoshone also harvested edible roots and plants and hunted small game. According to archaeologists and tribal elders, the Shoshone-Paiute preferred the solitude of life in the hidden nooks and crannies of the Owyhee Plateau.

Historian Carlos Schwantes, in his *In Mountain Shadows: a History of Idaho* tells of the rigorous demands of life on the plateau: "Even in the best of times, the small scattered Paiute bands, which lacked permanent villages and complex social organization, spent their days traveling on foot from one oasis to another in a never-ending search for water, firewood and food. Although individual bands occasionally cooperated with one another, there was no tribal unity. Usually only a few families remained together for any length of time, for the supply of rabbits, birds, pine nuts and other foodstuffs was simply too small to feed many people."

The Valley of the Caves and Spiritual Wonders not only provides hints about the Shoshone-Paiute people, but also the geologic forces that formed the Owyhee Plateau. It seems appropriate that the wonders of the Bruneau, Jarbidge, and Owyhee River canyons—easily the most dramatic and scenic in southern Idaho—can be traced to the first volcanic eruptions

that occurred in the western Snake River Plain some fifteen million years ago. Geologists trace the origins of the Snake River Plain and the Yellowstone hot spots to one eruptive center located in the heart of the Owyhee River Canyon—near the Idaho-Oregon-Nevada border—and another in the core of the Jarbidge-Bruneau watershed. Explosive events sent molten rhyolite—a mixture of dissolved water vapor and silica—spewing forth into the air, much like the impressive blast of Mount St. Helens in 1980. "The volcanoes erupted in great explosive clouds of hot, gas-charged rhyolite ash that shot five to ten miles into the sky," according to geologists Bill Hackett and Bill Bonnichsen in *Snake: The Plain and its People.*

Repeated eruptions in these two centers laid down extensive layers of rhyolite lava rock throughout the plateau. Much later, the reddish-orange rhyolite rock was overlaid by numerous flows of less-explosive basalt lava. Although basalt lava rock dominates much of the landscape of the Owyhee Plateau, the down-cutting action of the Owyhee, Bruneau, and Jarbidge Rivers preserved the geologic wonder of the rhyolite layers for perpetuity. The underlying remains were not fully exposed until about one million years ago, when the ancient Lake Idaho—an immense body of water that once covered much of the western Snake Plain—drained out through Hells Canyon. From that point forward, the cutting forces of wind and water carved spectacular displays of spires and monoliths, honeycombs and hoodoos in every canyon on the Owyhee Plateau.

Just north of the Bruneau canyon, North America's tallest sand dunes crest at 470 feet in the shape of a small mountain with a sharp spine. Formed by airborne sand accumulating in an abandoned meander of the Snake River, the dunes are the most popular tourist attraction on the Owyhee Plateau. A state park with a campground provides rare accommodations for tourists there, and its access is close to a state highway.

Due to its desert-like climate and rough terrain, the Owyhee Plateau is sparsely populated today. This corner of Idaho is the driest and hottest in the state. Owyhee County, Idaho's second largest with 7,662 square miles, averages slightly more than one person per square mile, with its eighty-five hundred residents. Only one paved highway snakes through the county, north to south from Bruneau to the Duck Valley Indian Reservation. One-hundred-fifty-thousand cows and six thousand California bighorn sheep—the nation's largest population—greatly outnumber the human population of Owyhee County. Of course, this imbalance is part of the area's charm.

The spelling of the name "Owyhee" was bestowed upon the area largely by accident. According to Lalia Boone's book, *Idaho Place Names,* early trappers visiting the Owyhee Plateau hired three Polynesian Natives to accompany them on the expedition to help communicate with the Shoshone-Paiute Indians. The Hawaiian trio went ahead of the trapping party to search for the Shoshone-Paiute, but they never returned and were presumed dead. British fur trappers later named the area, and one of its major rivers, "Owyhee," after the missionaries' phonetic spelling for Hawaii. Eventually, the county and a nearby mountain range came to bear the same name.

Early white settlers in Owyhee County made a living in one of two ways: either ranching or mining. Silver City, a charming summer getaway for adventurous travelers today, in 1863 was the site of one of the early gold and silver discoveries in Idaho. The town served as the seat of Owyhee County for nearly seventy years until the tiny ranching town of Murphy took over as the county seat in 1936. Mining is still an important industry in Owyhee County: for example, a modern open-pit gold and silver mine, just above Silver City on DeLamar Mountain. For the rest of the county, ranching, farming, the Envirosafe toxic waste dump, and a large feedlot near Grand View, owned by the Simplot Company, provide jobs for the economy.

Large expanses of high-elevation sagebrush and grassland habitat produce nearly year-round feed for cattle, antelope, deer, and wild horses. Pipelines pump water to scattered troughs in the dry uplands. A typical Owyhee County ranch features a small plot of private land, a family dwelling, small corrals and a few hay pastures as a base unit. To round out the working ranch, families may lease adjacent federal lands where their cows can graze for up to nine months of the year.

Like many of the Shoshone-Paiute, who now live on the Duck Valley Reservation on the Idaho-Nevada border, Owyhee County ranchers prefer to live a solitary life on the plateau. Because the place is so big, so quiet, and so wild, it's quite easy to feel absolutely insignificant in the whole scheme of things. It's just you, the wind, the sagebrush, and the harmony of happy meadowlarks. No phones or fax machines, no traffic, no signs of civilization, not even a power line.

These virtues of solitude may have attracted Claude Dallas, a twentieth-century "mountain man," to the Owyhee desert in the early 1970s. A native of Virginia, Dallas fled to the desolate open spaces of southwest Idaho, northern Nevada, and eastern Oregon to elude an indictment from Ohio for dodging the draft. He collected an assortment of pistols, rifles, and shotguns and wore a .357 magnum pistol in a Western-style holster around his waist at all times.

Dallas was "oddly contemptuous of game laws," wrote Jack Olsen, author of *Give a Boy a Gun: the Story of Claude Dallas.* He once drove a pickup with five freshly killed deer in the back, with no tarp to cover the poached animals.

The man's open disdain for game laws finally caught up with him after nearly a decade of lawless hunting. Two Idaho Fish and Game officers snuck up on Dallas's winter camp, Bull Basin, on January 5, 1981. Officers Bill Pogue, 50, and Conley Elms, 34, approached Dallas and inquired about various hides hanging up in his camp several days before the trapping season opened. As they reached to confiscate the furs, Dallas shot them both in cold blood with his pistol. With the assistance of a man who had been camping with him in Bull Basin, Dallas dumped Elms's body in the South Fork of the Owyhee River and buried Pogue. Then he fled.

Dallas hid out in the remote desert for fifteen months, staying one step ahead of the FBI and Owyhee County Sheriff Tim Nettleton. A $20,000 reward was placed on his head. To some, Dallas was considered a "folk hero" for killing the game wardens. He was finally caught in April 1982 at a trailer house in northern Nevada. Dallas was convicted of voluntary manslaughter by a Canyon County jury, who sympathized somewhat with Dallas's anti-law enforcement outlook. Judge Edward Lodge sentenced Dallas to thirty years in prison.

After spending just three years behind bars, Dallas escaped from the Idaho State Penitentiary and fled to the Owyhee desert again. The FBI placed him on its "Most Wanted" list, but in the Owyhees, it was nearly impossible to track him down. Almost a year later, he was arrested at a California Stop-N-Go store. Dallas beat a felony escape charge, but he is expected to remain in federal prison for most of his original sentence.

Much like that isolated, secret cave in the Bruneau canyon, the Owyhee Plateau is one of the rare places where you can hide from modern America—as long as you can stand to be alone.

▷ *Southeast of Jordan Valley, frigid weather creates an icy surface on the Owyhee River's north fork.*

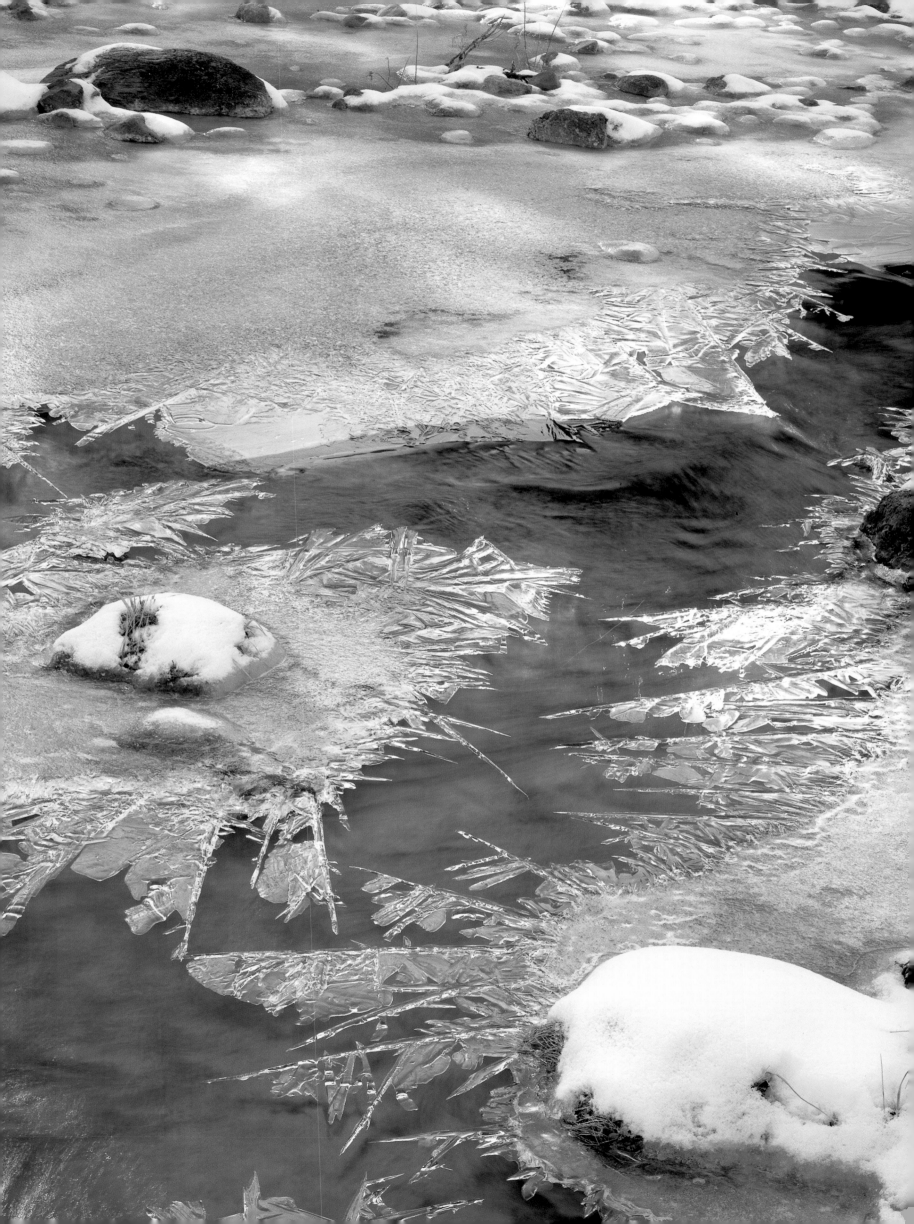

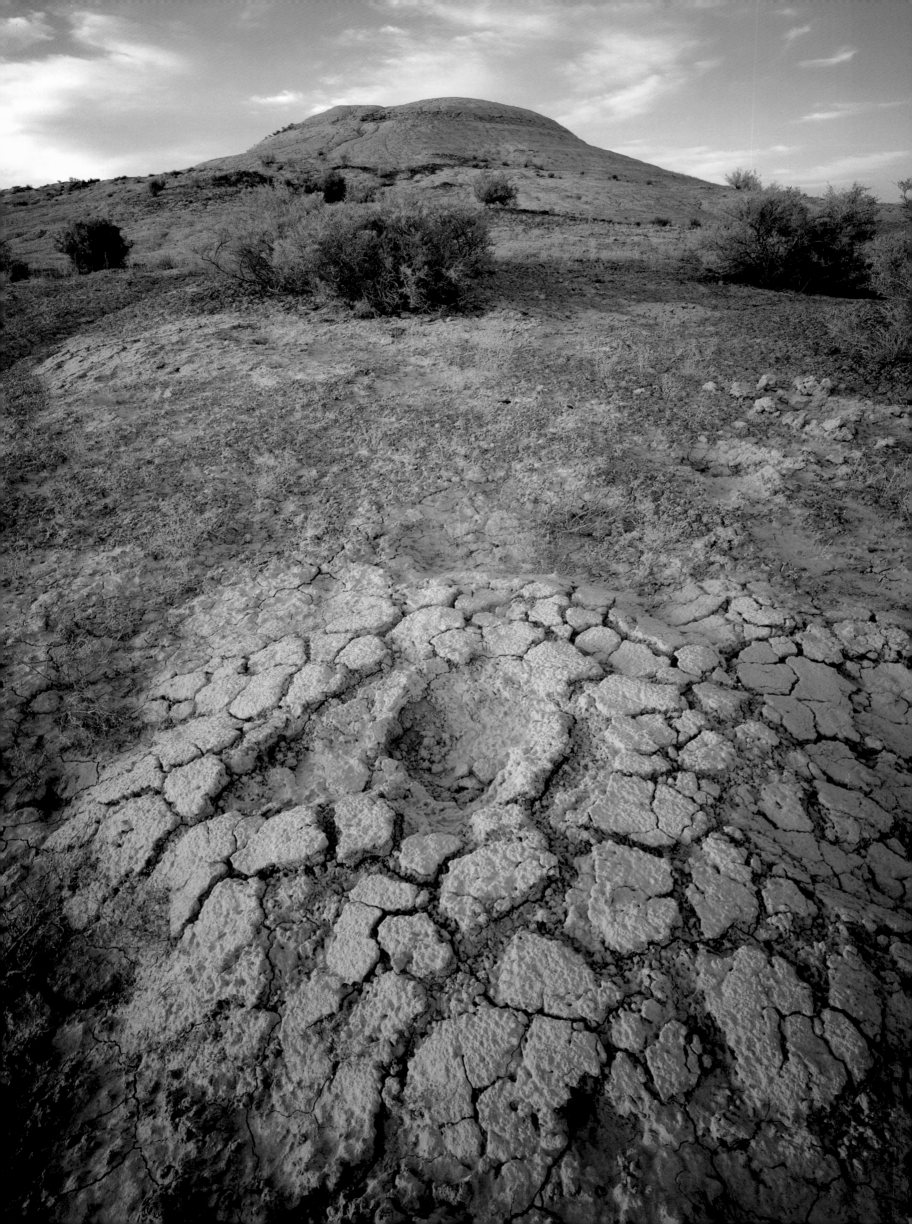

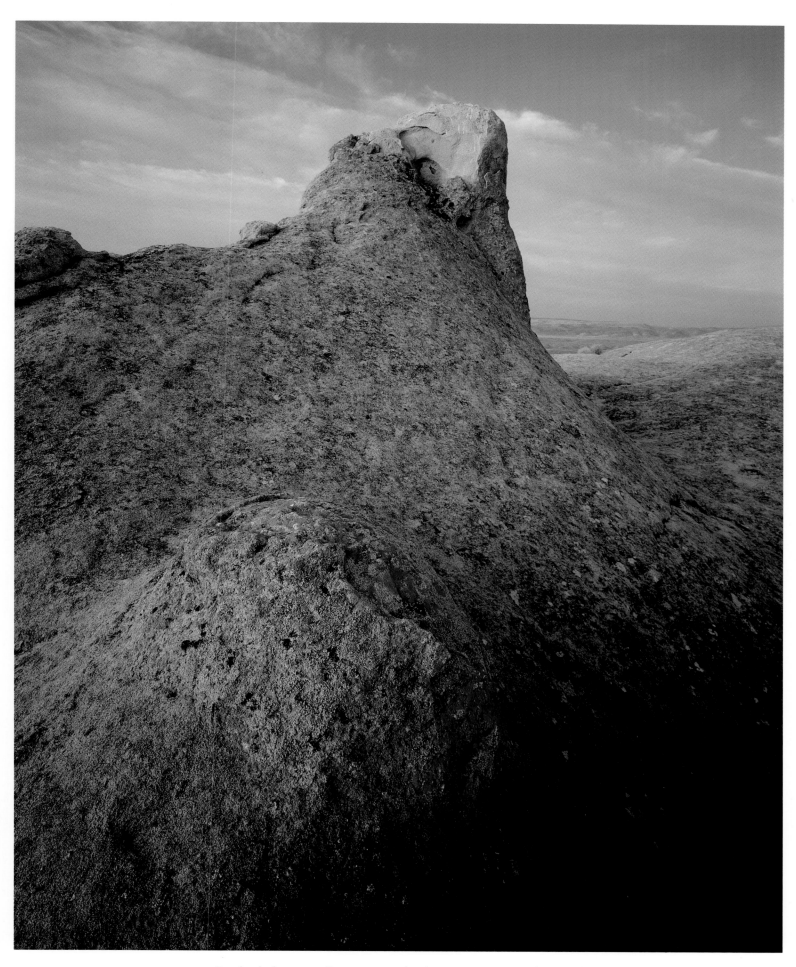

◁ Parched desert soil attests to the hot summer weather in the
Owyhees near Oreana. Temperatures can zoom over 100 degrees
in the lower reaches of the Owyhee Range during July and August.
△ Lichens smother an isolated sandstone spire.

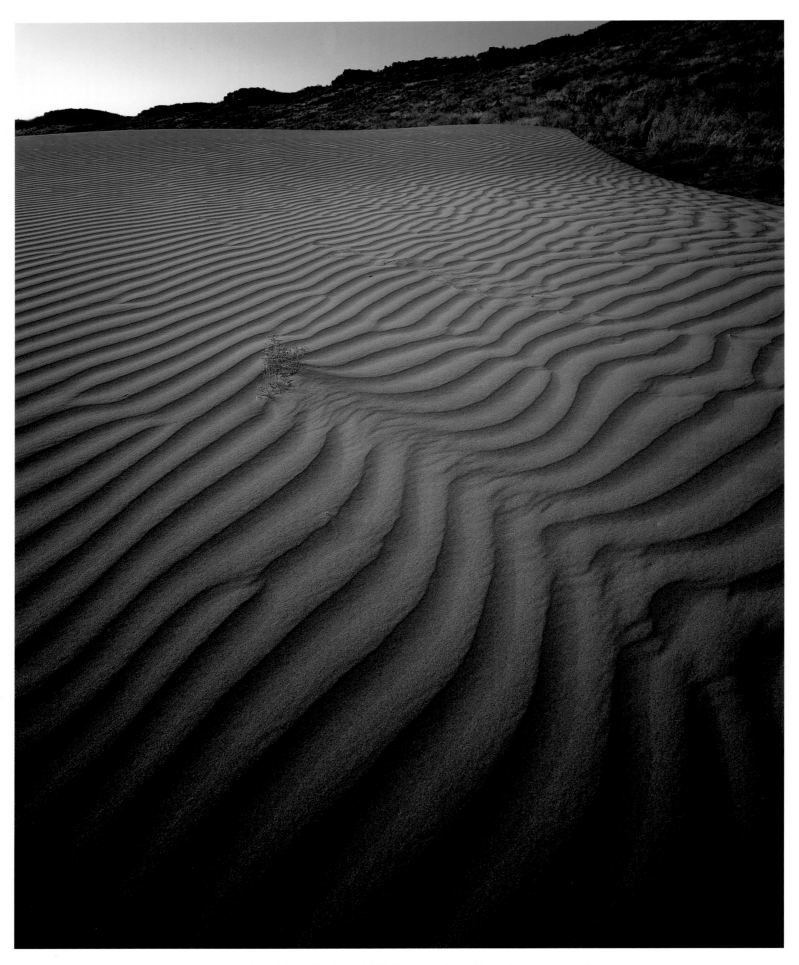

△ An isolated island of sand fills in a pocket of basalt on the south-west flank of the Owyhee Mountains. ▷ The Bruneau Dunes lie on the northern edge of the Owyhee desert, near the town of Bruneau. ▷ ▷ Twelve million years ago, volcanic eruptions in southwestern Idaho showered rhyolite ash and lava on the Owyhee Plateau.

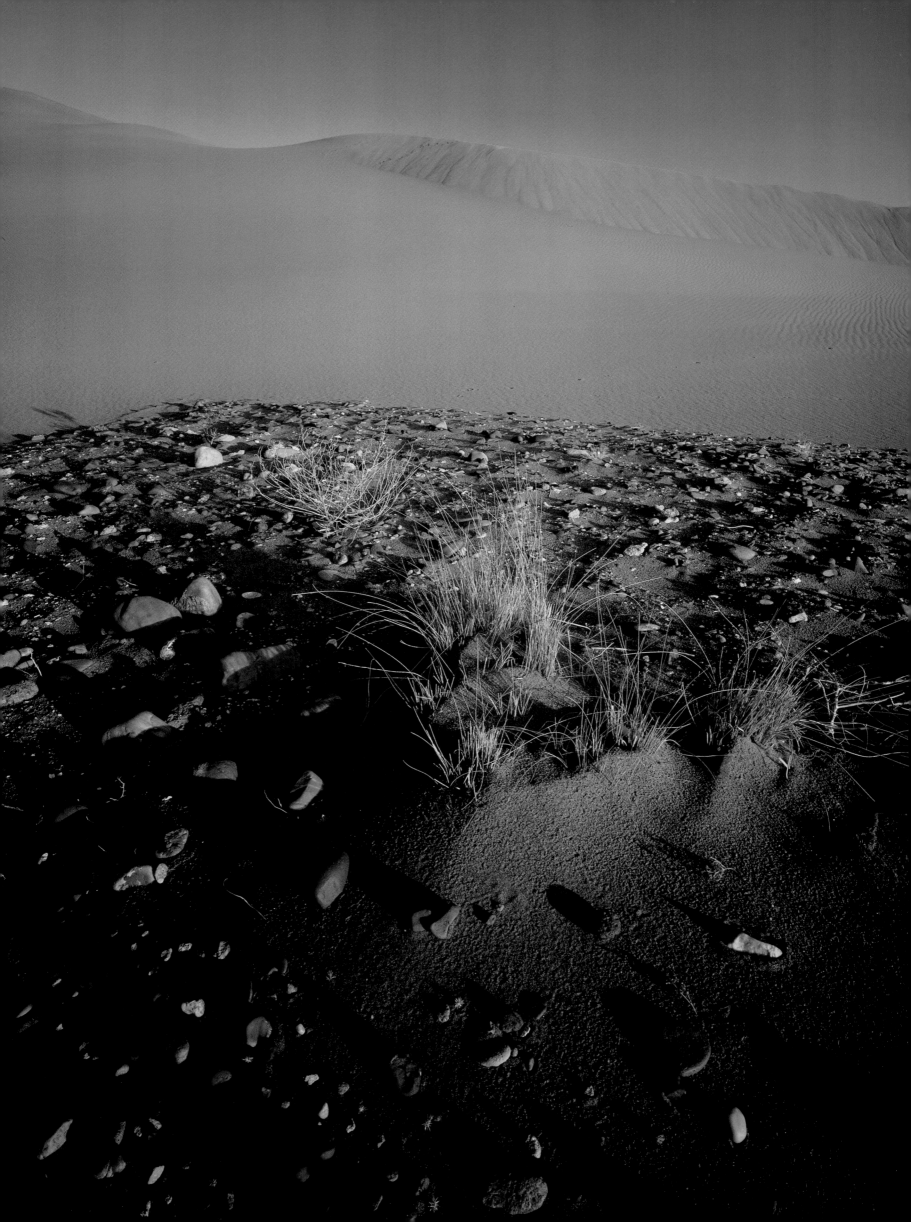

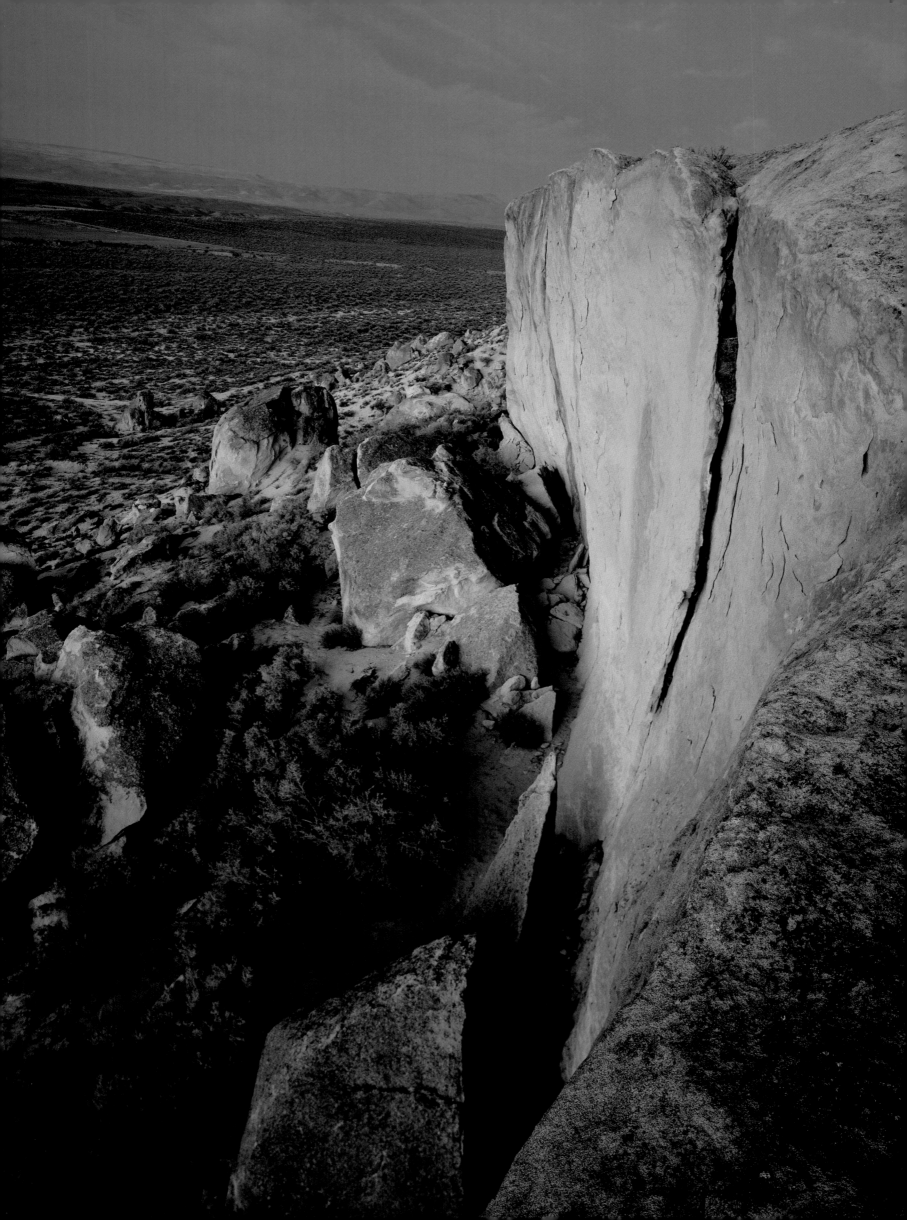

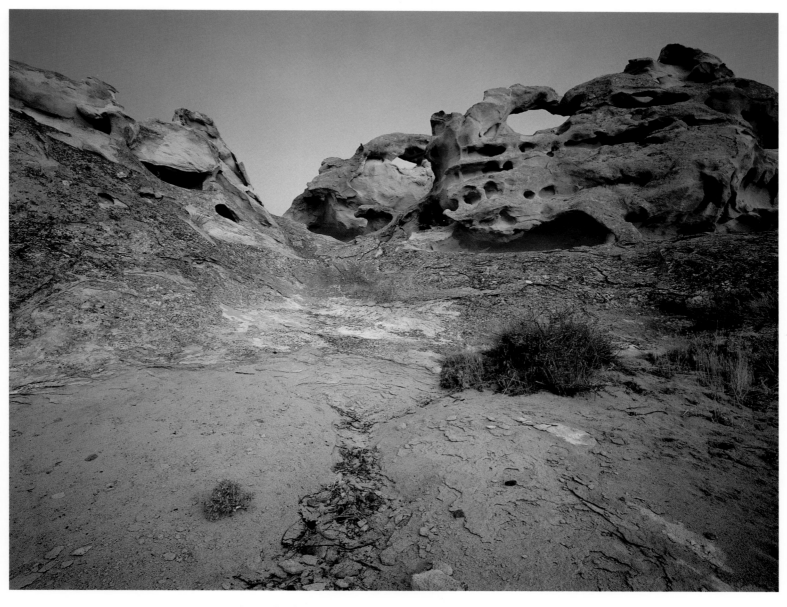

◁ Travelers who brave Owyhee jeep trails are rewarded with views of basalt and rhyolite formations along Mud Flat Road. △ In the Owyhee country, wind and weather have carved secret honeycombs, caves, and arches. ▷▷ On the Owyhees' high plateau, new snow stencils the outlines of lichen-covered basalt rock.

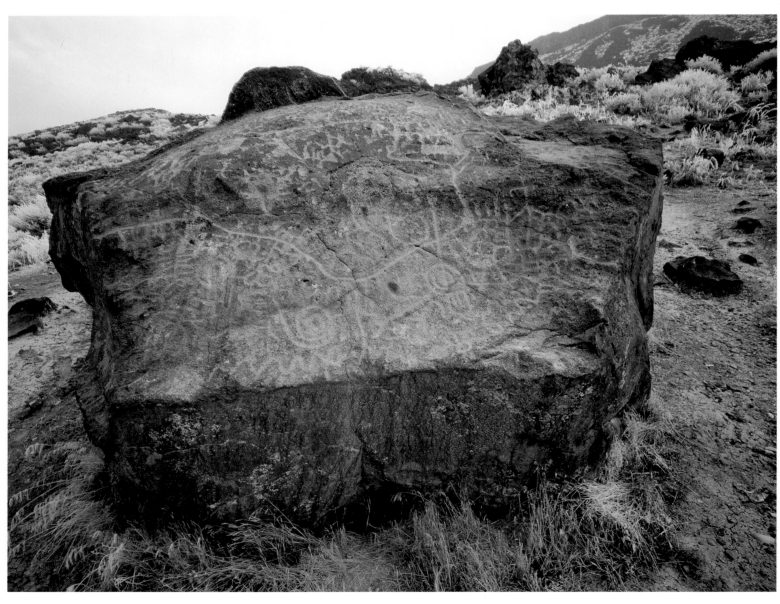

△ Map Rock got its name from a series of petroglyphs inscribed on this basalt boulder, located on the banks of the Snake River. Some fifteen thousand years ago, the Bonneville Flood carried boulders such as this from the Snake River cliffs. ▷ Yellow blossoms adorn a rabbitbrush plant in the lower reaches of the Owyhee Mountains.

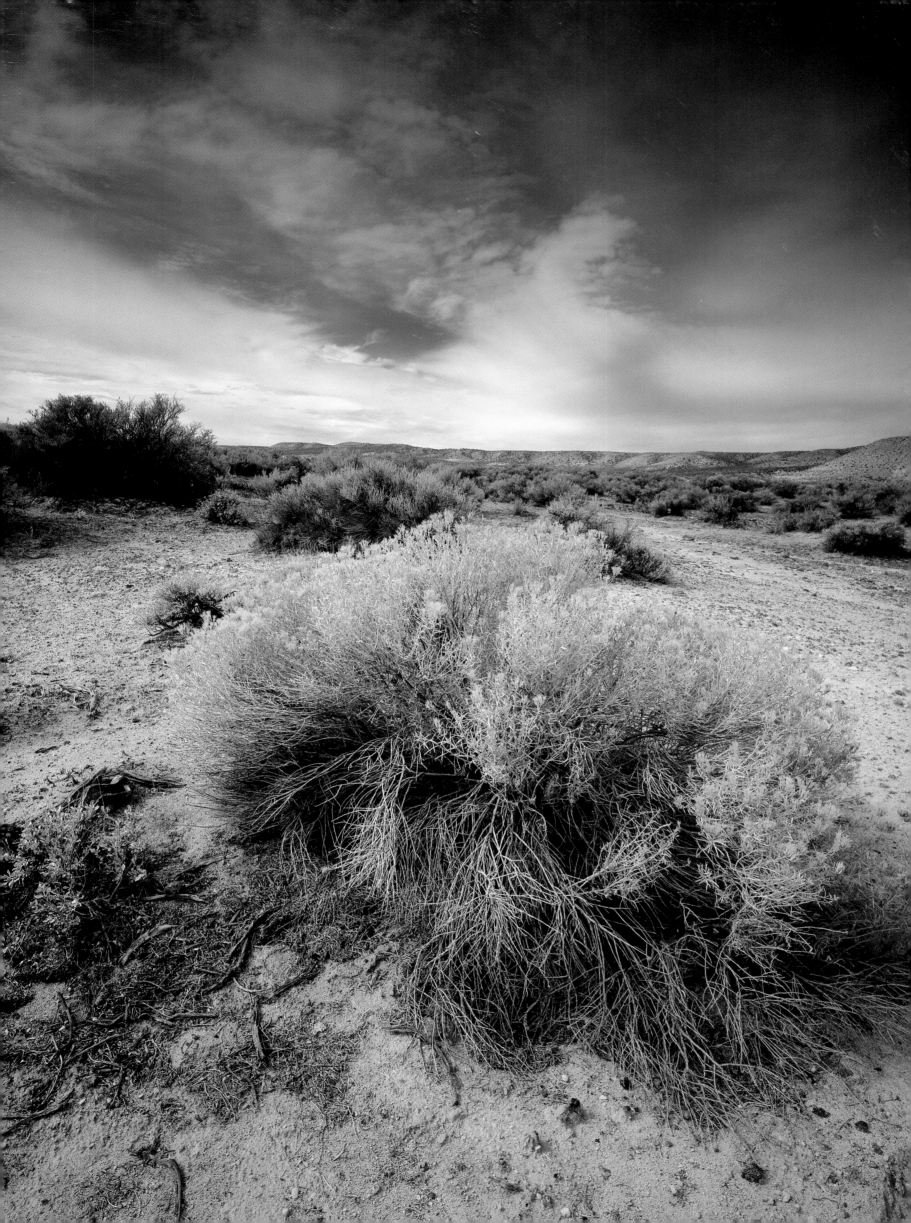

Acknowledgments

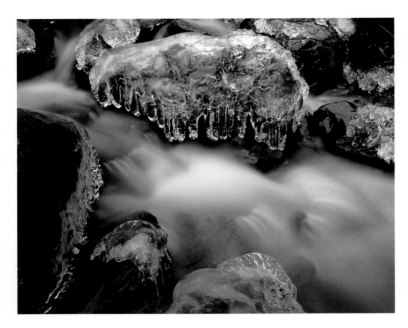

I have been a very fortunate person to have had the honor to walk in the soul of Idaho. All of my life I have been inspired by the scenic wonder and truth of nature. There are few places on this earth that give me as much insight and fulfillment as this great state.

I would like to thank my family for creating an atmosphere of worth and passion: my mother and father who allowed me to follow my heart; my brother who can always give me perspective; my grandfather (Wood Pecker Bill) who told my brother and me many wild bear stories. Most of all, I would like to thank my beautiful son, Wyatt, who takes me places no one else but he and I can travel.

A special thanks to Steve Stuebner for all of his help and inspiration throughout the production of this book. Thank you all for the wonderful impressions you have left on me.

MARK W. LISK

It has been a true privilege to work on this book about the lovely state of Idaho. Without a single exception, every Idahoan I talked to for the purposes of this book was extremely helpful. Before I started to work on this project, I thought I had a pretty good sense for the totality of Idaho, but the whole experience of researching this book created a much greater appreciation for the place I call home.

I want to thank my wife for her patience and tolerance as I spent many hours away from home traveling around the state for this book.

A great, unanticipated benefit from this project was that I made a new friend, Mark Lisk, a guy who has an insatiable zest for adventure and new experiences.

STEPHEN STUEBNER